*Hidden Treasures of San Francisco Bay*

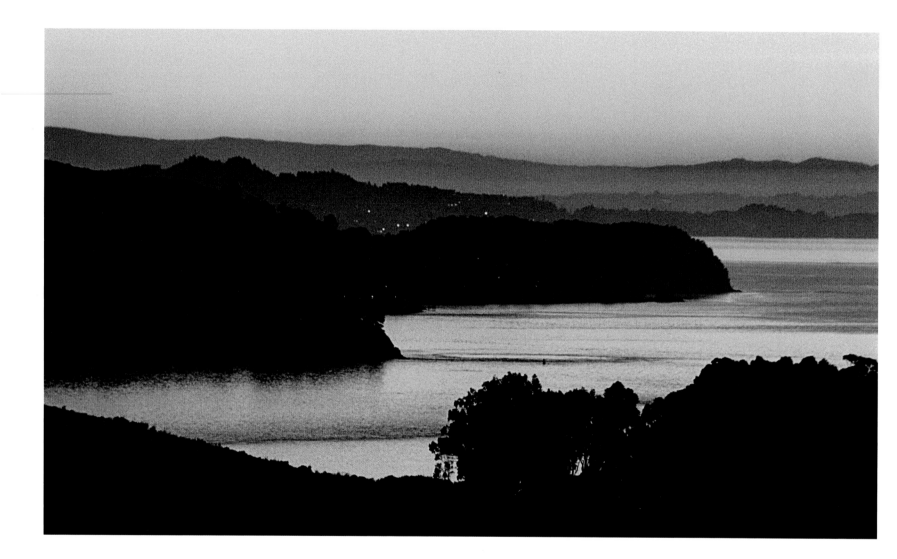

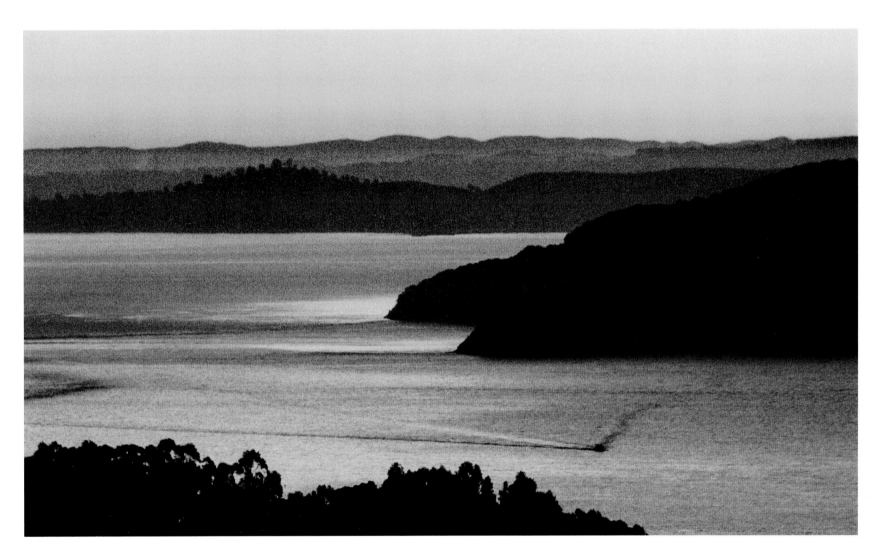

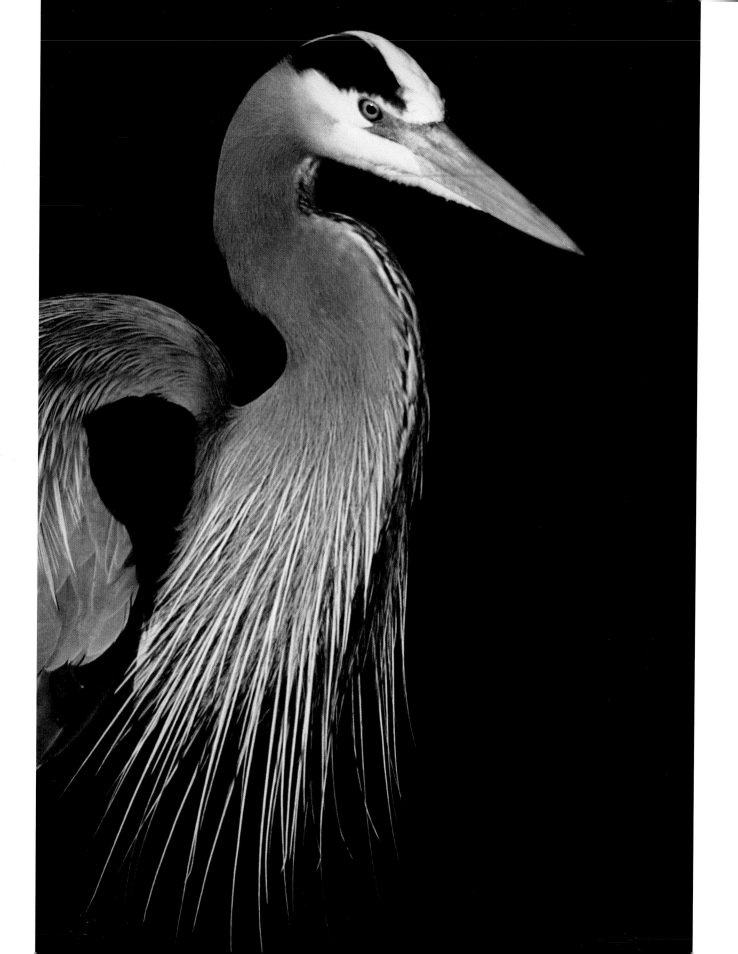

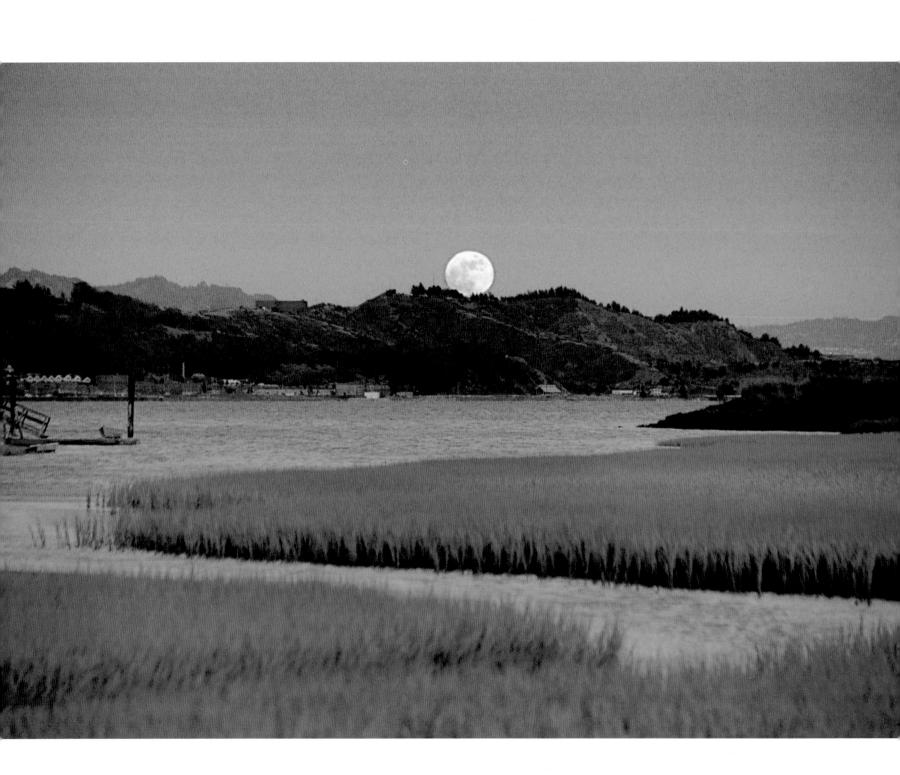

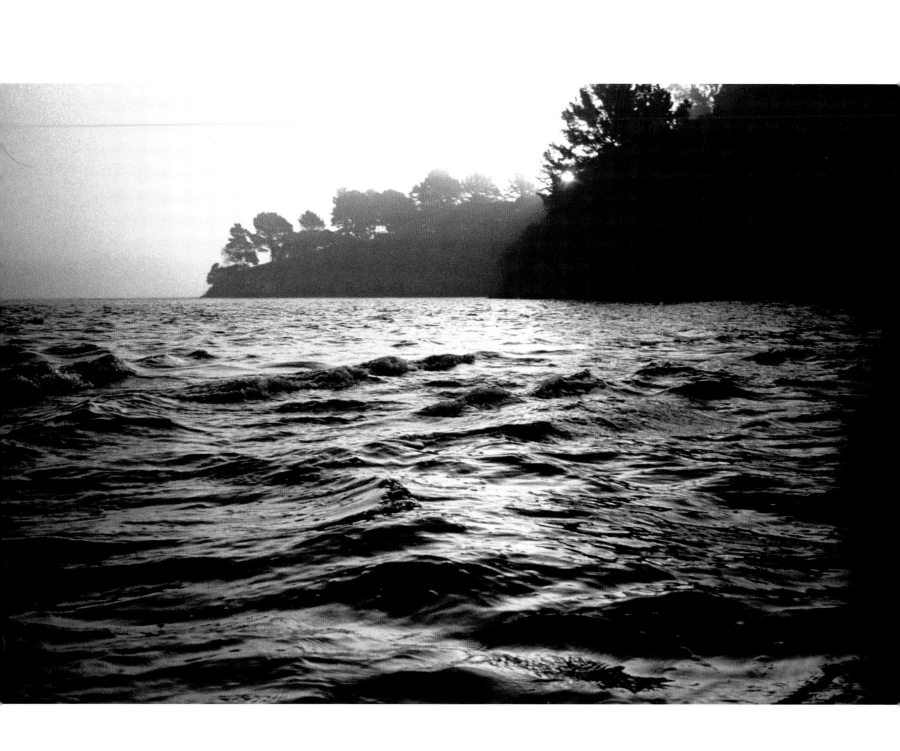

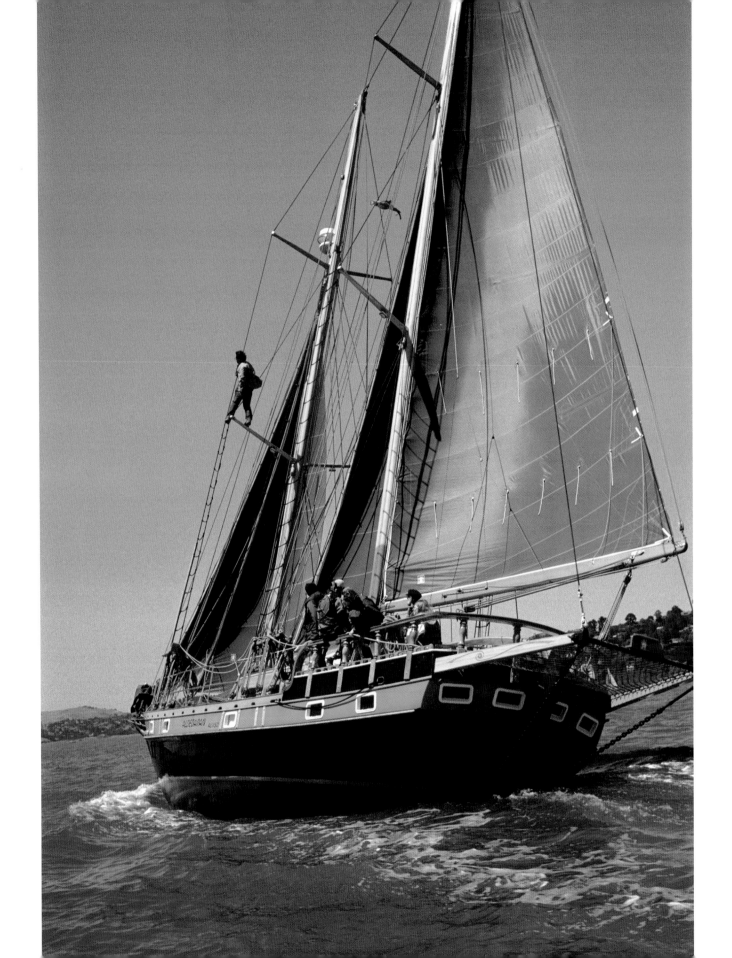

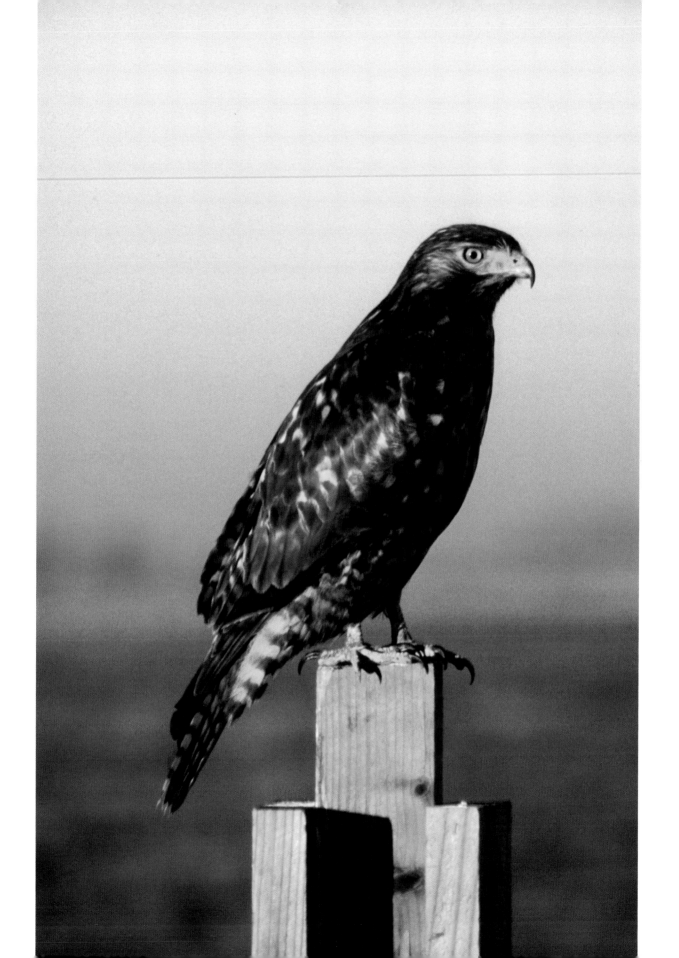

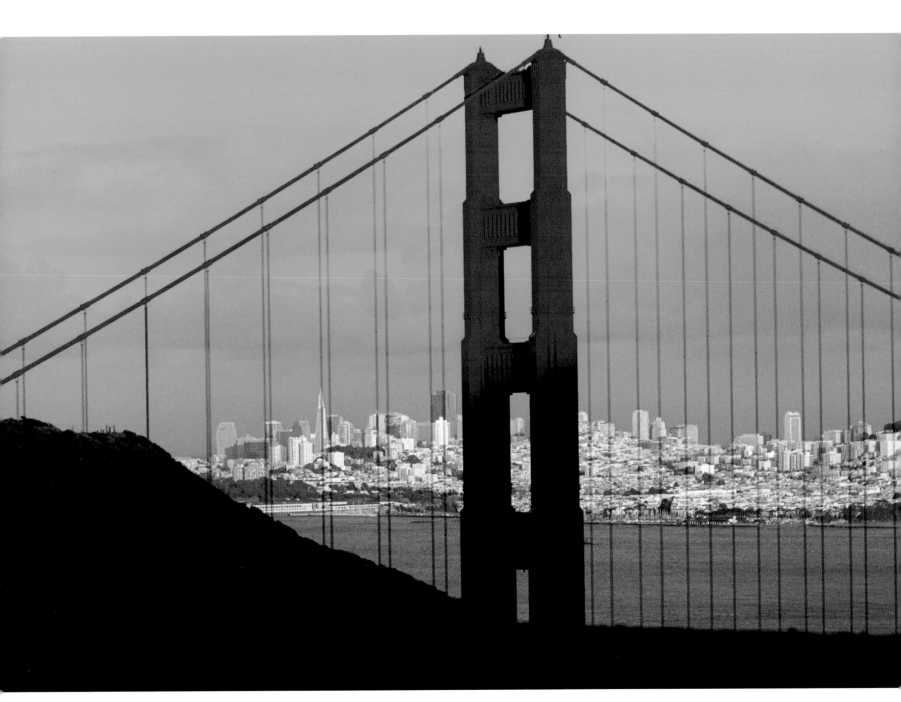

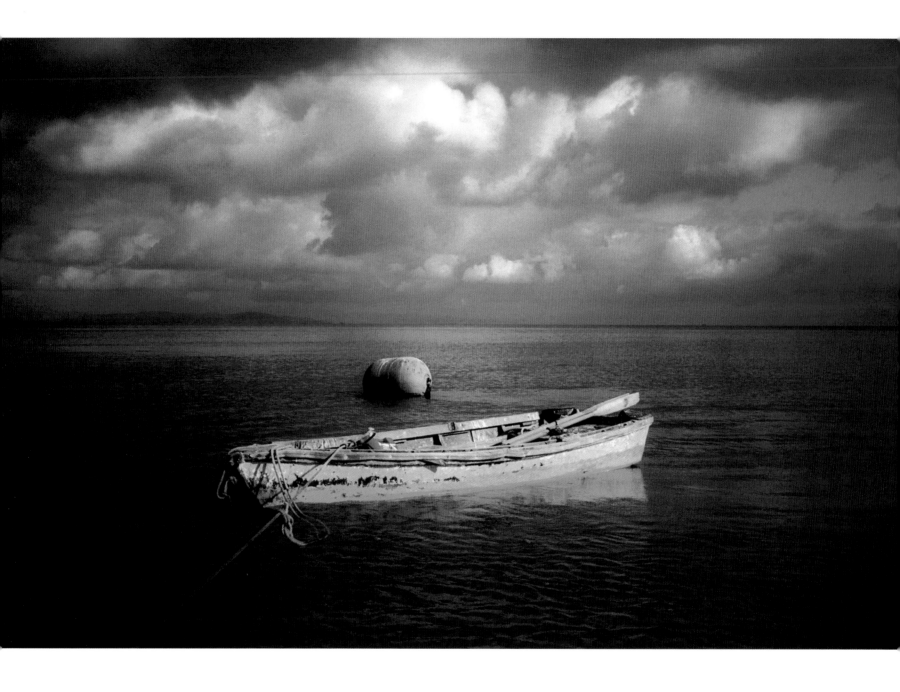

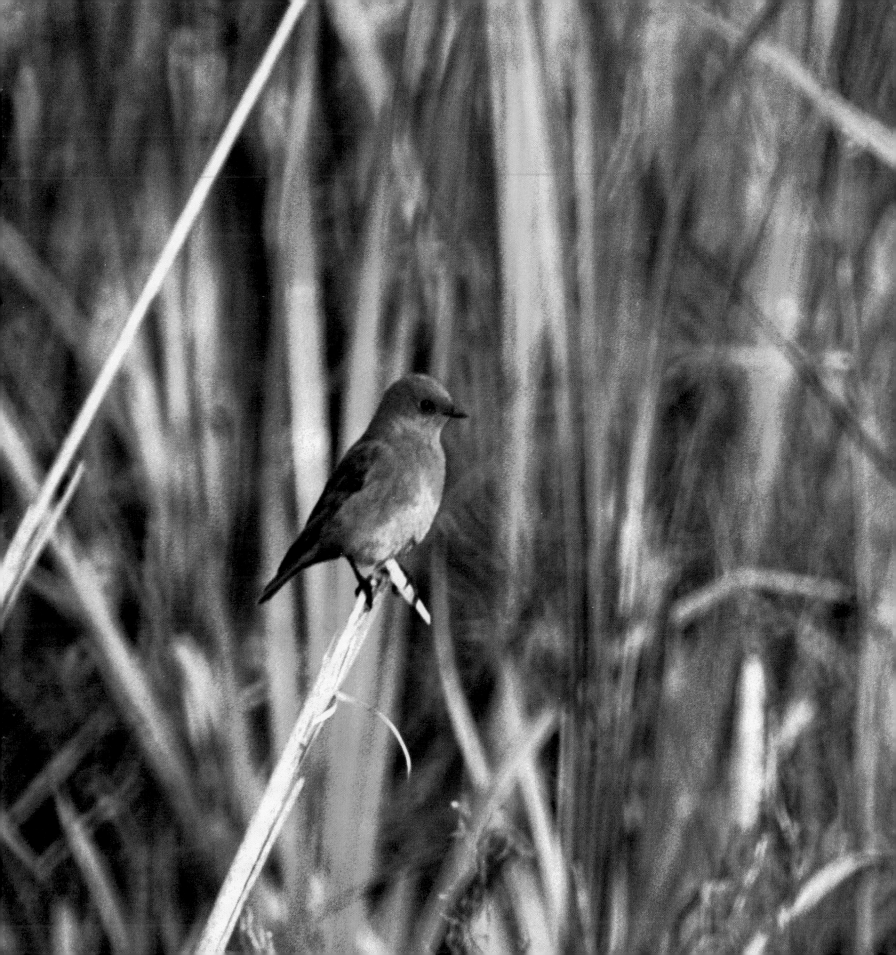

# Hidden Treasures of

# SAN FRANCISCO BAY

Photographs by Dennis E. Anderson

Text by Jerry George

BLUE WATER PICTURES, SAN RAFAEL, CALIFORNIA

HEYDAY BOOKS, BERKELEY, CALIFORNIA

*Library of Congress Cataloging-in-Publication Data*
Anderson, Dennis E.
  Hidden treasures of San Francisco Bay / photography by Dennis E.
Anderson ; text by Jerry George.
     p. cm.
  ISBN 1-890771-76-7 (cloth)
  ISBN 1-890771-75-9 (pbk.)
  1.  San Francisco Bay (Calif.)--Pictorial works. 2.  Natural
history—California—San Francisco Bay—Pictorial works. 3.  Fishing
boats—California—San Francisco Bay—Pictorial works. 4.  San Francisco
Bay (Calif.)—Description and travel. 5.  Natural
history—California—San Francisco Bay. 6.  Underwater photography.  I.
George, Jerry. II. Title.
  F868.S156A54 2003
  508.3164'32--dc21
                                        2003011900

Design: Rebecca LeGates

Orders, inquiries, and correspondence should be addressed to:
Heyday Books, P. O. Box 9145, Berkeley, CA 94709
(510) 549-3564, fax (510) 549-1889
www.heydaybooks.com

Printed in Singapore by Imago

10 9 8 7 6 5 4 3 2 1

# CONTENTS

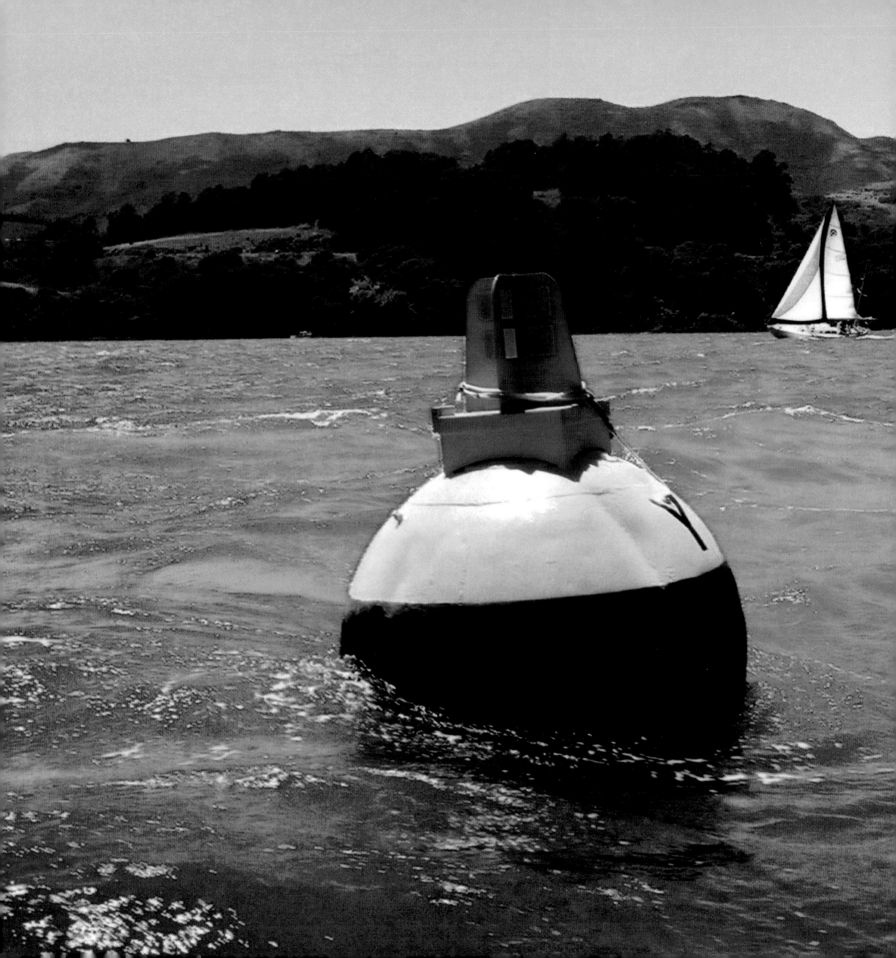

# CYCLES OF WIND AND WATER

See once this boundless bay and live;
See once this beauteous bay and love;
See once this warm bright bay, and give
God thanks for olive branch and dove.

Such room of sea! Such room of sky!
Such room to draw a soul-full breath!

*Joaquin Miller*

Man draws inspiration from bodies of water. I doubt there is a single human soul who has cast his or her eyes on San Francisco Bay without pausing, however momentarily, to reflect, to let go. The Bay is captivating: pale green in times of storm, deep blue when bathed in sun, and always, always changing. Few bodies of water are more exquisitely set among golden mountains. No matter where you view the Bay, you find humbling, grand vistas and intimate, ephemeral moments of discovery. Seafarers who have spent their lives on the Bay will tell you that no matter how familiar and predictable

1

the Bay may seem, it reveals something new, something previously hidden, every day.

The story of San Francisco Bay begins offshore. Through a weir-like gap less than two miles wide, the mighty, misnamed Pacific streams in and out of the Golden Gate twice each day, flooding and draining a vast stretch of saltwater covering 450 square miles. The magnitude of the current created by the tides is quite literally staggering. Combine all of the rivers and streams that empty through the Bay, then multiply their total daily flow by ten. That is the volume of water that shoots through the Golden Gate with each change of the tide. Looking postcard-peaceful from shore, the resulting currents in the Gate are both swift and dangerous. Many ships and smaller boats, even long-experienced tour boats, have miscalculated the current and found themselves suddenly driven onto the rocks.

More subtle but no less dramatic, hot summer air rising over the state's sunbaked Central Valley acts like a giant bellows sucking in moisture-rich cooler air from the ocean. As the marine air passes over cool currents its moisture condenses to form fog: the famous San Francisco fog that blows in through the Golden Gate and silently rolls into the East Bay hills. When the temperature difference between the valley air and the marine layer is large, more fog is drawn in. It spills over the coastal mountains and settles in the Bay's basin, making temperatures as much as fifty degrees lower than those in the Central Valley.

Birds come, birds go. Storms rage, then they pass. Change is the one constant in San Francisco Bay. No two days are the same. No two nights. Yet there is some predictability. What is today will come again, not exactly perhaps, but close. Most of the change on and in the Bay is cyclical, not evolutionary.

At each step we take, from the grand to the minute, from the Bay Area to individual bays to single channels or harbors or to barnacle-encrusted rocks, we see the cycles of water and air uniquely played out. Fog condensing on trees and smaller plants provides precipitation in the rainless summer. Shallow water heats faster than deep water, so shallow bays are warmer and may grow more algae. But warm water carries less oxygen than cool water and therefore supports fewer critters. During the heavy storms of December and January great quantities of freshwater flow into the Bay, pushing denser saltwater and saltwater-dependent marine life from the marshes. Different plants and animals that thrive in the freshwater add food for migrating waterfowl that make the Bay their winter home.

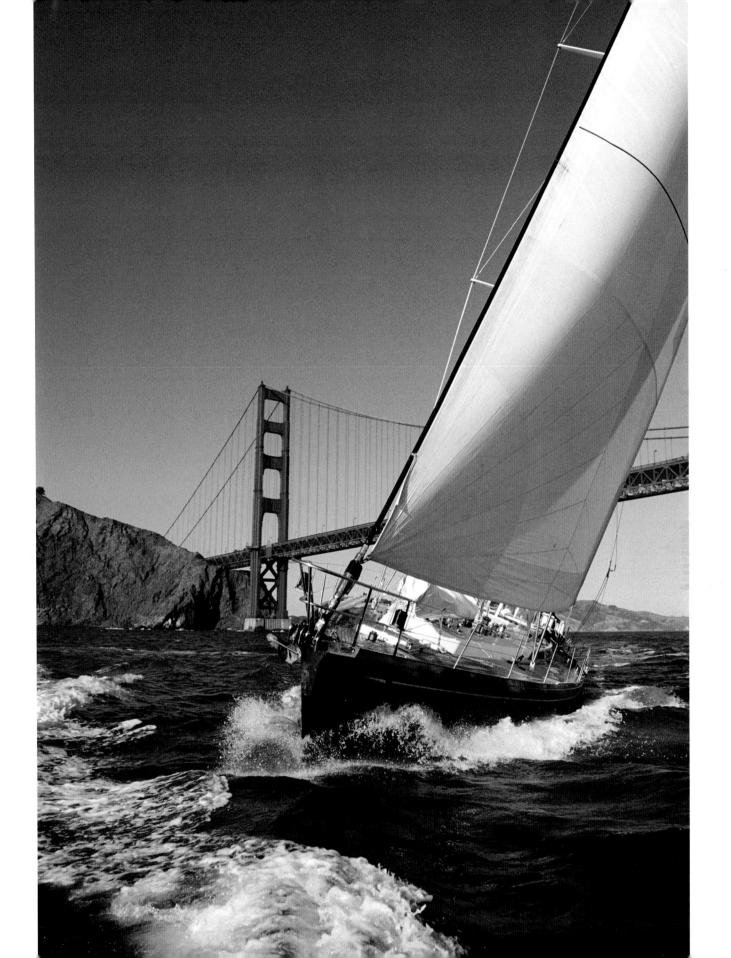

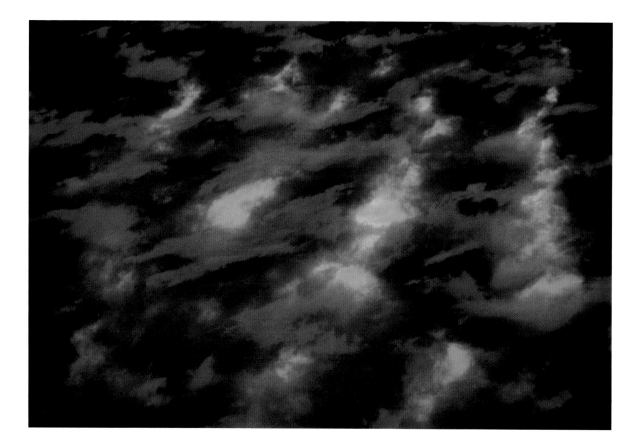

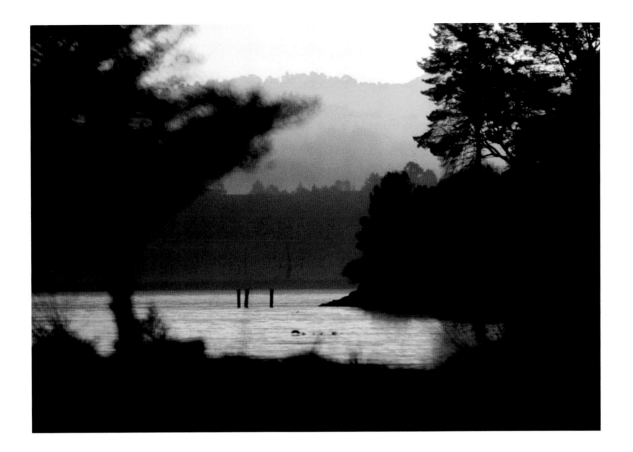

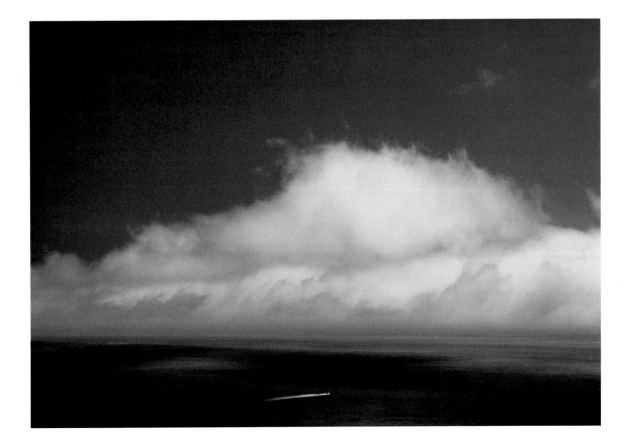

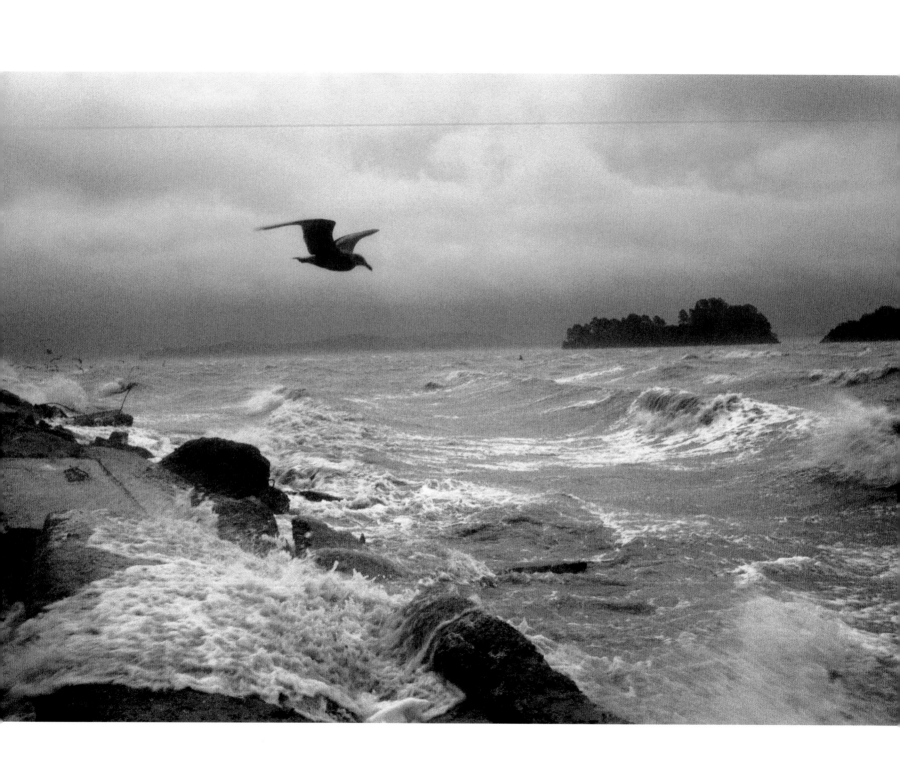

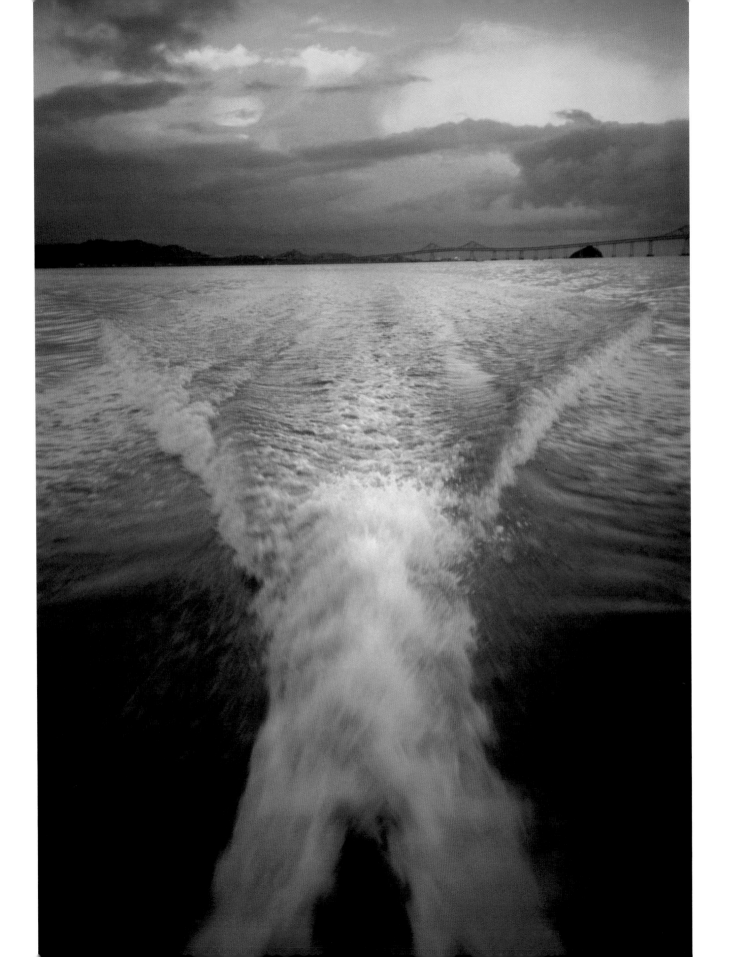

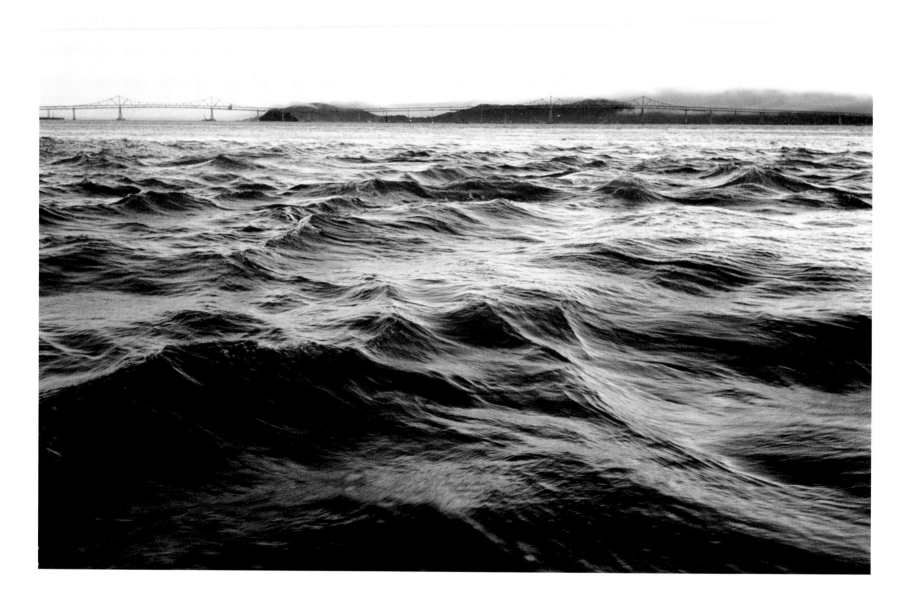

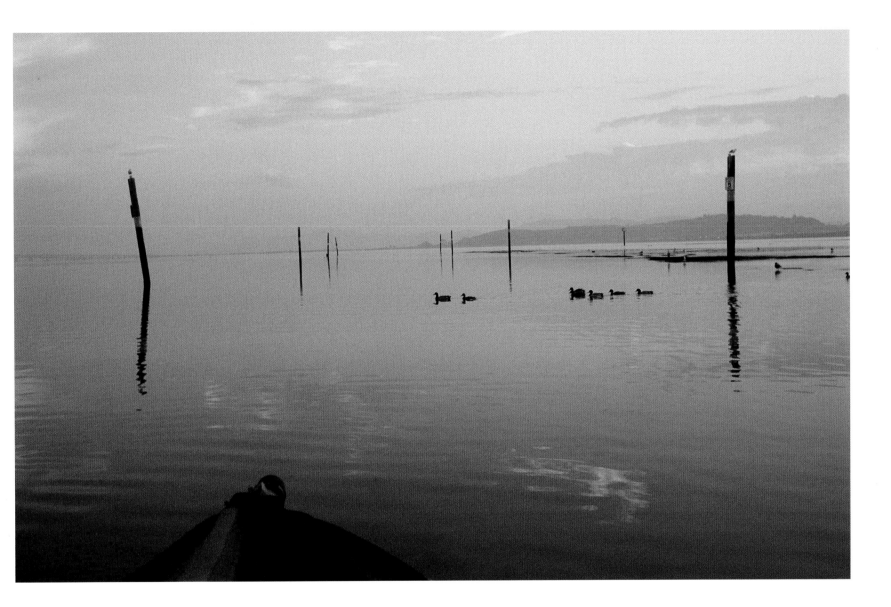

9

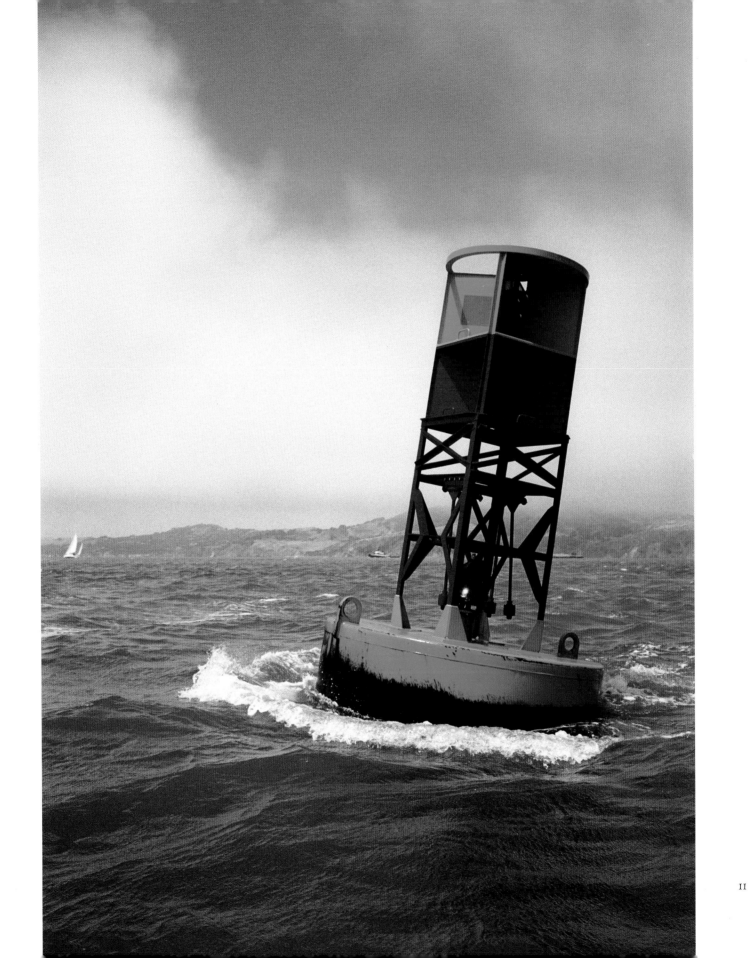

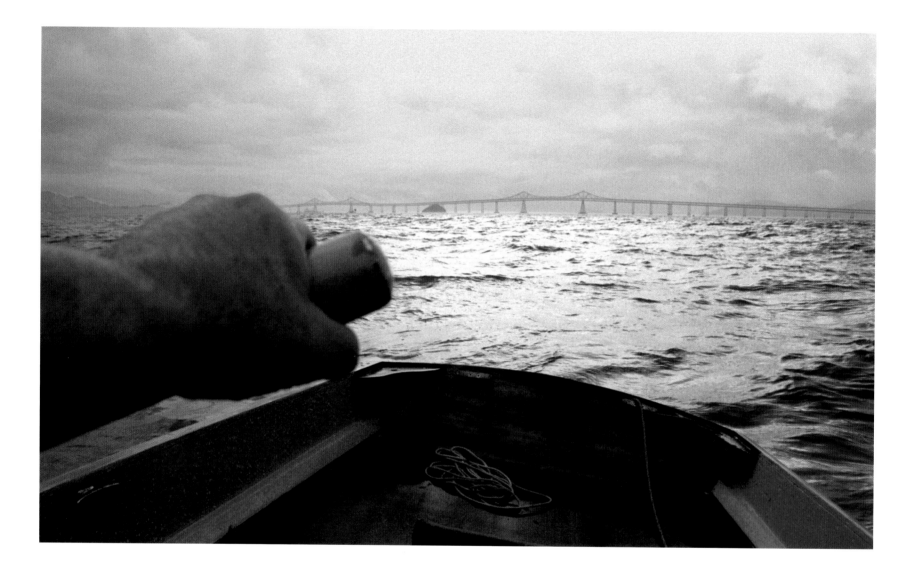

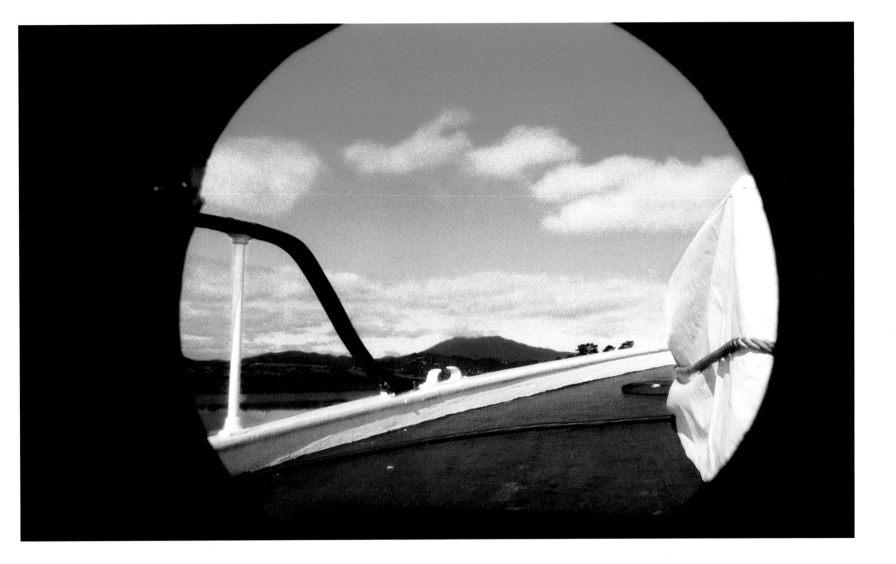

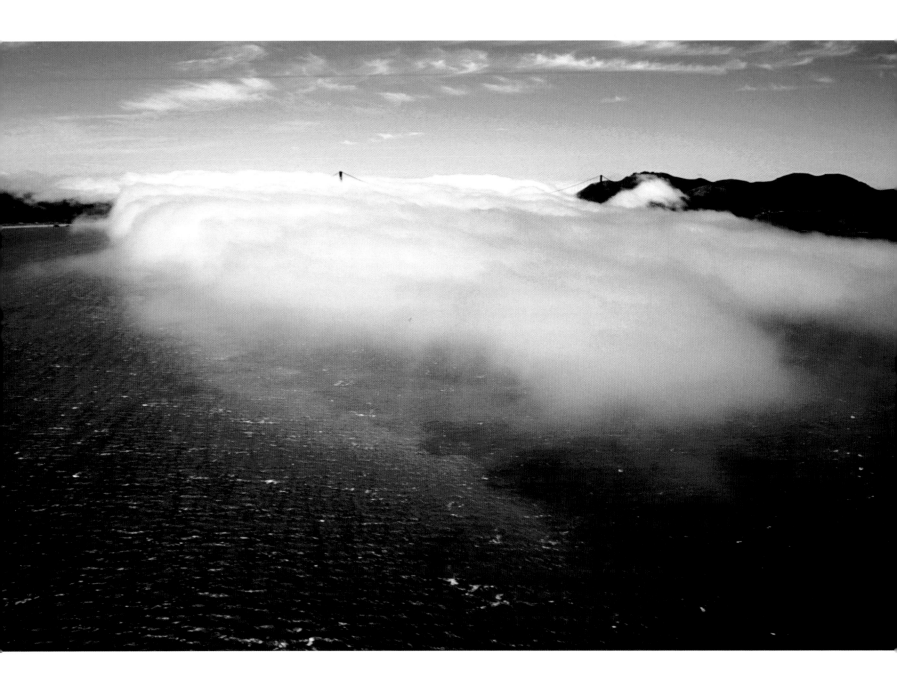

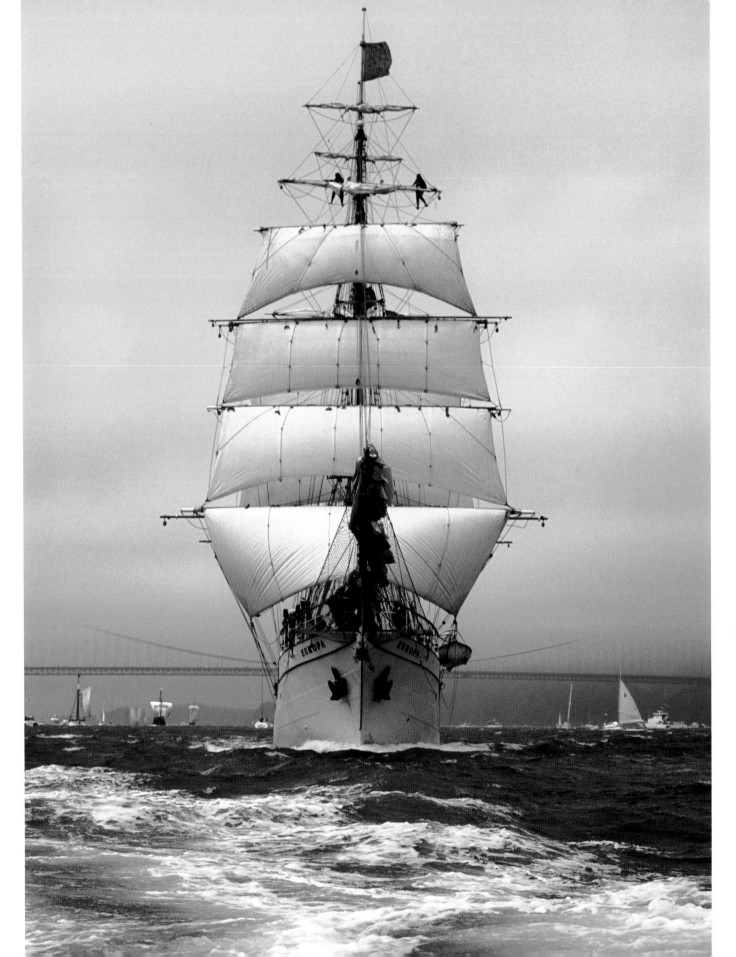

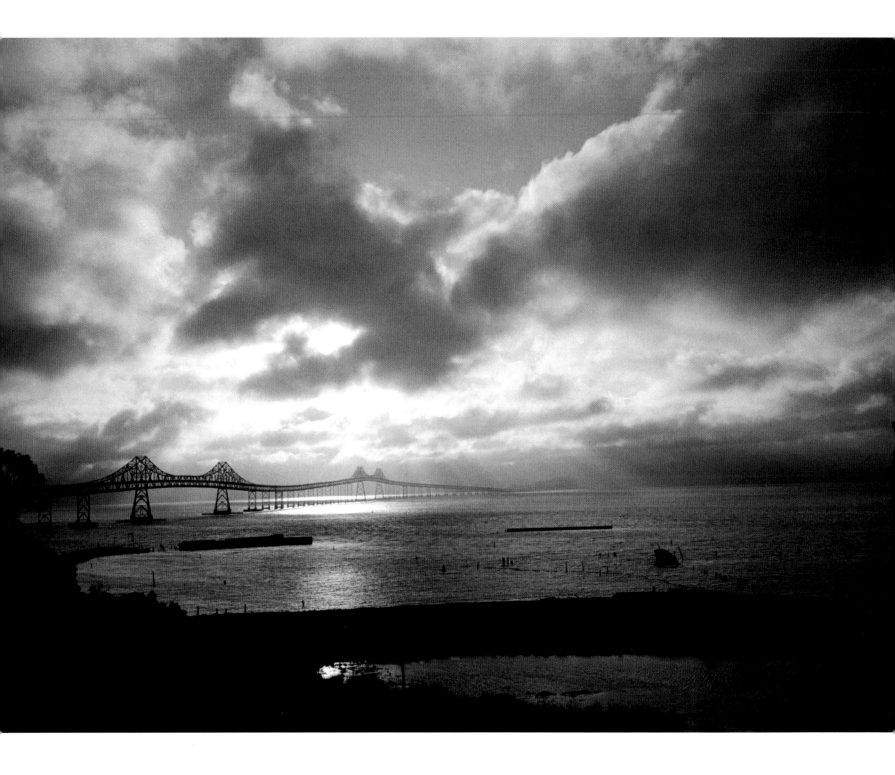

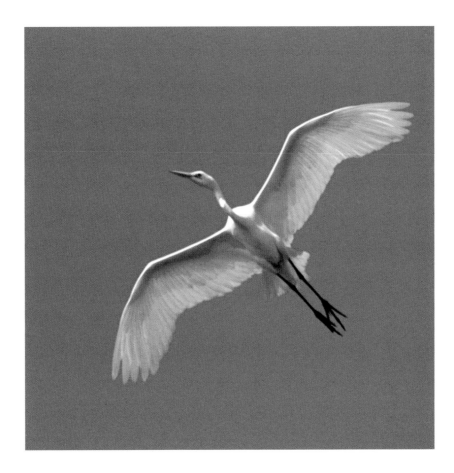

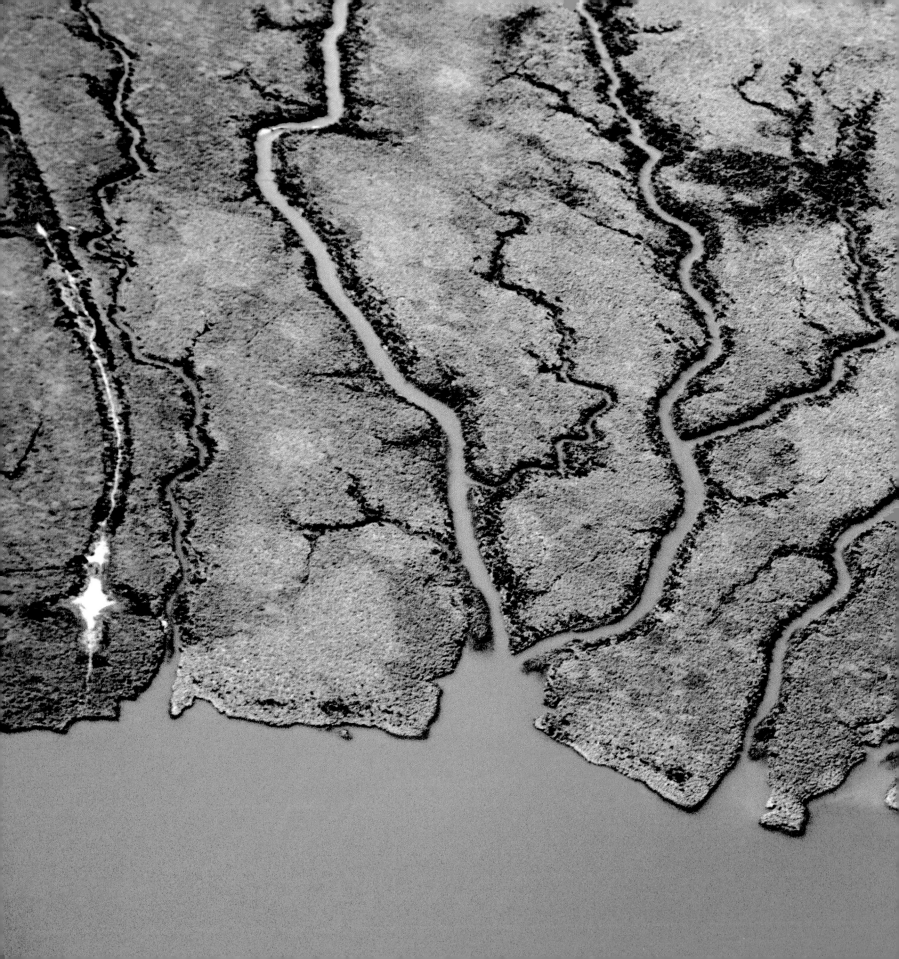

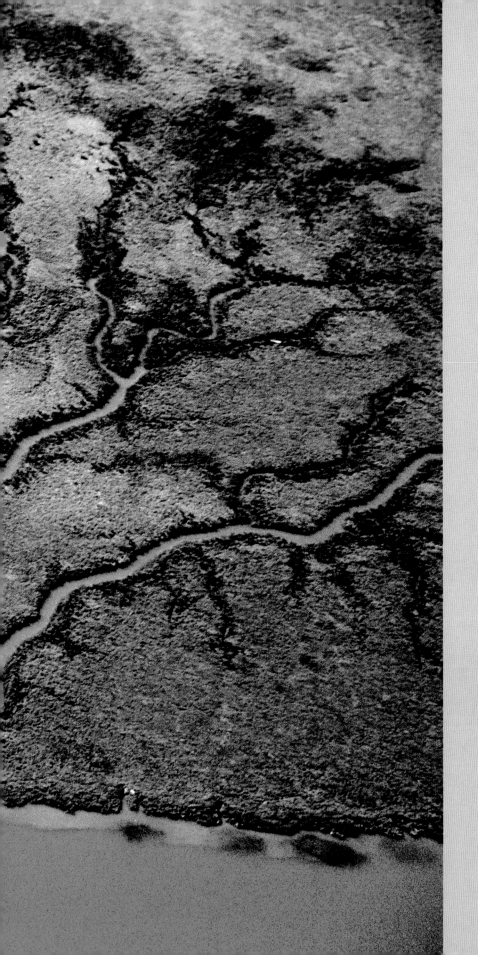

# WETLANDS

San Francisco Bay is very young in geological terms. Fifteen thousand years ago—less than the blink of an eye in Earth history—sea level was 300 feet below today's shoreline and Pacific waves broke somewhere west of the Farallon Islands. A mighty river tumbled through a steep-sided mountain valley and out through a cleft in the final coastal ridge to a delta that fanned out over a broad coastal shelf to the ocean. No saltwater touched the Golden Gate except as windblown spray. Then the planet's climate warmed and the world's glaciers began to melt, especially the Arctic and Antarctic ice sheets. Gradually, probably never more than half an inch per year, sea level rose and the ocean crept eastward over the Continental Shelf toward California's coastal mountains.

With warmer temperatures came more rain. Runoff from the Sierra mountains increased, as did the sediment load in the rivers. When the rivers reached the broad Central Valley their speed slowed and the sediment dropped out, creating great expanses of freshwater marshes. Millions of migrating birds, ducks, geese, and the like set down in these marshes

to rest and refuel before continuing their journeys. In the valley that was to become San Francisco Bay, local streams carried debris from the Coast Mountains to form marshes, but their extent was not great.

About 10,000 years ago the Pacific reached in through the Golden Gate, flooding and expanding the old river channel in a process that continues to this day. Every year, the Bay rises by one one-hundreth of an inch. In the beginning the rate was faster, though still far too slow for an observer to notice, even in the course of a long lifetime. As the Bay flooded, sediment from the rivers was deposited in the shallower places along the edges of the expanding Bay, and salt marshes began to grow. Channels resembling the branches of a venerable tree linked the farthest reaches of these marshes with the tidal life of the developing Bay. Local streams dropped their sediment behind the salt marshes, and the borders between fresh- and saltwater marshes broadened.

Depending on your definition, somewhere between 350 and 450 square miles of wetlands exist on the Bay today. Looking a bit like impenetrable swamps to most people, the Bay's marshlands are its most vital ecological community. Marsh plants provide food and shelter to migrating birds on the Pacific Flyway. The labyrinthine mini-channels are nurseries to millions of fish fry and tiny crabs. Shy seals give birth along the larger, secluded channels.

Esthetically and biologically, it is hard to imagine the Bay without wetlands, yet they are transient and fragile environments. Wetlands are a stage, a phase in the evolution of waterscape to landscape. Over time, as sediment continues to accumulate, wetlands fill in just as islands grow in river deltas. Ecologists call the process "succession"—mudflat to marsh to meadow to grasslands wet only by the rain.

If the processes we now witness were to continue unchanged, the Bay would eventually fill in. But that's not likely. The global climate is on a warming trend. Some scientists are now predicting that the rate of sea level rise will soon be faster than at any time in the Bay's short history. If true, the rate of Pacific flooding would exceed the sedimentation rate from Sierra rivers, and the Bay wetlands would be drowned. But Bay surface area lost to hydraulic mining sedimentation and subsequent filling might be recaptured by the rising sea, thus creating opportunities for new marshes. In short, things would change.

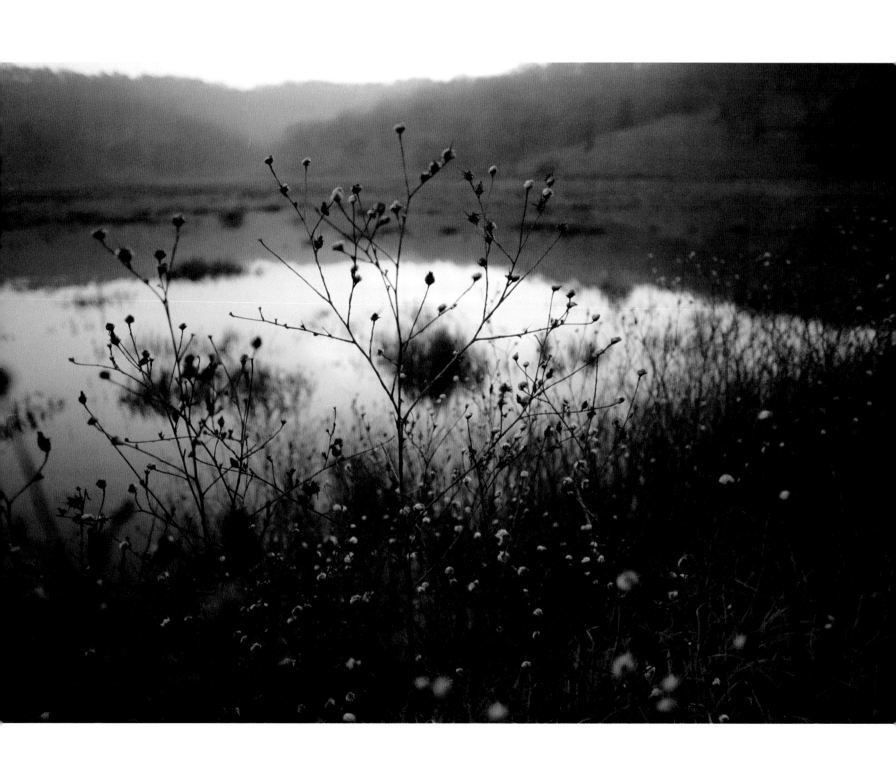

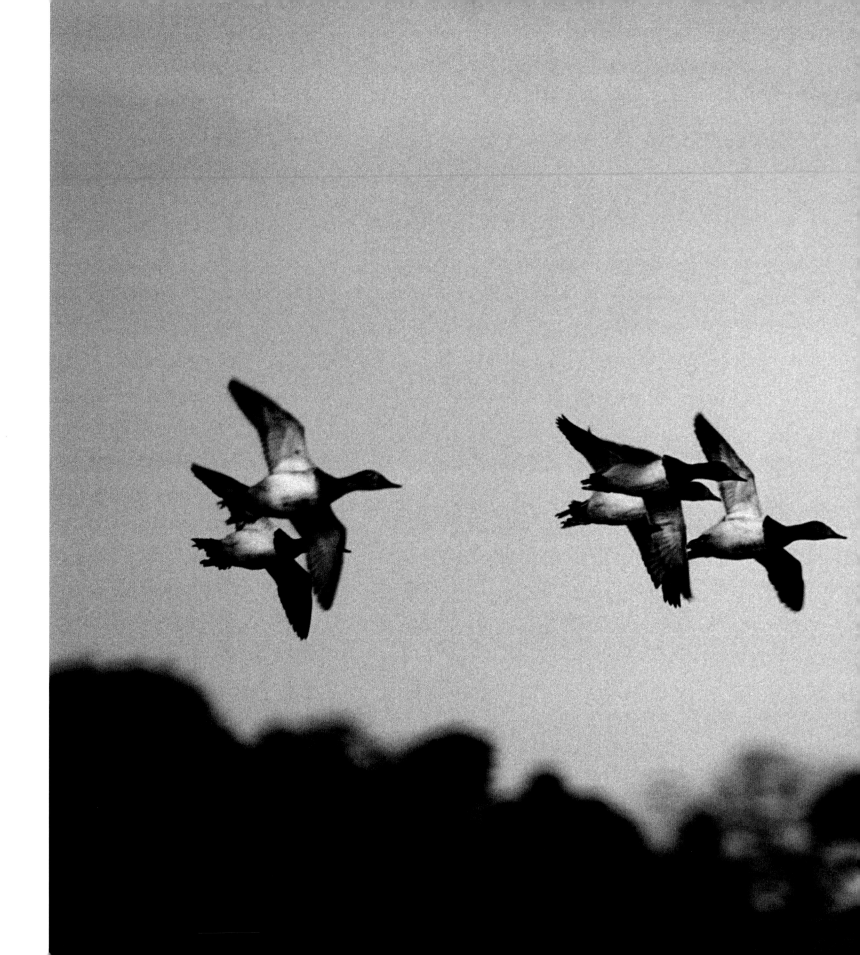

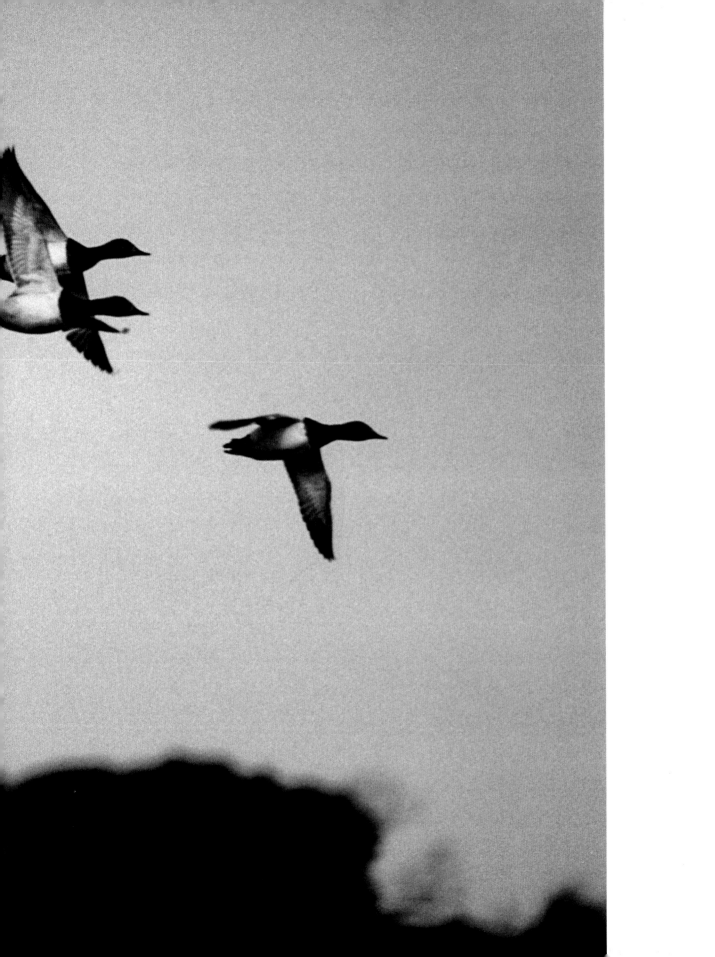

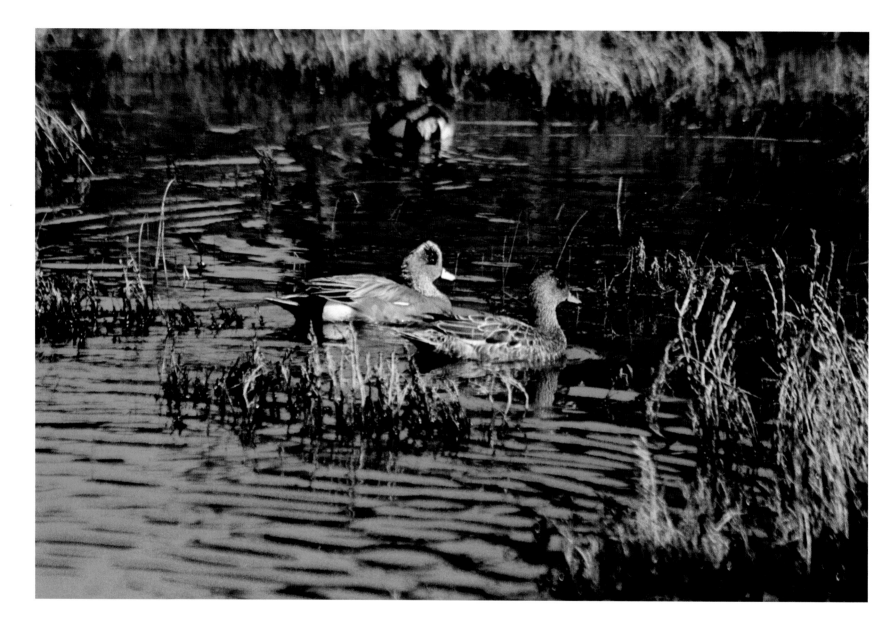

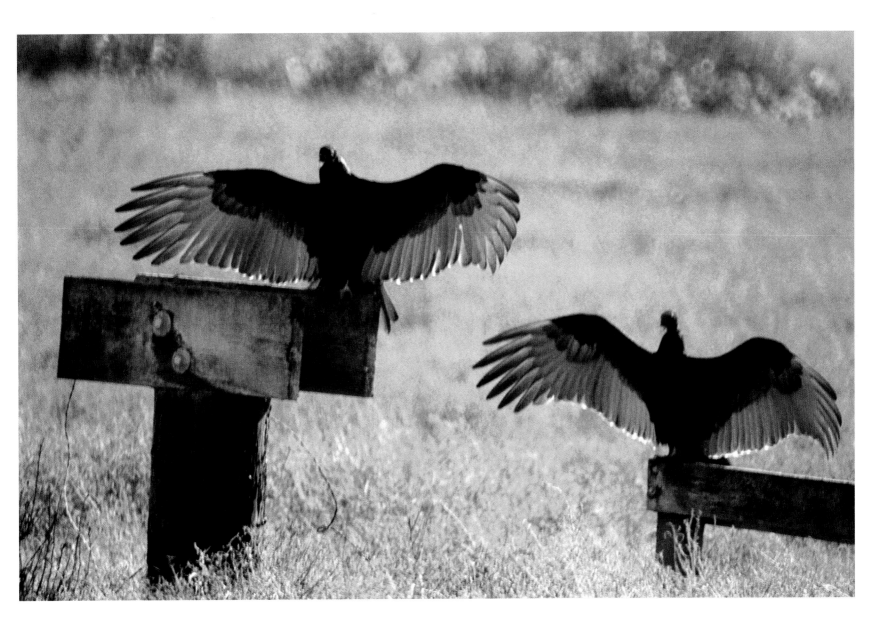

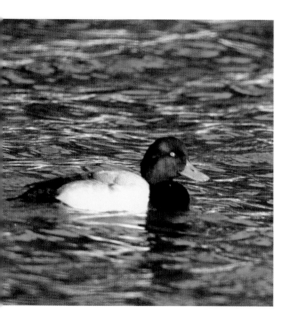 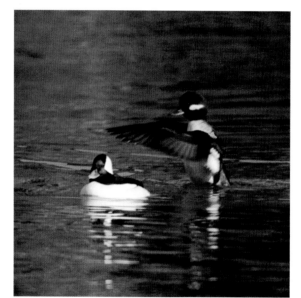 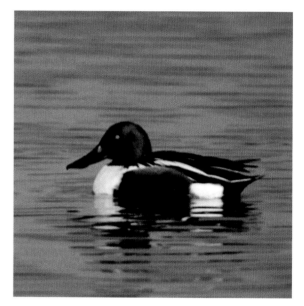

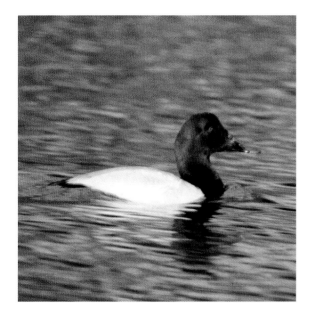 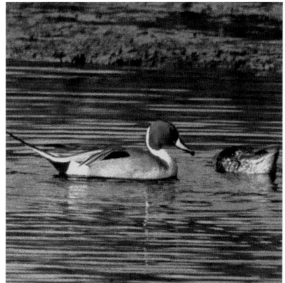 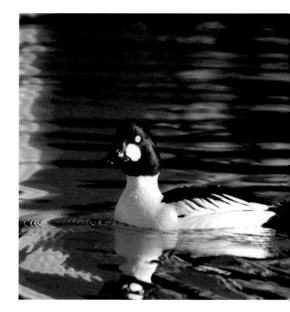

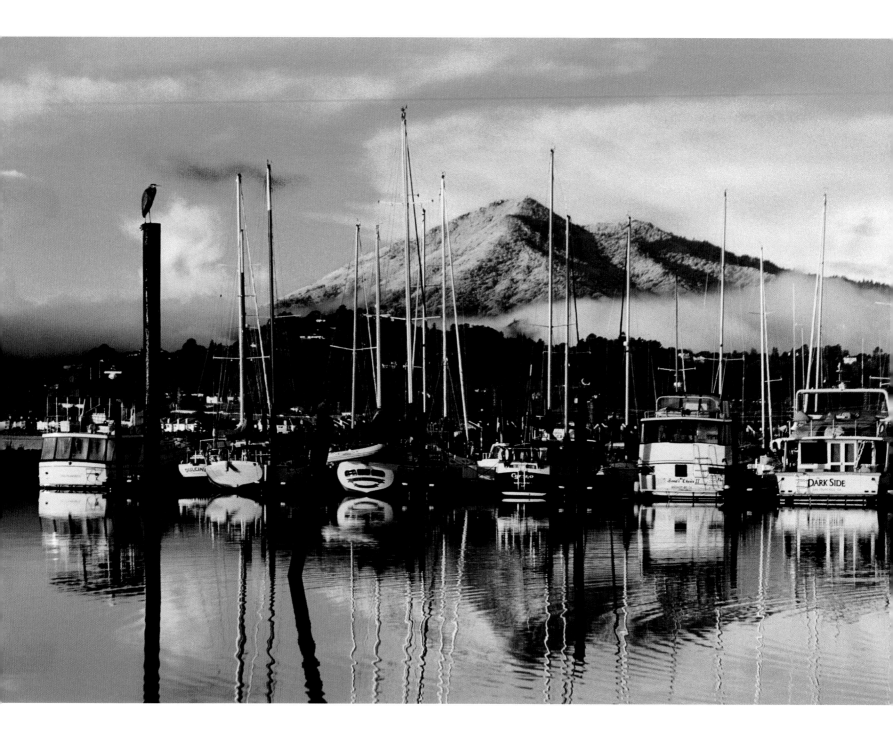

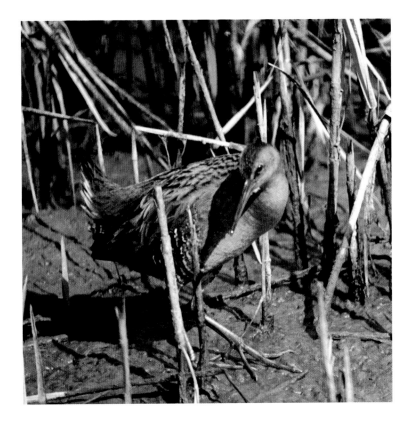

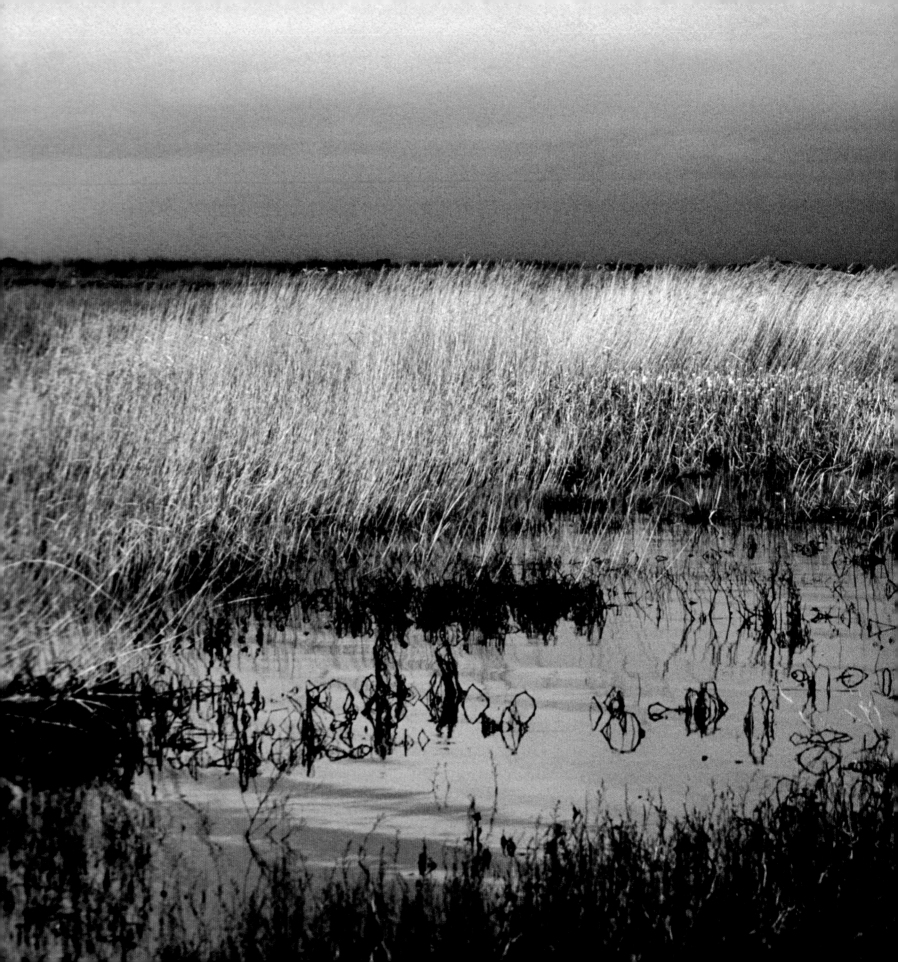

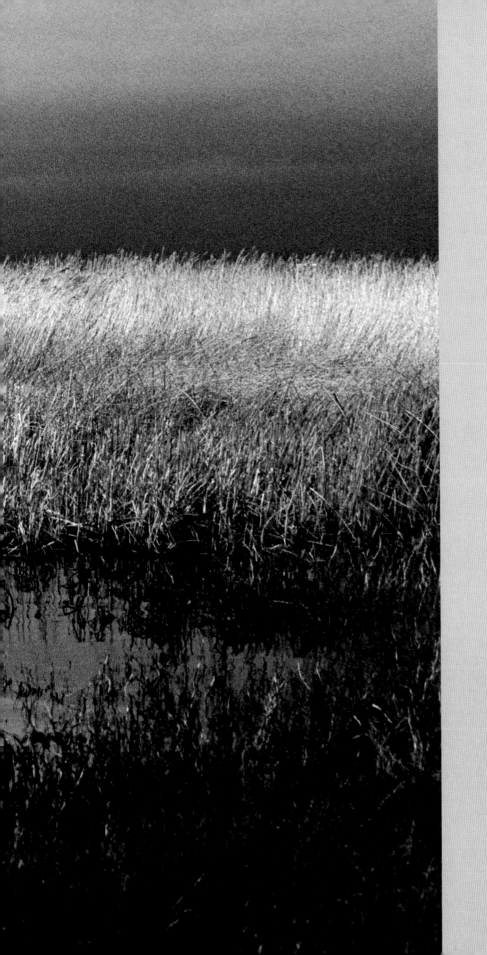

# GRIZZLY ISLAND

Grizzly Island. The name itself is a preserve of sorts. Grizzly bears once roamed the Bay and great Central Valley, feeding on spawning salmon and steelhead, berries, and tule elk. Marshes like those on Grizzly Island were favored bear habitat. The bears are gone now but the island that carries their name remains, providing precious habitat for creatures that once lived with the great golden bears.

Halfway between San Francisco and Sacramento, Highway 12 leaves the crowded freeway and runs east through a gauntlet of encroaching real estate. A right turn at the first hamburger joint puts you on Grizzly Island Road, where "development" stops. Fifteen miles later, eons it seems from the bustling world, you cross over Montezuma Slough and enter the primordial.

Rough-legged hawks circle and white-tailed kites hover, scanning the grasses below for an unsuspecting mouse. A pair of hapless coyotes nip at the heels of a grazing female tule elk, who kicks at the pair. Two other females join her in fending off the pestering

canines. The ruckus spooks the herd and they thunder off into the morning mist, kicking up mud in their wake. When the elk noise settles, the island comes alive with the quacks and whistles of countless ducks punctuated now and then by the retort of a shotgun. First here, then over there. Each shot silences the ducks for a moment and then, like night crickets, the duck chorus gradually returns.

I was on Grizzly Island the last day of duck hunting season at the invitation of Conrad Jones of the California Department of Fish and Game. He had suggested meeting at 9 A.M. It was the annual Youth Hunt. Fathers, sons, and bird dogs had hiked off into the marsh to set their decoys in the pre-dawn hours, and now the first of them were proudly returning with their prizes, fathers deferentially in the rear. A rite of passage.

Our ancestors were hunters. It is in our genes. Hunting or, more properly, getting good at hunting, played a significant role in developing human language and intelligence. In many cultures, hunting is part of the ceremony that binds generations together and connects hunters to the hunted. Intriguingly, it is the latter, the bond between hunter and hunted, that has led hunting organizations to be among the largest savers of habitat in the world.

Grizzly Island is 80,000 acres of diked wetlands. The Department of Fish and Game holds 13,000 acres and the rest is owned and managed by private duck clubs. Duck hunting bought the island and duck hunting maintains it as one of the most important wetlands on the Bay. Duck hunting paid for the repatriation of the tule elk on the island and, inadvertently, supported the return of the coyote. In maintaining the island the hunters also provide habitat for endangered river otters. But most of all, Grizzly Island is about ducks. There are tens of thousands of them, year after year after year. The hunters seem not to diminish the population at all. While it's paradoxical to think about shooting a pintail duck to save the species, I sure didn't see any pintails in the new mall out on Highway 12.

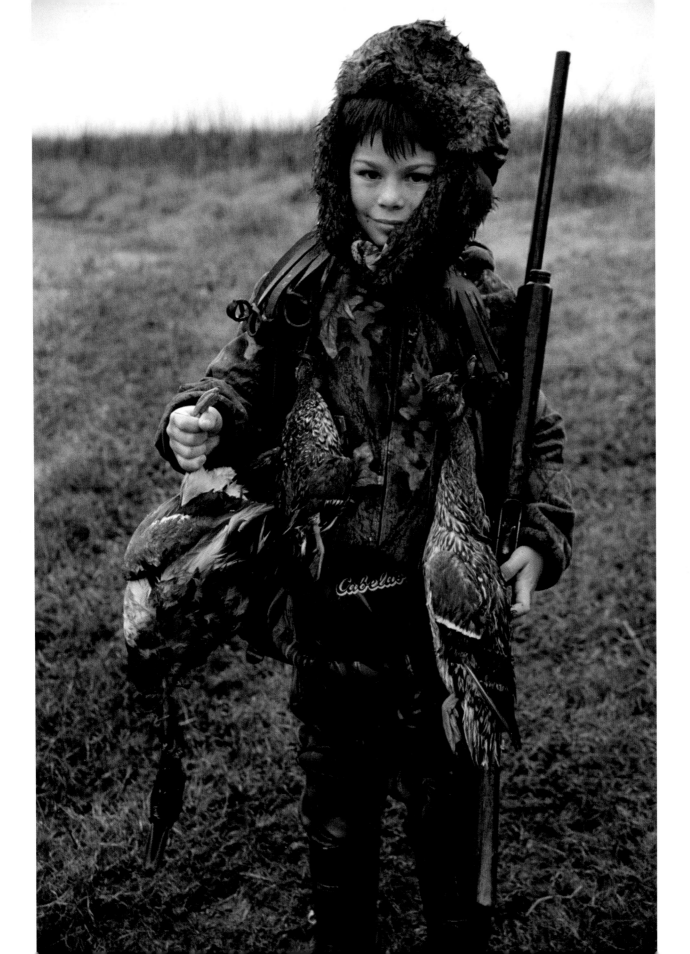

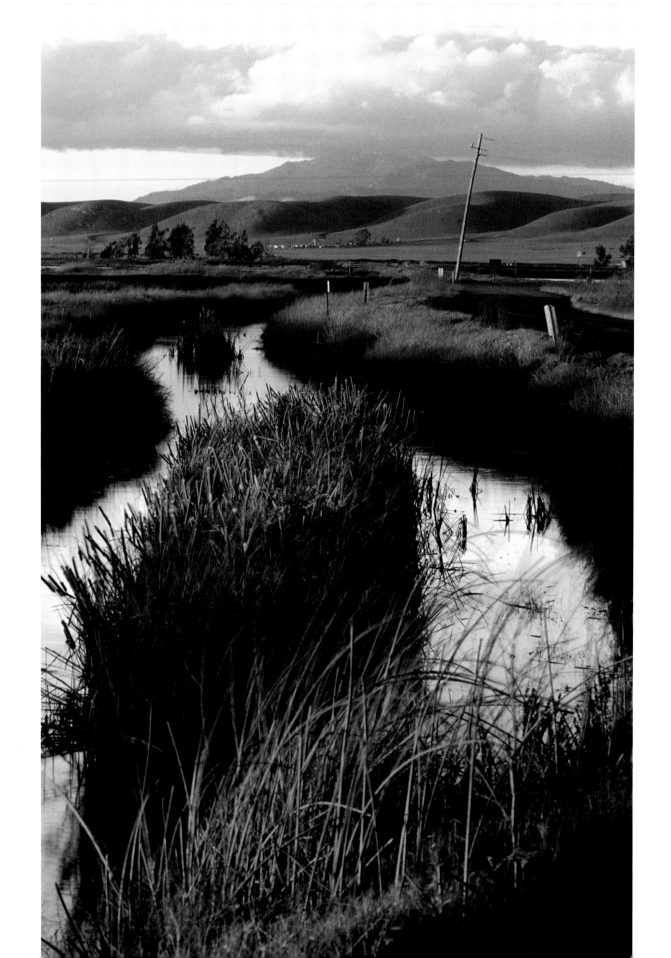

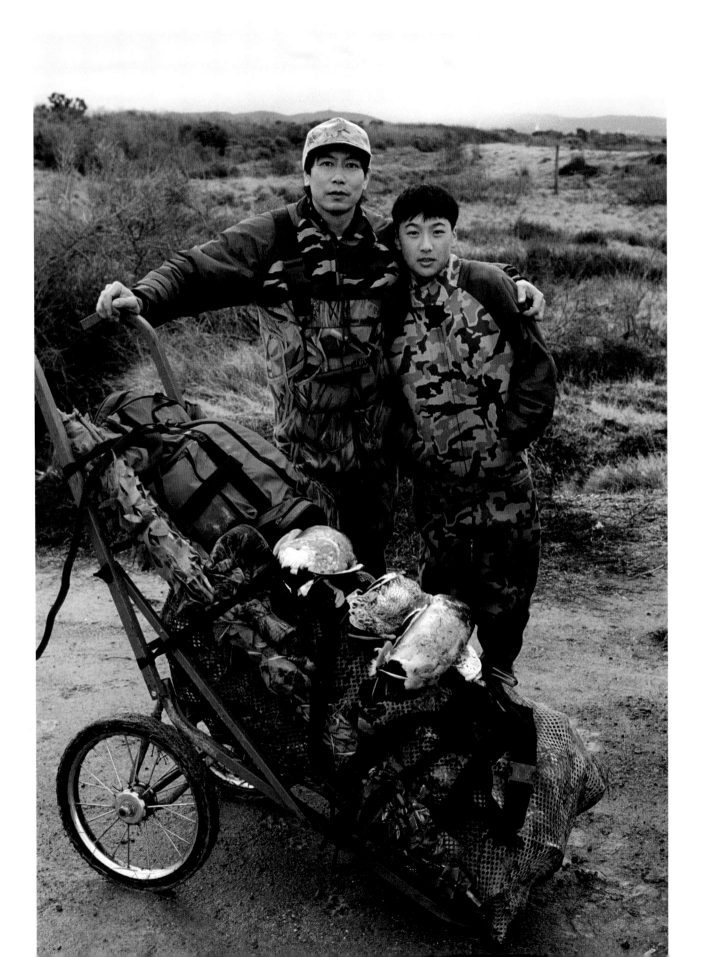

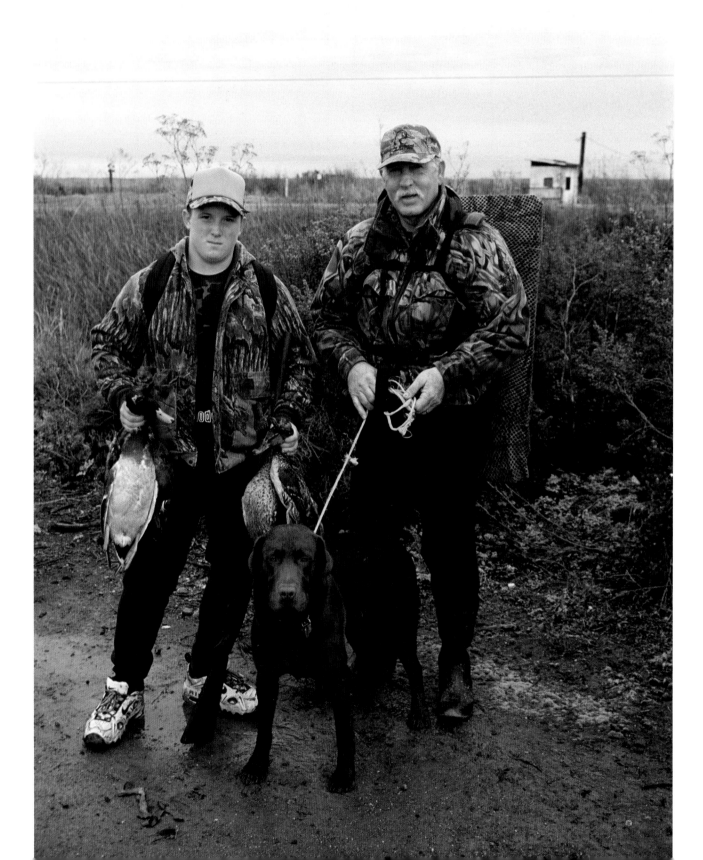

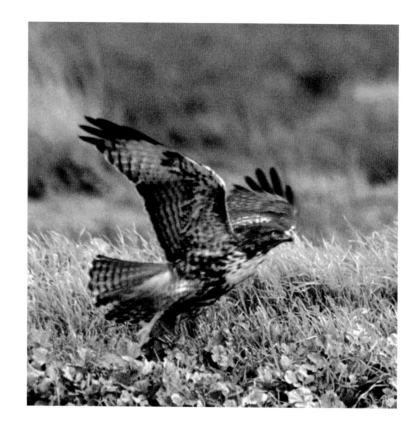

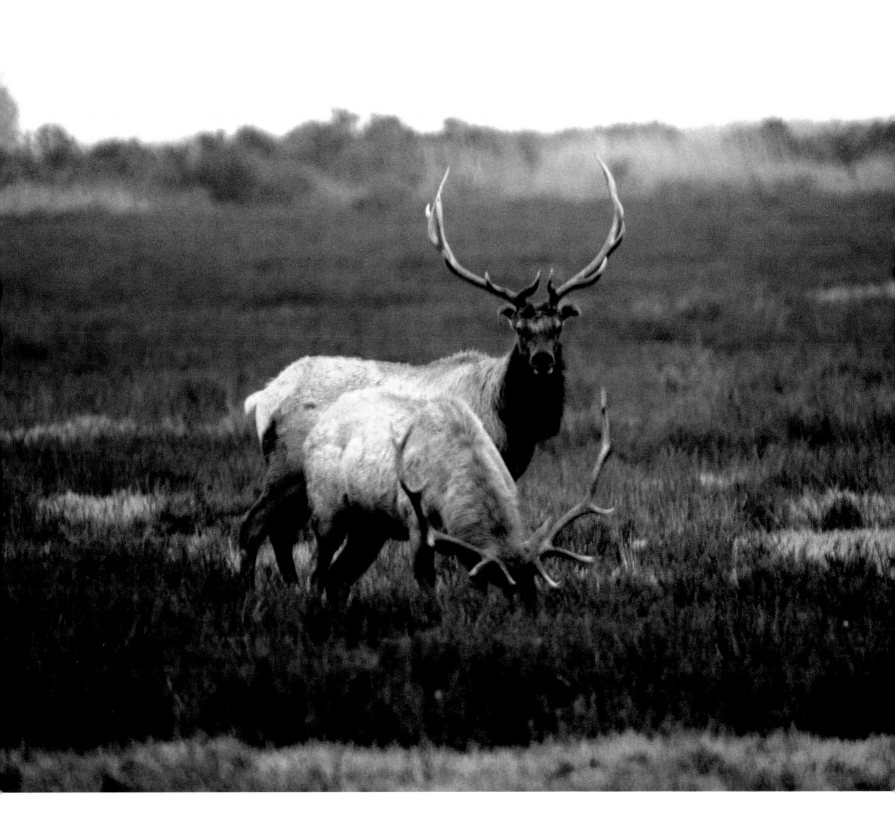

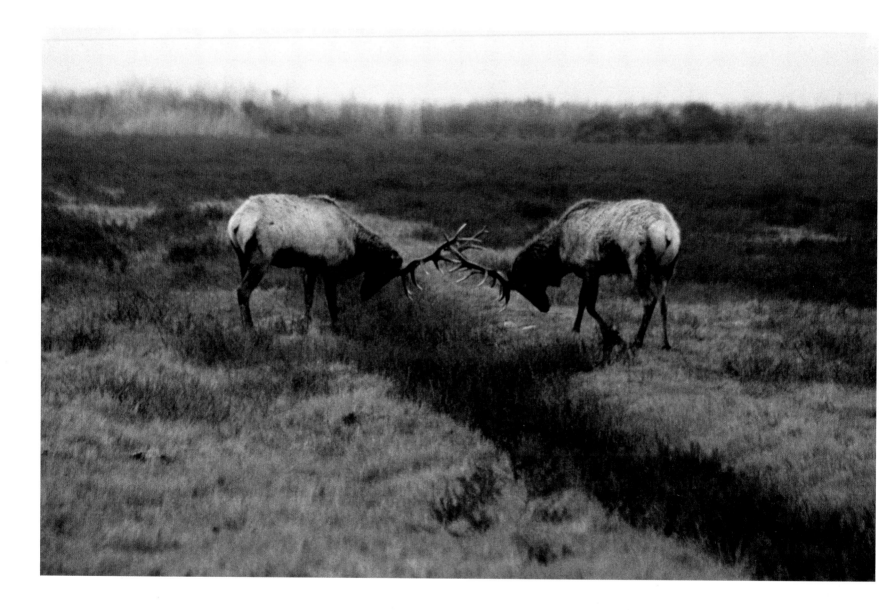

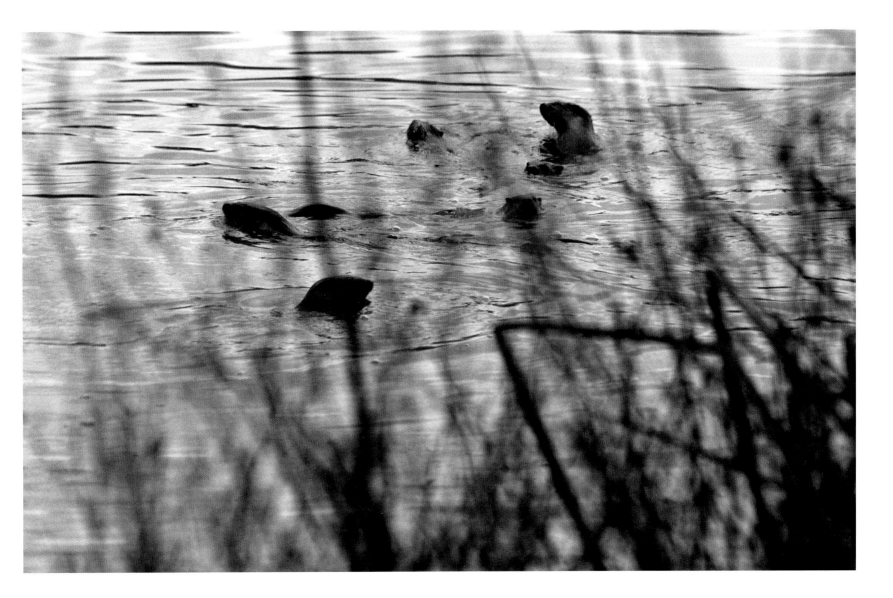

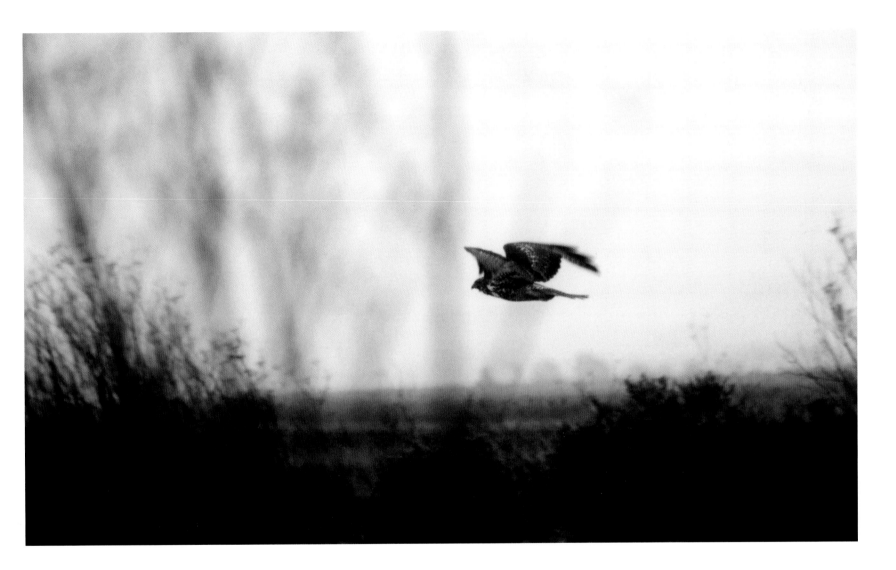

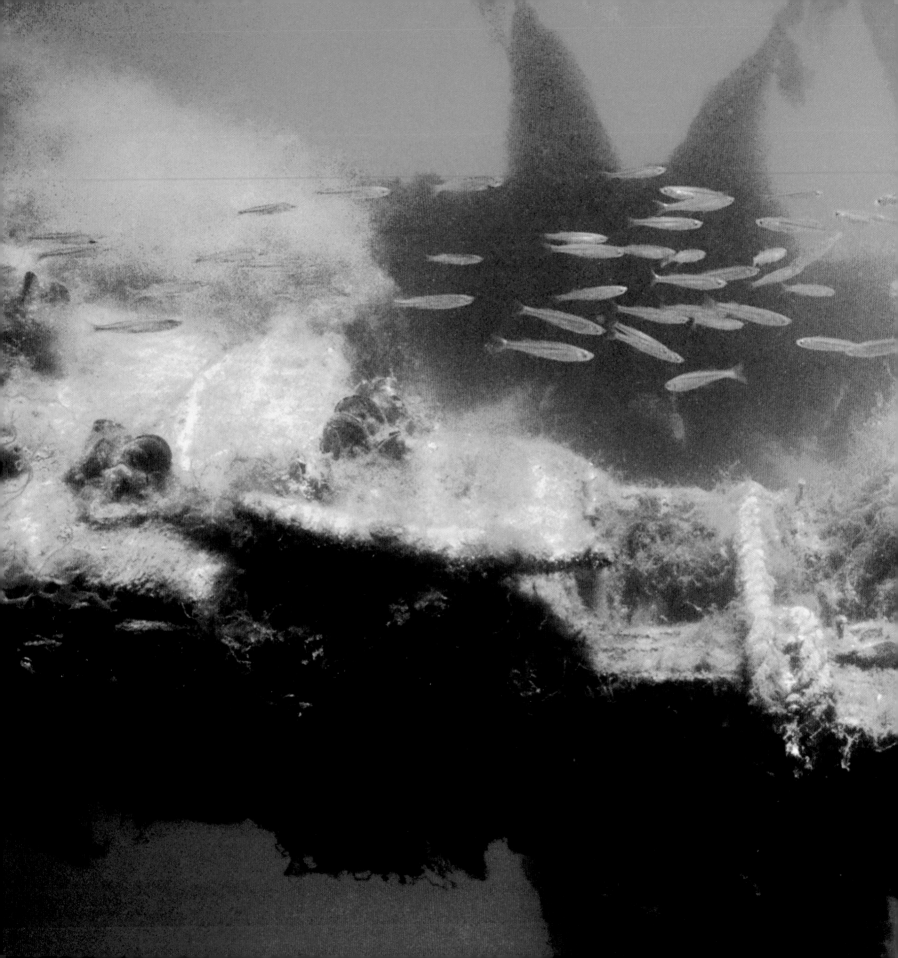

# UNDERWATER WORLD

The first time I put on a diving mask and stuck my face underwater was in Hawaii thirty years ago. I was captivated. The colors were rich, the creatures exotic, and even familiar landforms like boulders and ridges looked somehow different, especially in the filtered light.

San Francisco Bay's underwater world is also rich, but it is harder to see. Every day, sloshing tidal currents kick up mud, and river runoff carries new bits of ground-up mountain into the Bay. With an average Bay visibility of six inches, it's often that you can't see your hand in front of your face.

Richmond's inner ship channel, however, is deep and calm and relatively untouched by currents and runoff. There I found bottom-feeding leopard sharks and winged bat rays "flying" gracefully through the water. Schools of smelt swam around an old boat with a wondrous array of invertebrates on its keel.

The invertebrates (animals without backbones) are a strange lot. Take sponges, the red, finger-like animals in these photographs. They are really communities of single-celled animals that have organized to

form tubes with tiny hairs, one from each cell, on the inside. The hairs beat in a collective rhythm like a "human wave" in the cheering section at a football game. Water flows through the tube and plankton carried in the stream floats into the hairs, gets stuck, and is drawn into the cell. Biologists call the process "filter feeding."

Translucent sea squirts (tunicates) pump water in through one opening and out through another.

Barnacles, which are related to shrimp and crabs, are also filter feeders. They attach themselves to rocks, boats, and even whales with a sticky substance that rivals superglue, then spend their lives waving their fan-like arms in the water to pick up plankton and other small bits of food. Glued beside the barnacles you'll occasionally find other filter feeders, the tiny tube worms with gilled "heads" that resemble feather dusters. With most of their body safely in a twisting, turning armored tube, the creatures' feathers wave about with the shifting water movements. But if the slightest shadow falls over the feathers, they are quickly withdrawn and a trap door slams over the tube, a protection against possible predators.

Jellyfish and their relatives the sea anemones are more aggressive feeders. Stinging cells in their long dangling tentacles paralyze tiny floating animals and even small fish, which are then pulled into the beast's simple but effective digestive system.

One of the most interesting animals that dwells in the underwater world of San Francisco Bay is not often seen. White sturgeons, venerable fish that have changed little in 200 million years, live their secretive lives in the muddiest Bay waters. Record sturgeons have reached 1,500 pounds. They look like oversized catfish with diamond-shaped armor plates along their sides. When winter rain or spring runoff comes, the lunkers swim lazily at the bottom of a swift-moving channel and wait for food to come to them. But let one of the monsters feel the sting of a fisherman's hook and the slothful beast comes suddenly alive. A fighting sturgeon can easily haul a small boat for several miles before the fish tires.

Sturgeon fishing today is almost mystical. White sturgeons have become the marlins, the game fish, of San Francisco Bay. But more often than not, when one of the ancient giants is landed, a camera clicks, the hook is gently removed, the fish is tagged, and then it is sent on its way. For the real sturgeon fisher, the trophy goes in the scrapbook and a note goes in the fishing log about where and at what point of the tide the giant was caught and which bait worked. Both creatures live to fight another day.

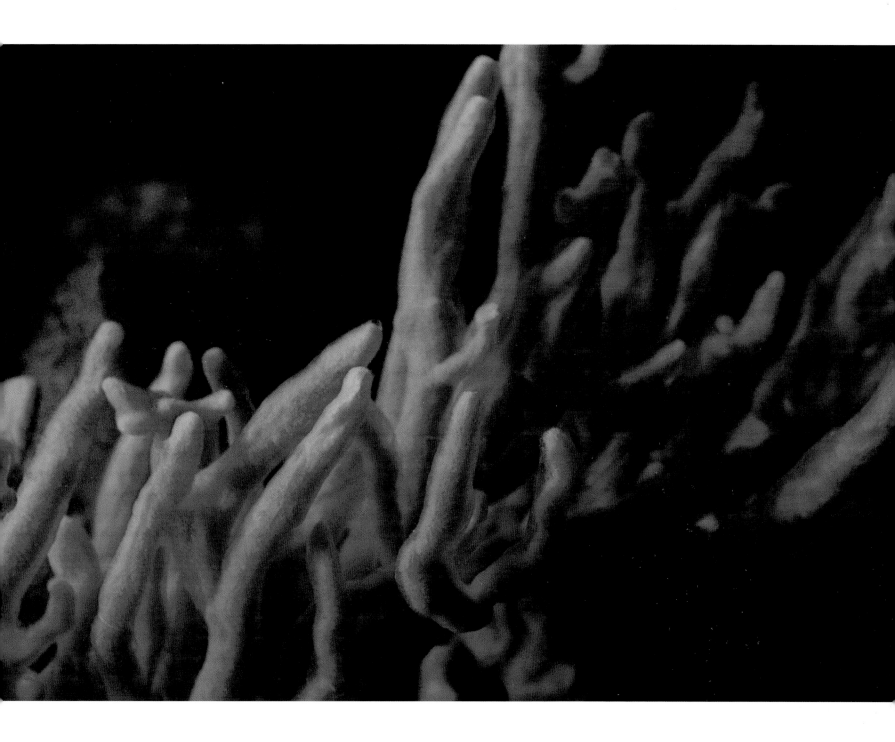

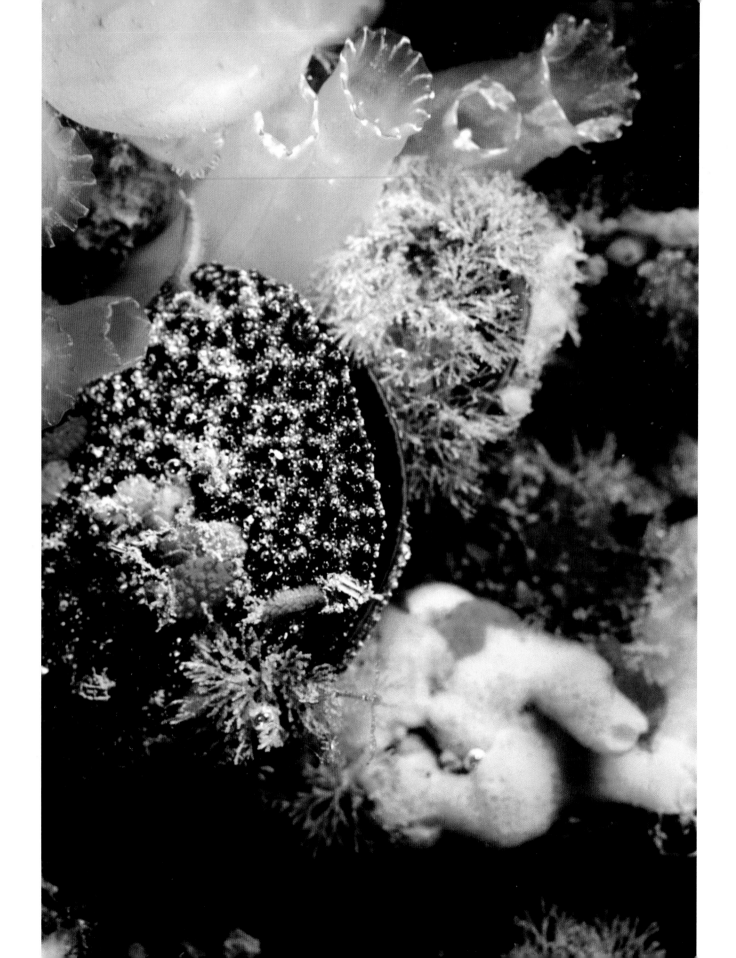

48

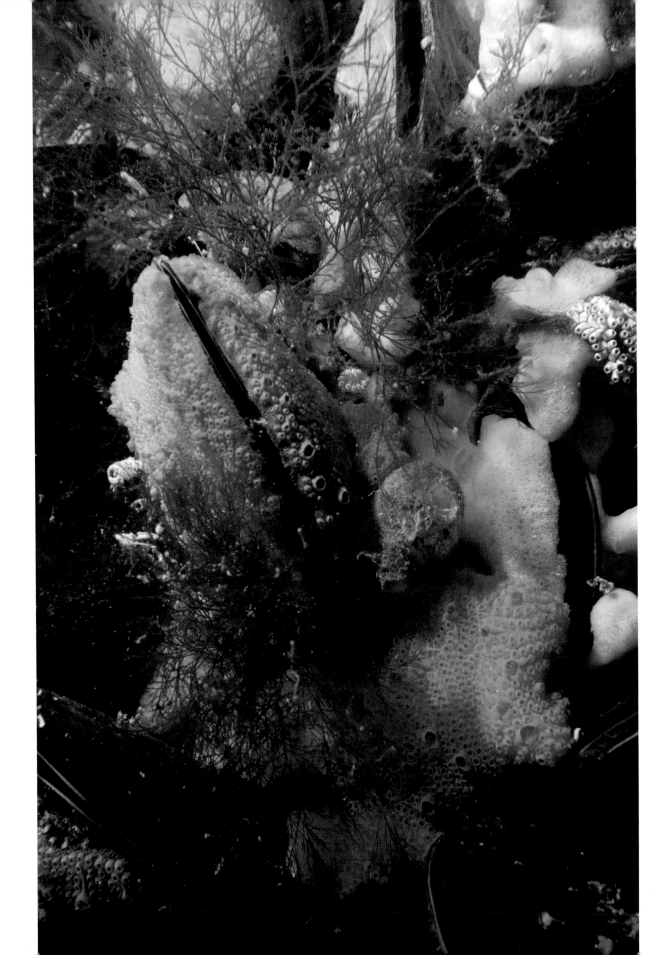

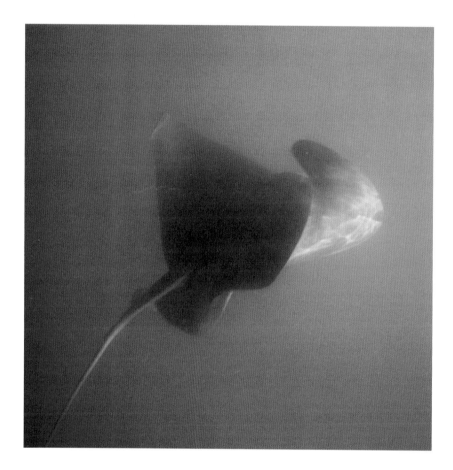

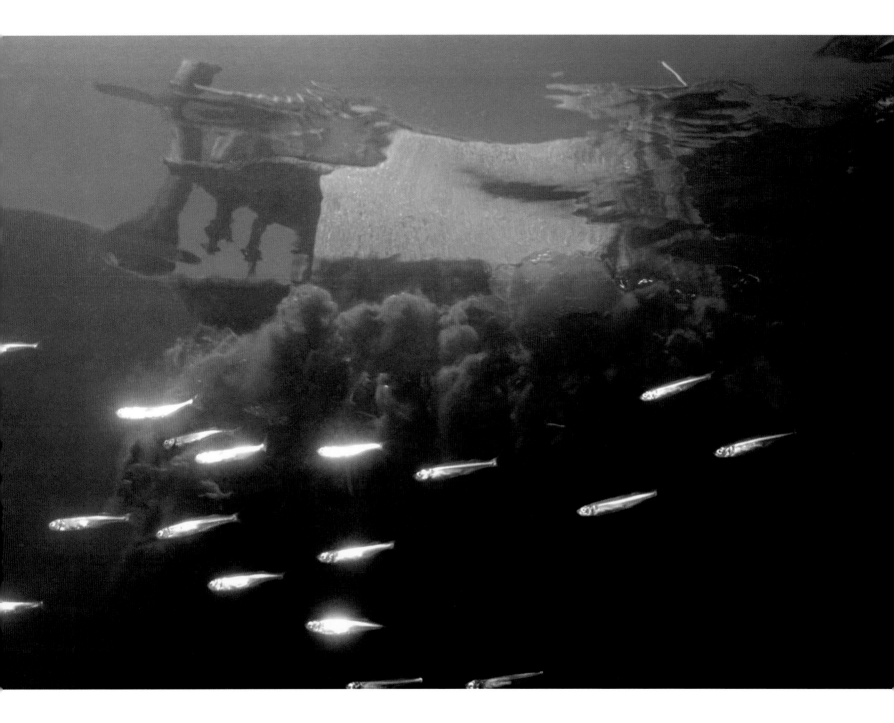

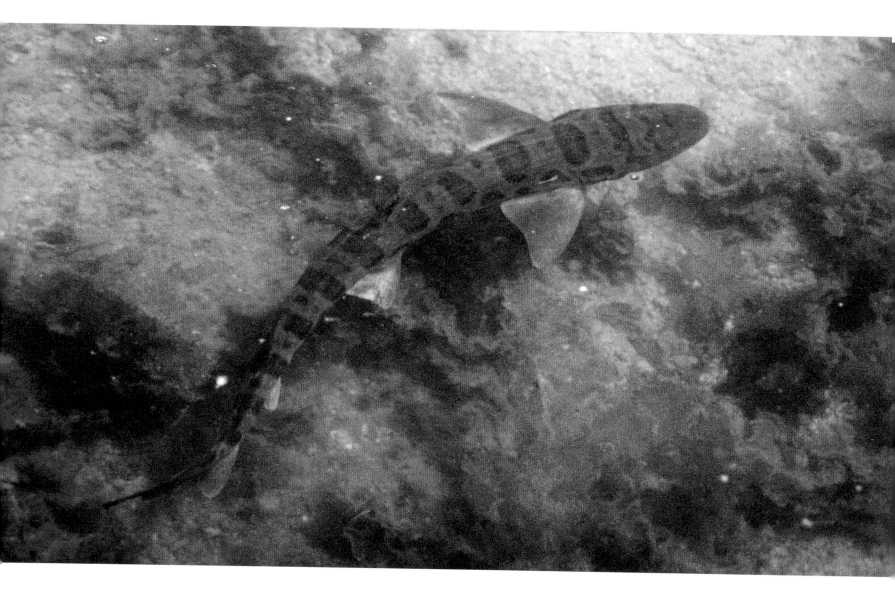

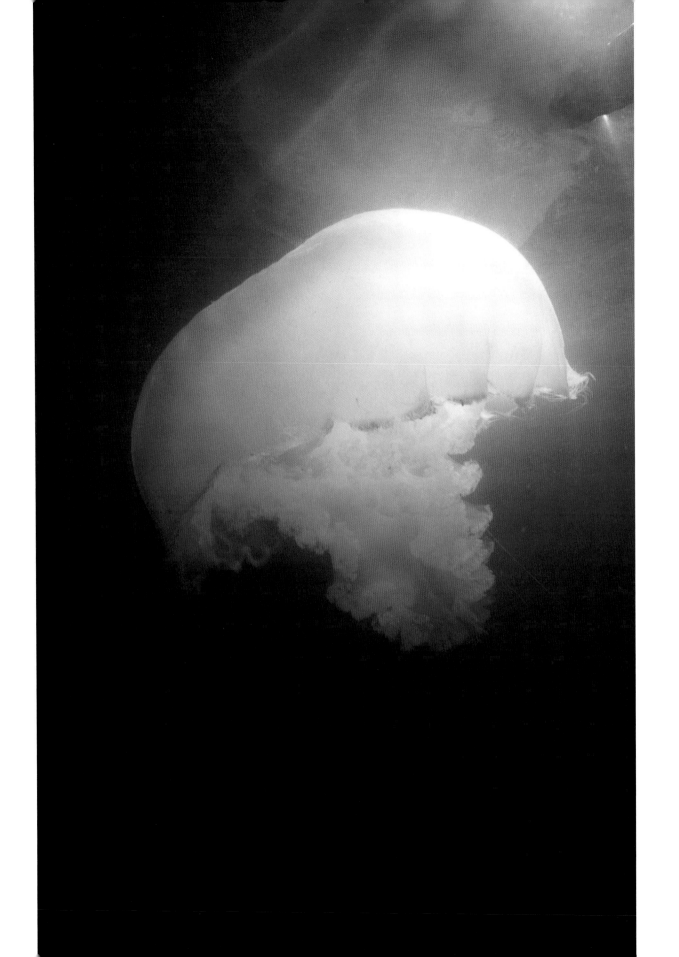

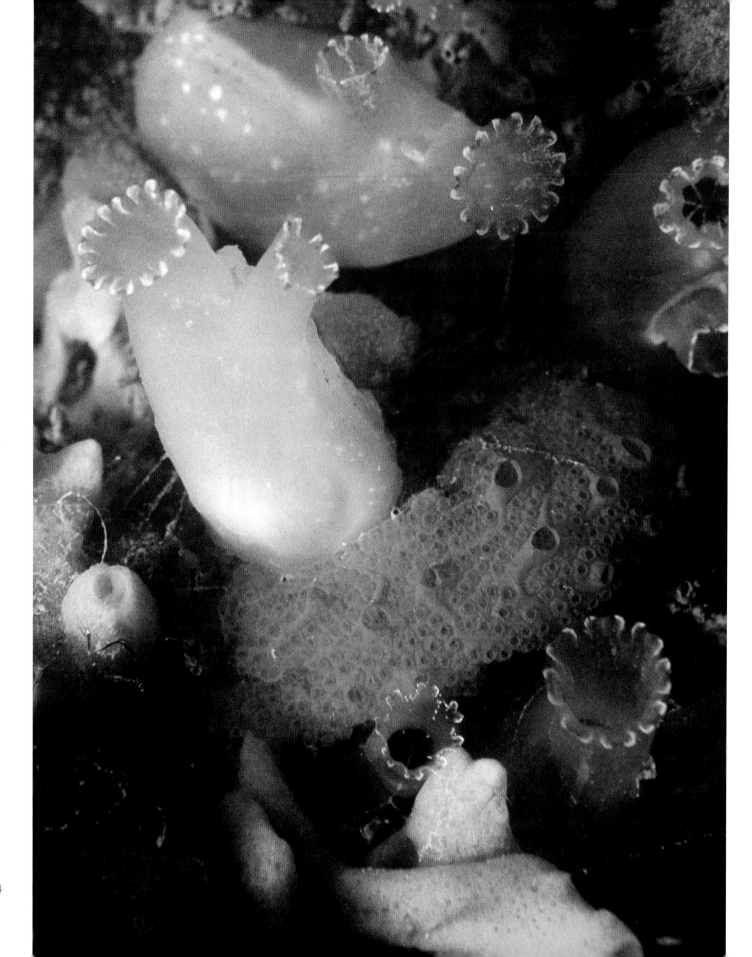

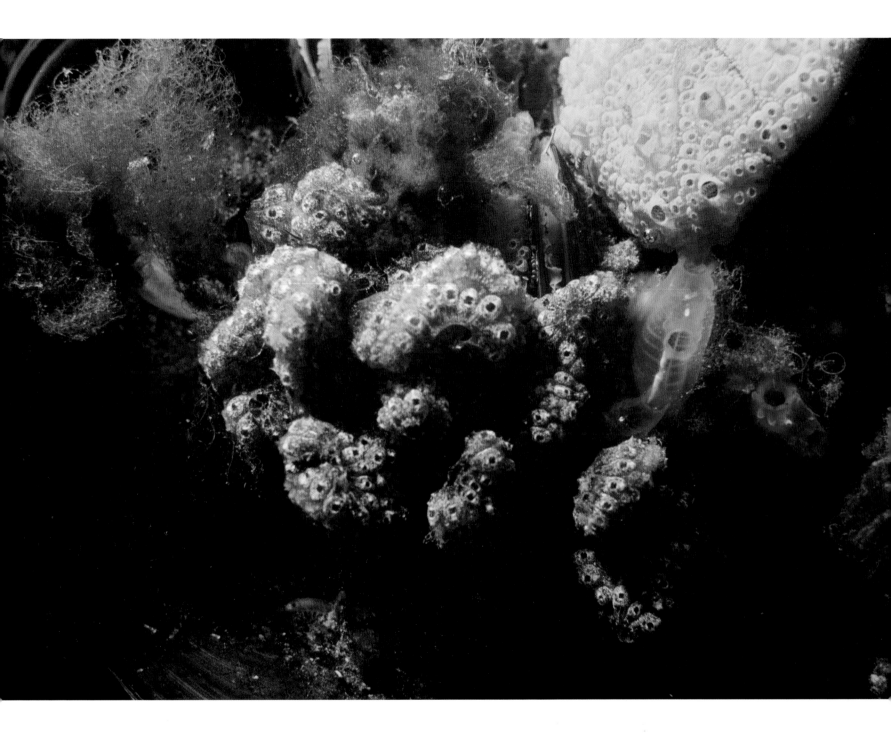

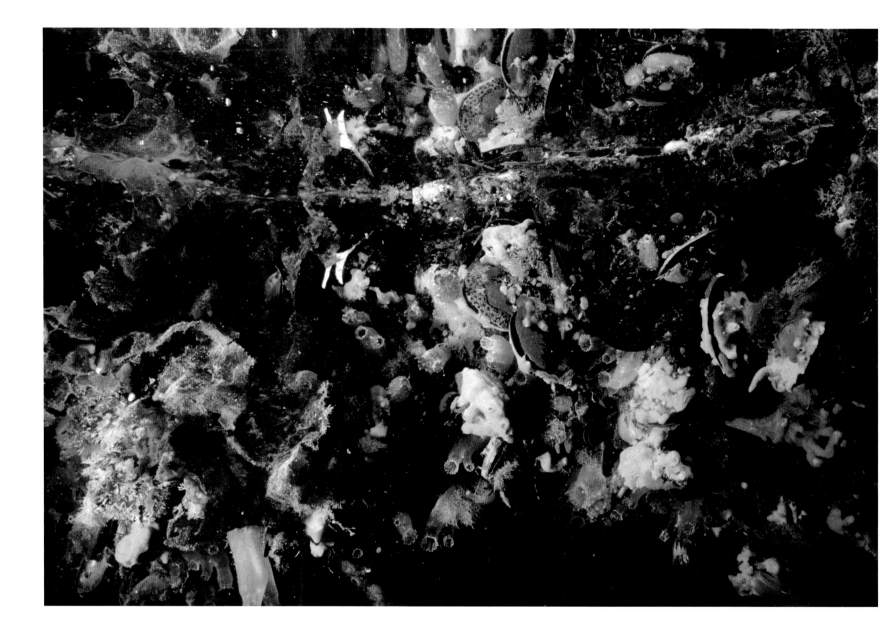

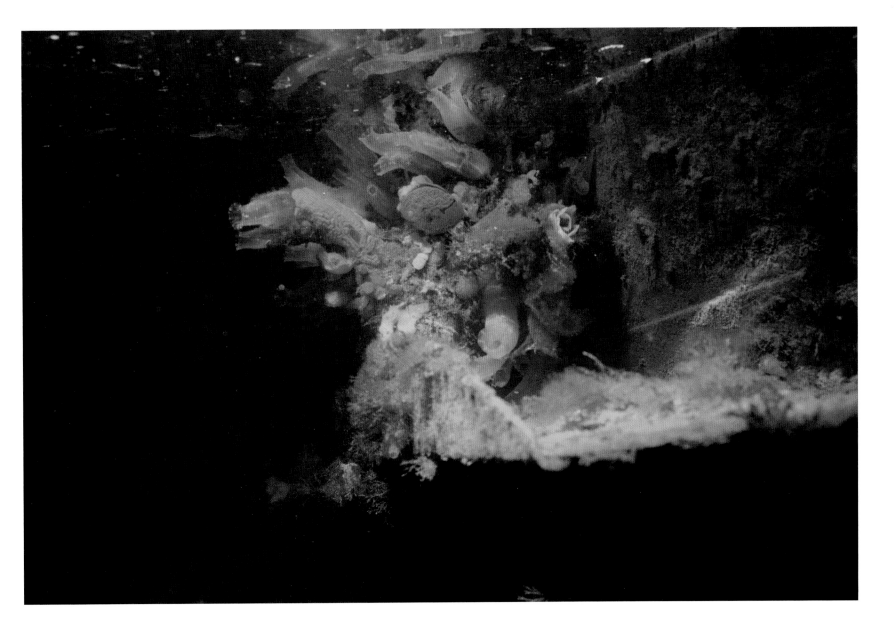

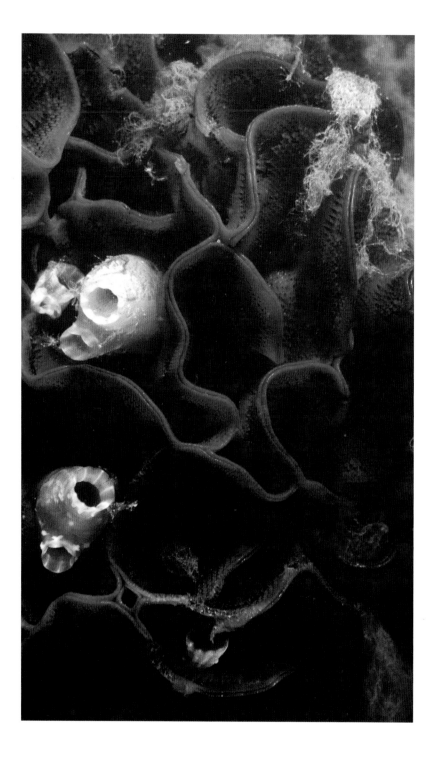

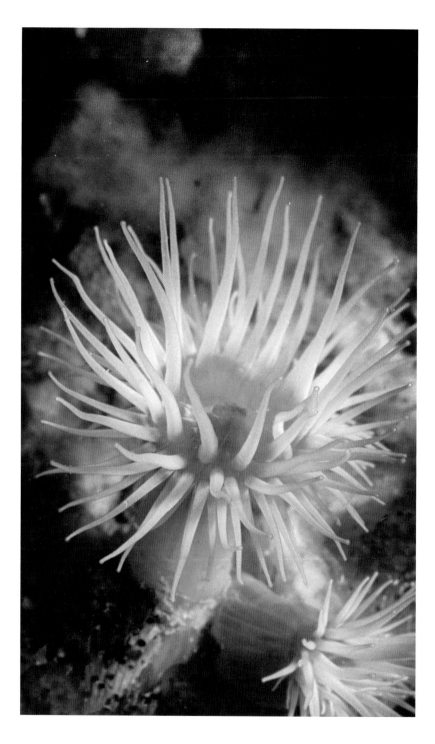

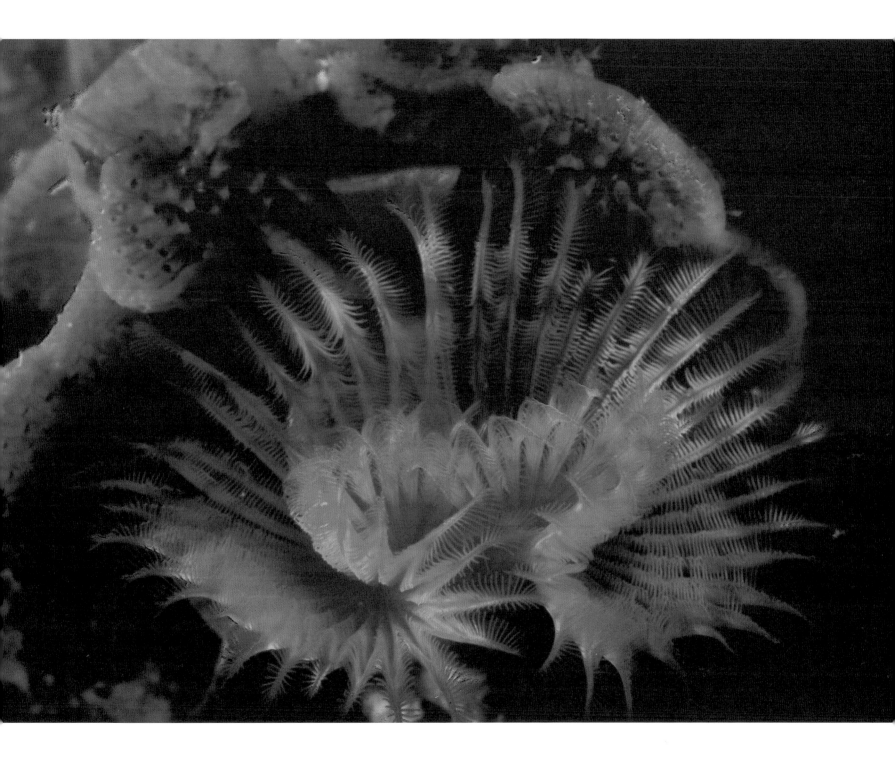

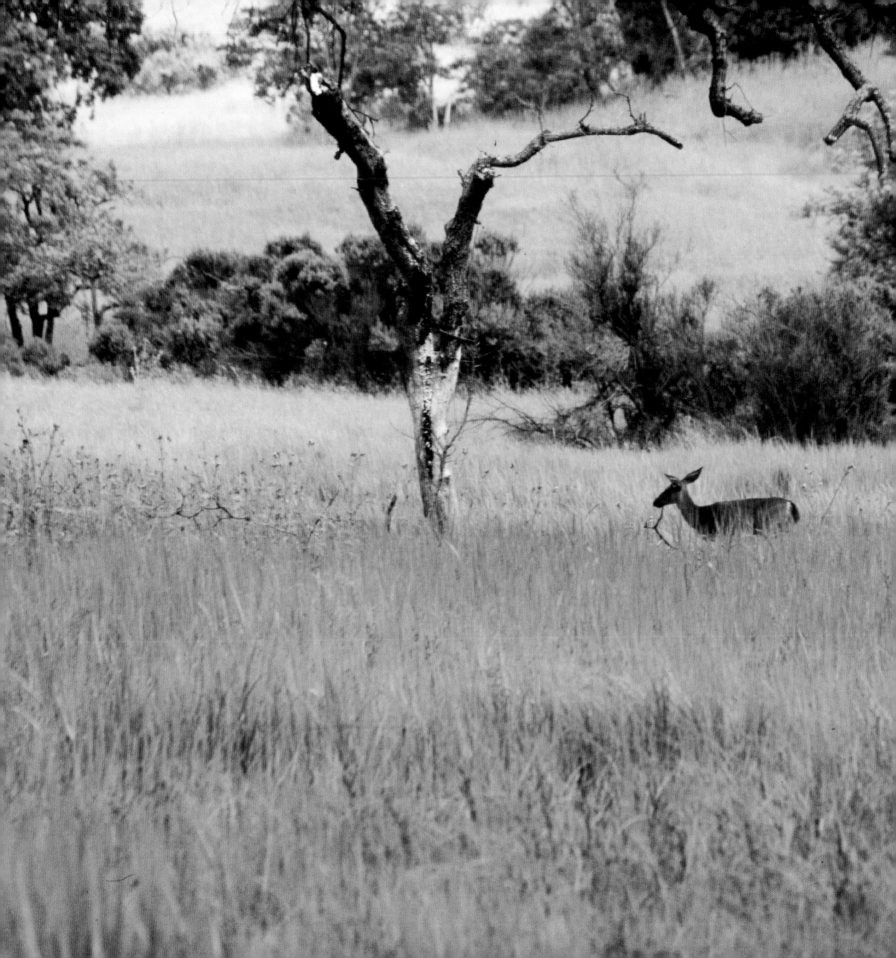

# THE LIVING ESTUARY

In the simplest terms, an estuary is where the ocean meets runoff from the land, usually in a bay or river. Less a physical place than a set of responses to the mixing of land and sea, the San Francisco Bay watershed can be said to begin at the crest of the Sierra and extend down through the Bay. Anything that happens in that vast area can have a serious effect on life in and around Bay waters.

As an example, until they were stopped in 1895, giant water cannons blasted away Sierra foothills in search for gold. Once the gold was extracted, the rest of the mountain washed down creeks and rivers to the Bay, creating huge mudflats. Mudflats became marshes and marshes provided increased habitat for mosquitos carrying yellow fever. Both the public and politicians demanded that the marshes be diked, filled, and dried—whatever it took to get rid of the dread mosquitos. The sediment from hydraulic mining reduced the Bay's open water surface from 750 square miles to 450 square miles, a loss of more than one third of the Bay's volume. The effects of that sedimentation on Bay ecosystems are incalculable.

In a less dramatic way, deer populations have been growing steadily. Forced to forage more widely than before, deer can now be seen routinely in the fresher portions of Bay marshes. Deer swim—yes, even in Bay waters—apparently voluntarily. Boaters have seen deer crossing Raccoon Straits, a very deep and swift bit of water between Angel Island State Park and the Tiburon Peninsula in Marin County. Just what makes a deer plunge into the Bay is unknown. One wonders, though.

Mountain lion populations are on the increase too. Naturalists claim that wherever there are deer there are mountain lions.

Naturalist John Muir pointed out that everything in nature is connected to everything else. So it certainly is with the San Francisco Bay estuary. Even the slightest change seems to spread its influence through Bay waters like ripples from a drop of water hitting a still pool. If there is too much silt in the water, for instance, shrimp don't breed and their populations decline. Reduced shrimp populations may in turn adversely affect survival of young nestling herons and egrets in their North Bay sanctuary. Elsewhere, warming water in spring draws small fish into coves and harbors protected from wave action. Bait fish, shiners, smelt, and such follow the fry, and striped bass follow the bait. Close behind the stripers are harbor seals feeding themselves up before pupping. The cycle is repeated every year, sometimes sooner, sometimes later, depending on how late cold winter rains last into spring, keeping the Bay's protected waters cold. If the warming is delayed too long, striped bass numbers may be low and harbor seal moms may give birth to underweight pups.

An estuary is like an organism. It is alive in a way that makes it greater than the sum of its parts, yet dependent on them all for complete health. One or two or many of the parts may be removed, but not without affecting the health of the system. Sardines, once supporting the largest commercial fishery on the Bay, were part of the Bay's ecosystem until the 1950s, when they were fished out. They have not come back. Why? No one knows. Perhaps the sardines' role has been assumed by another fish. All we know is that the sardines are gone.

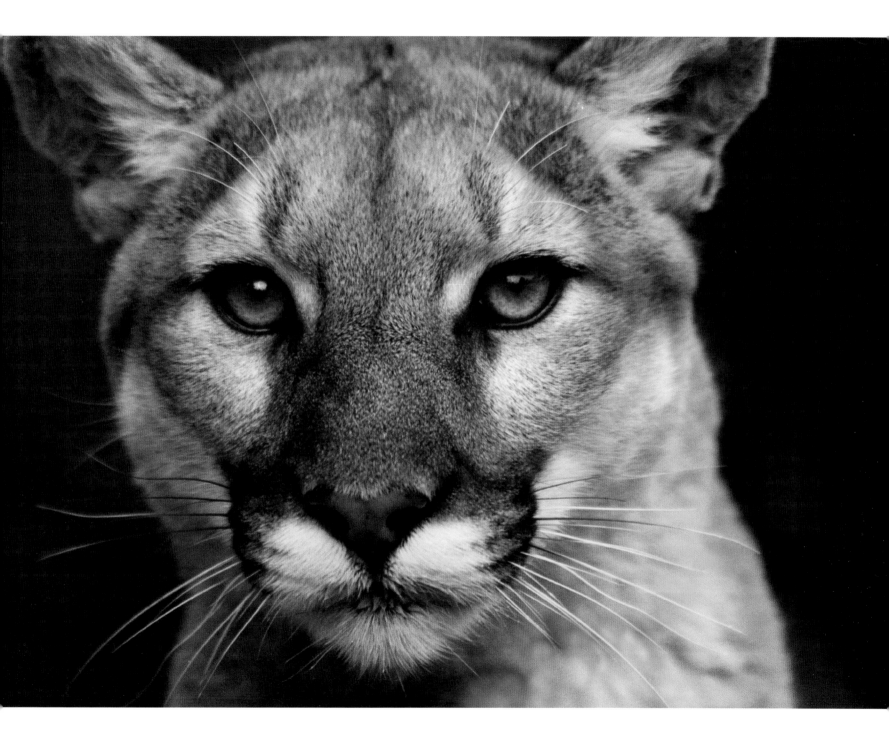

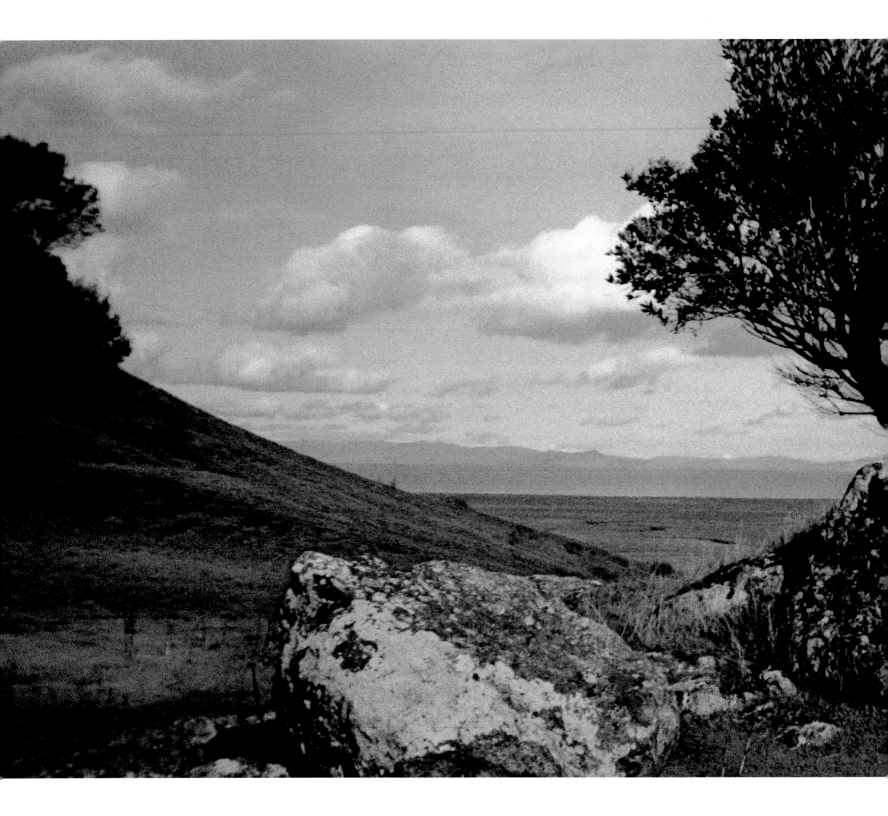

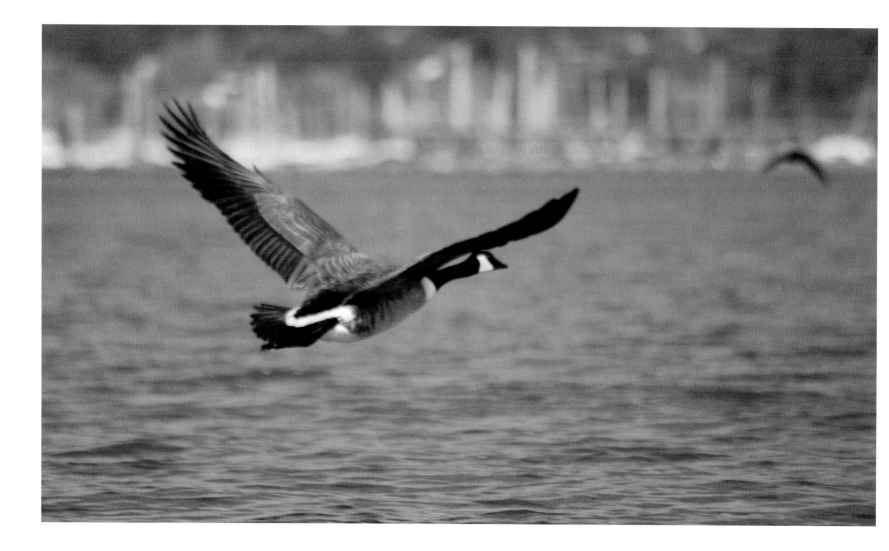

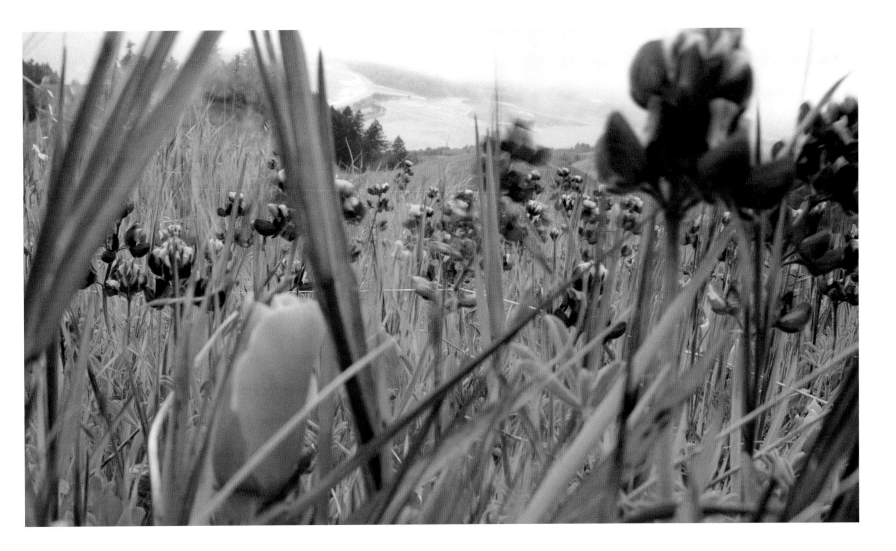

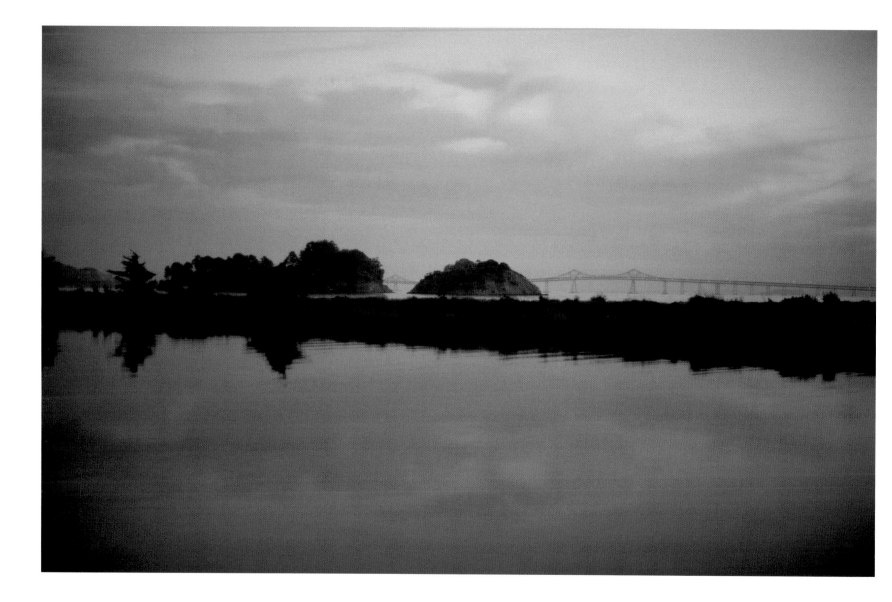

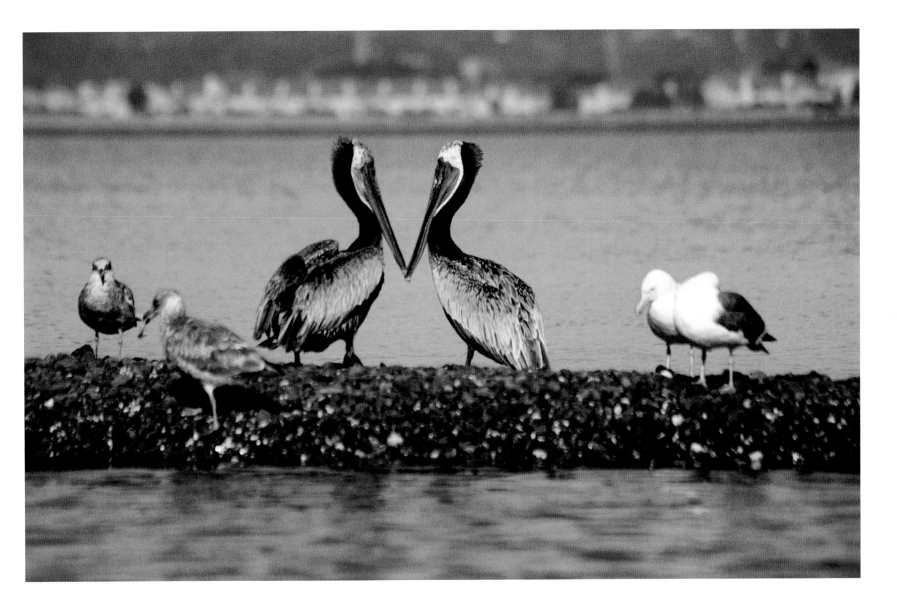

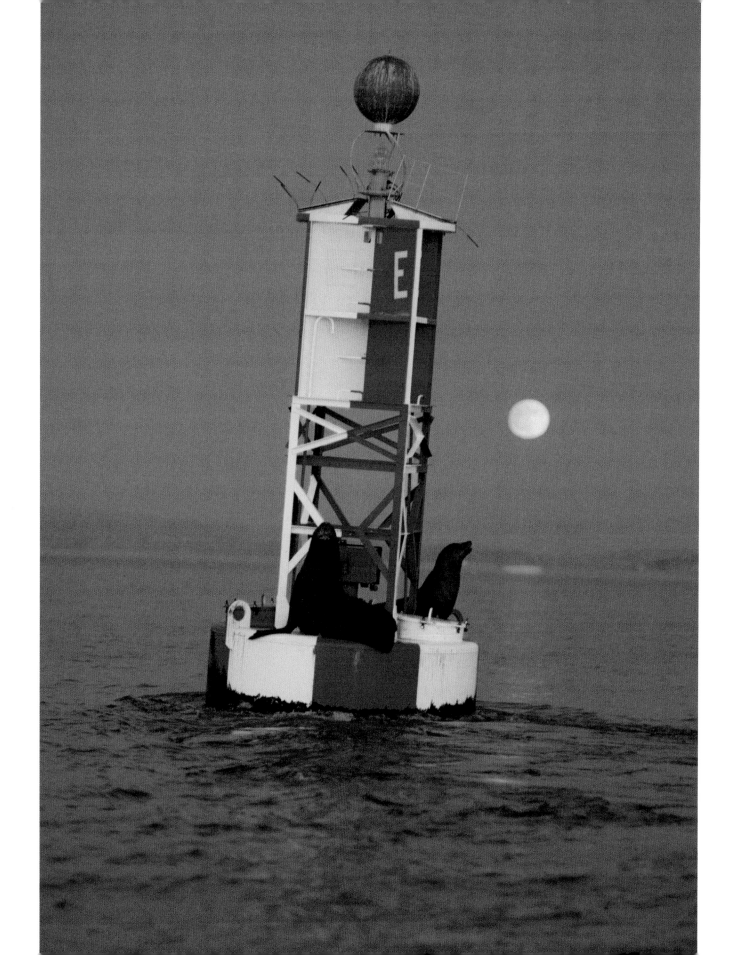

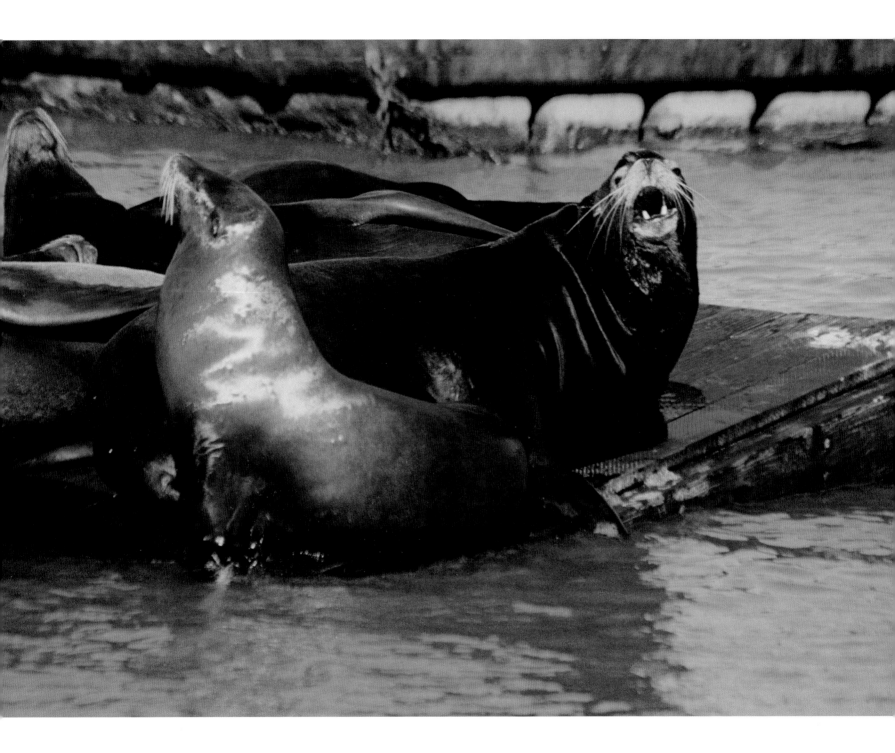

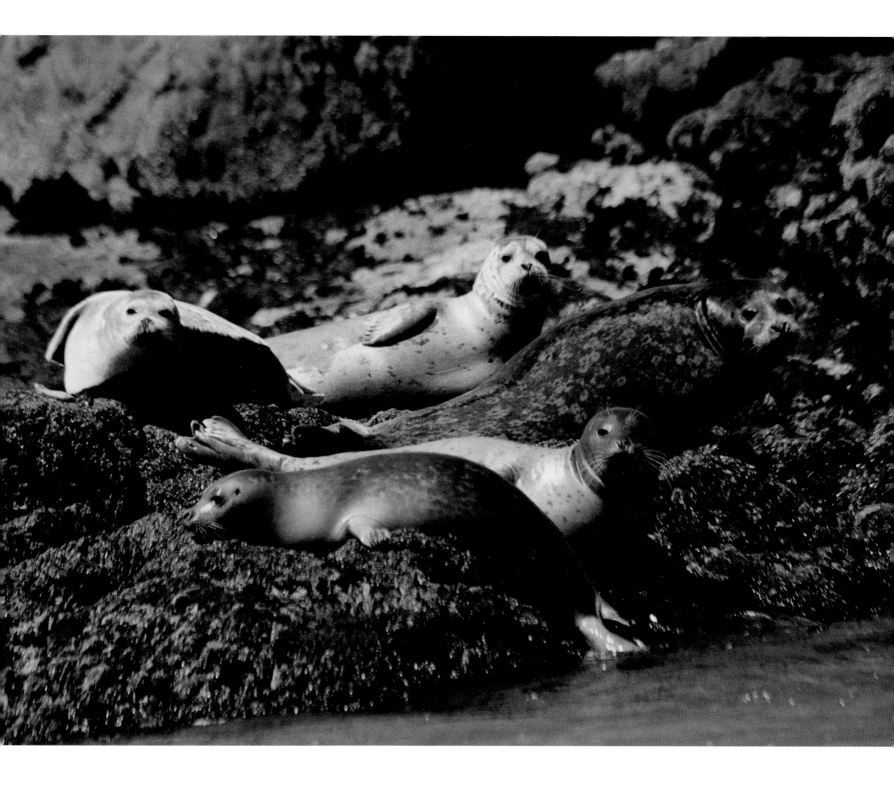

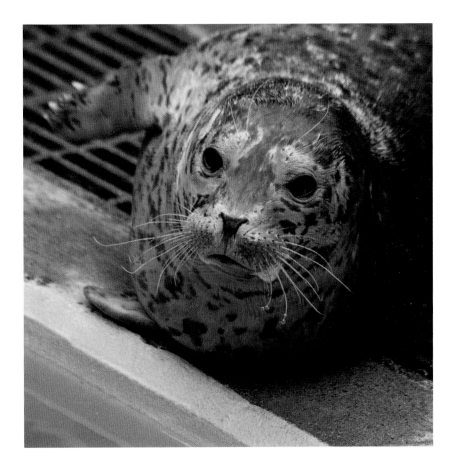

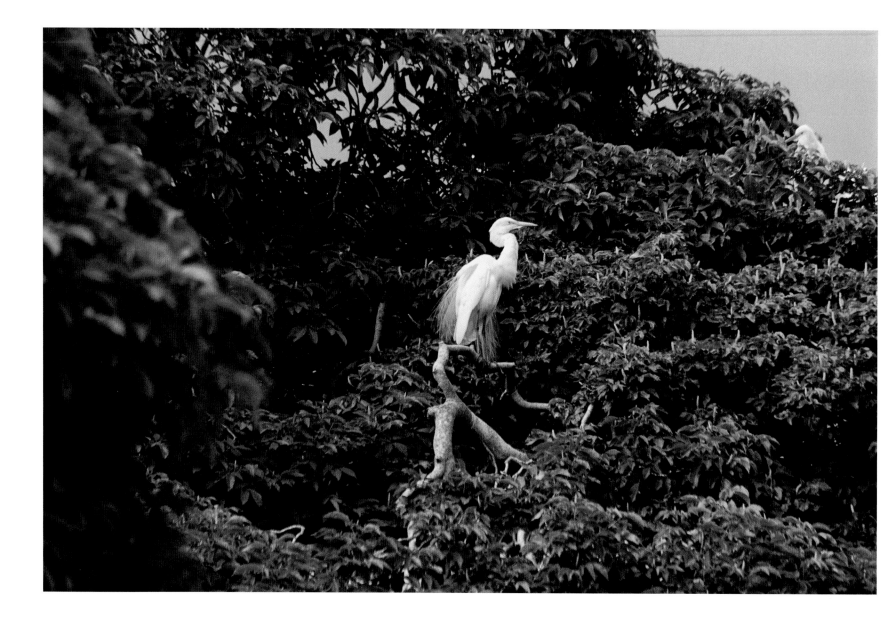

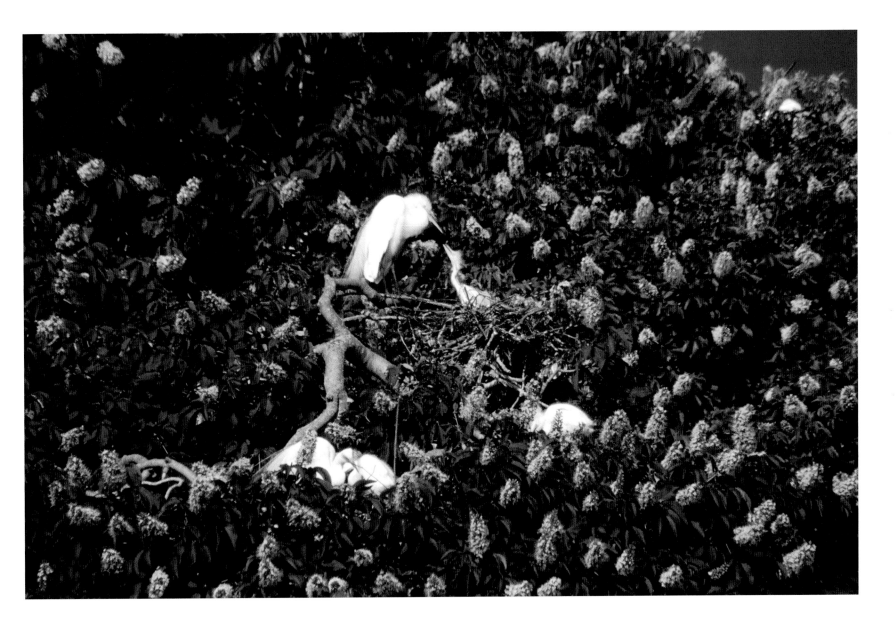

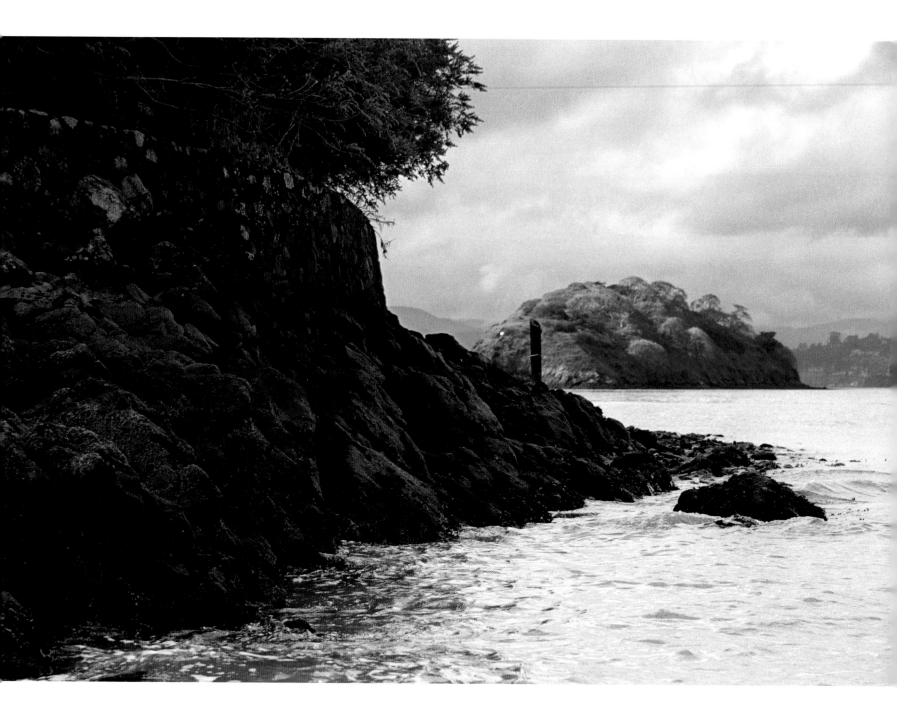

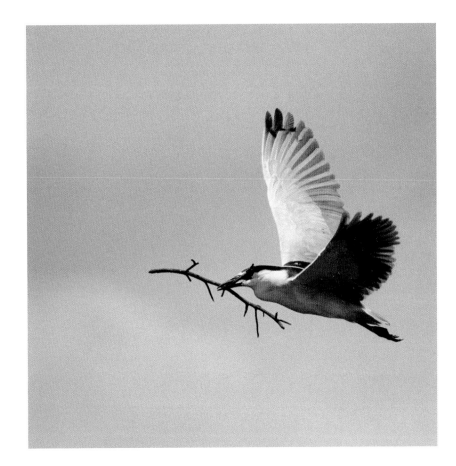

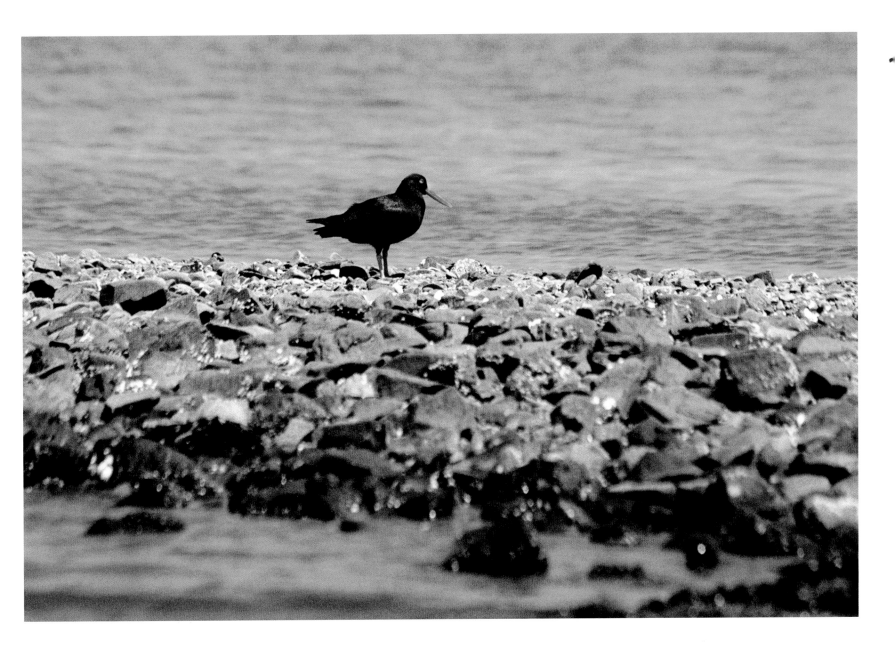

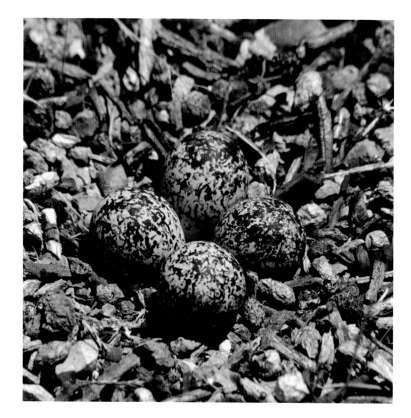

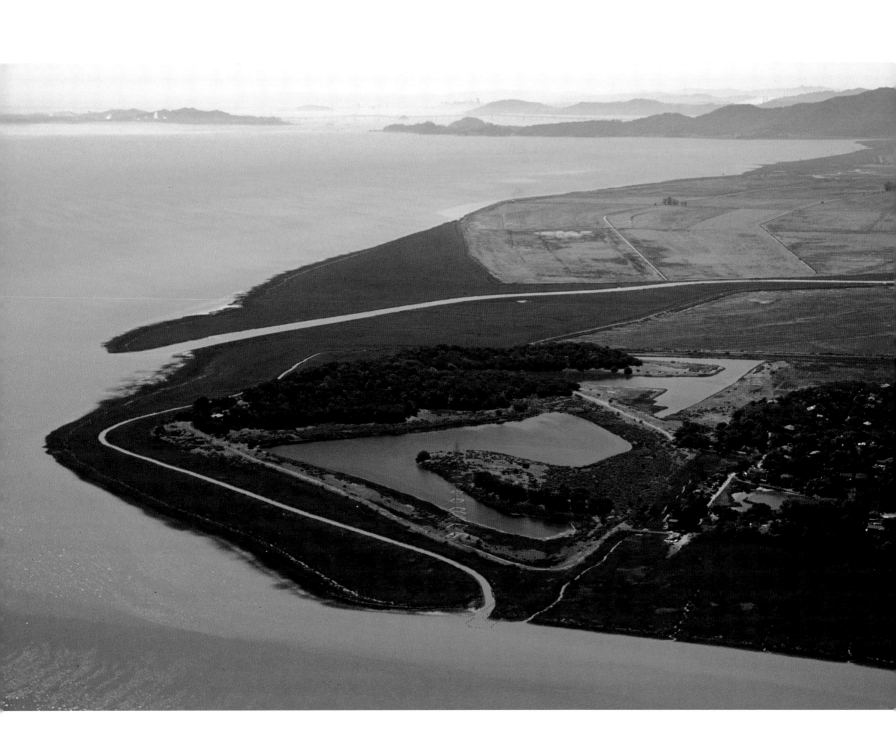

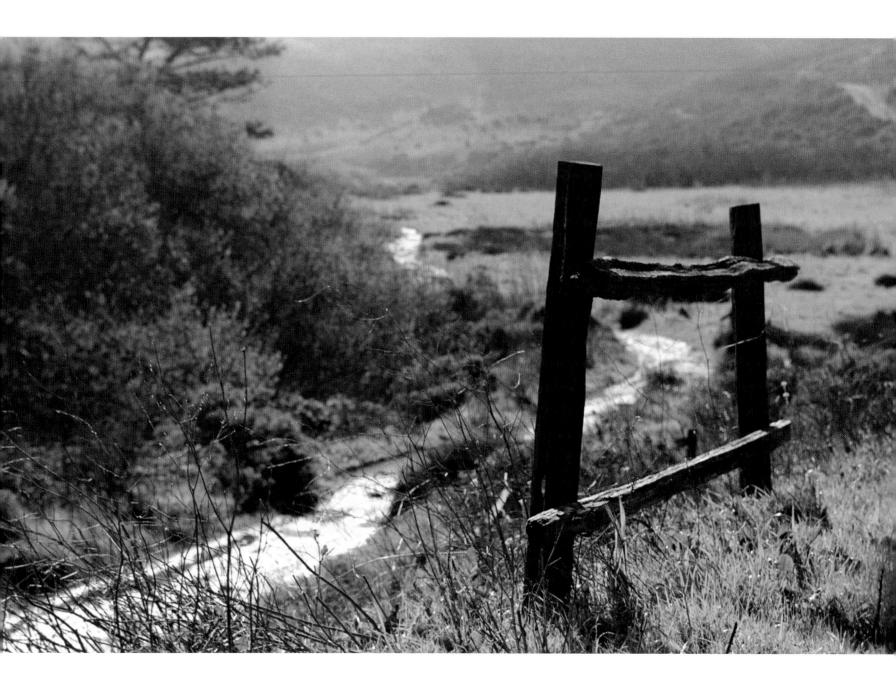

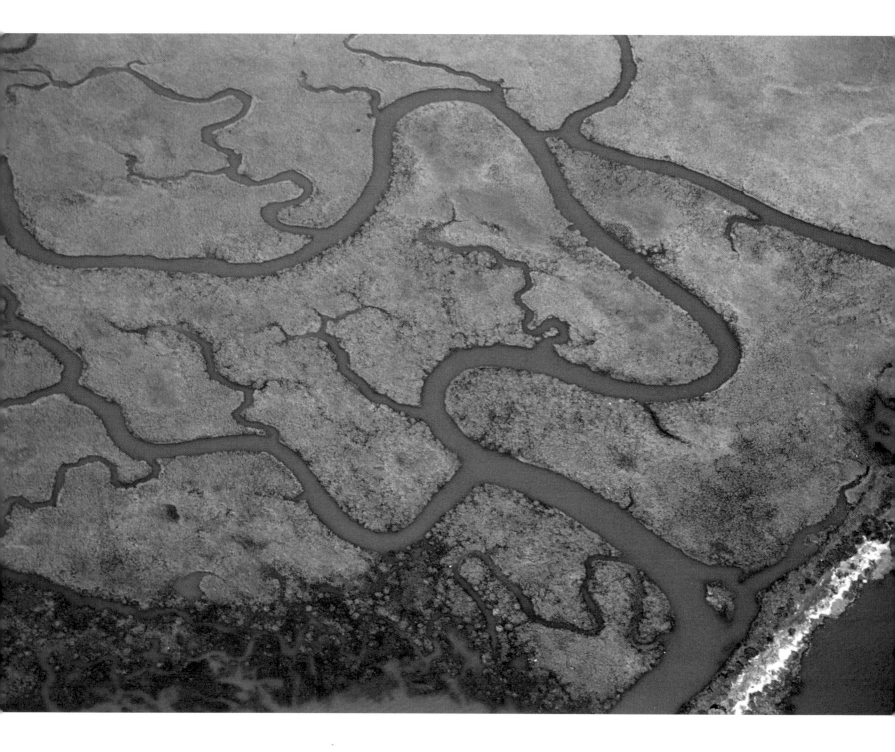

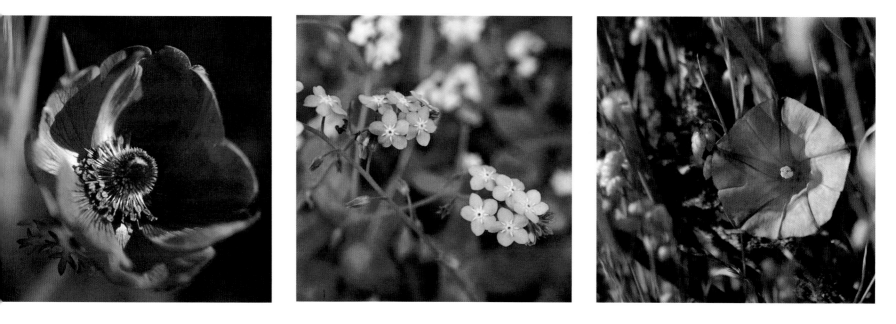

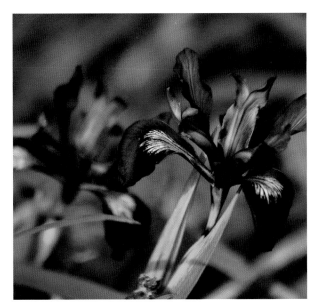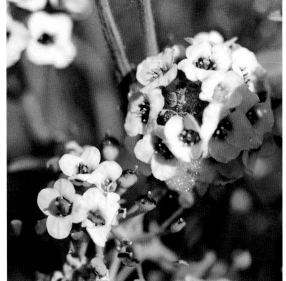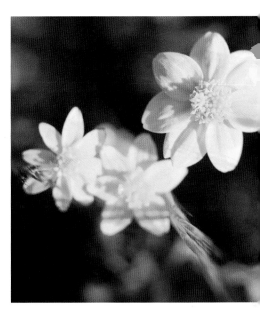

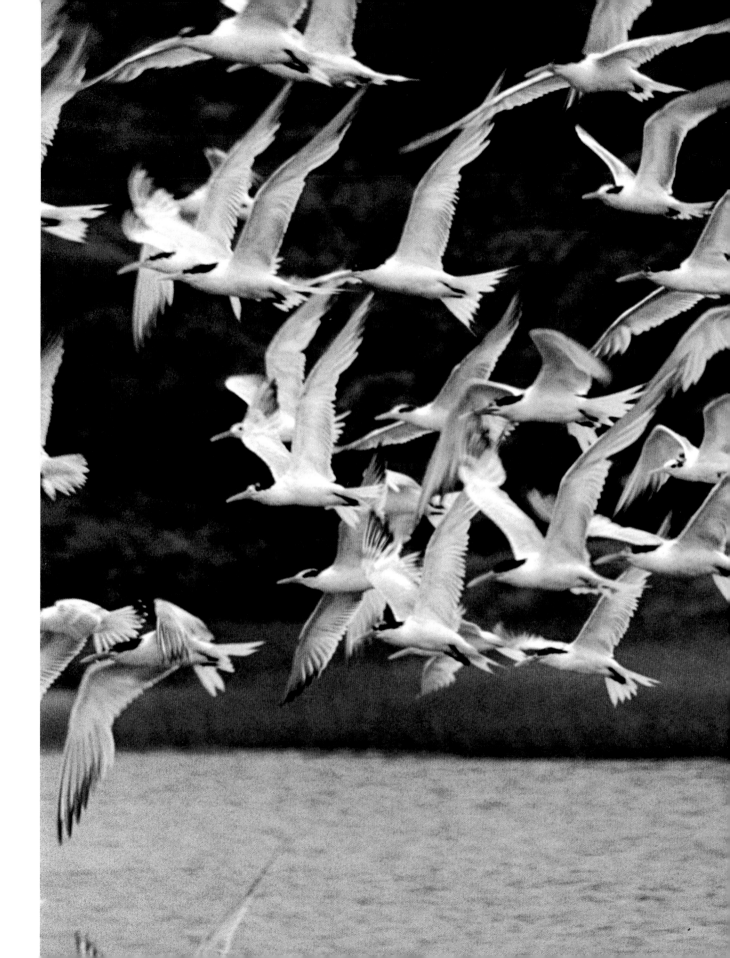

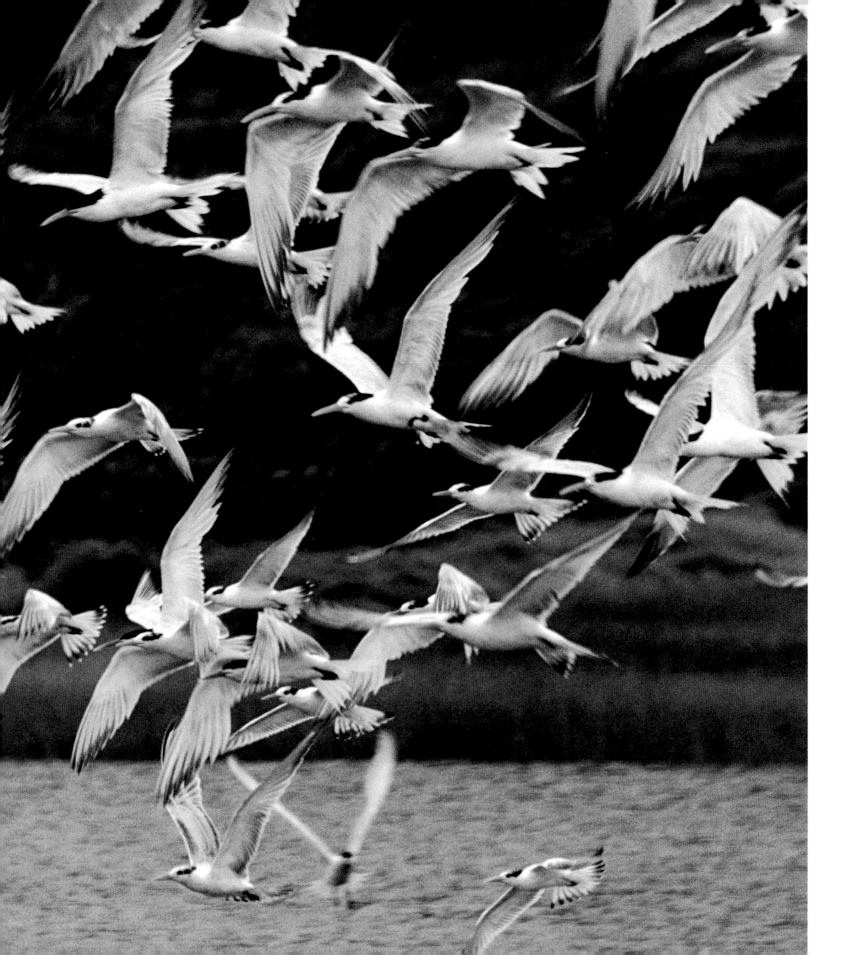

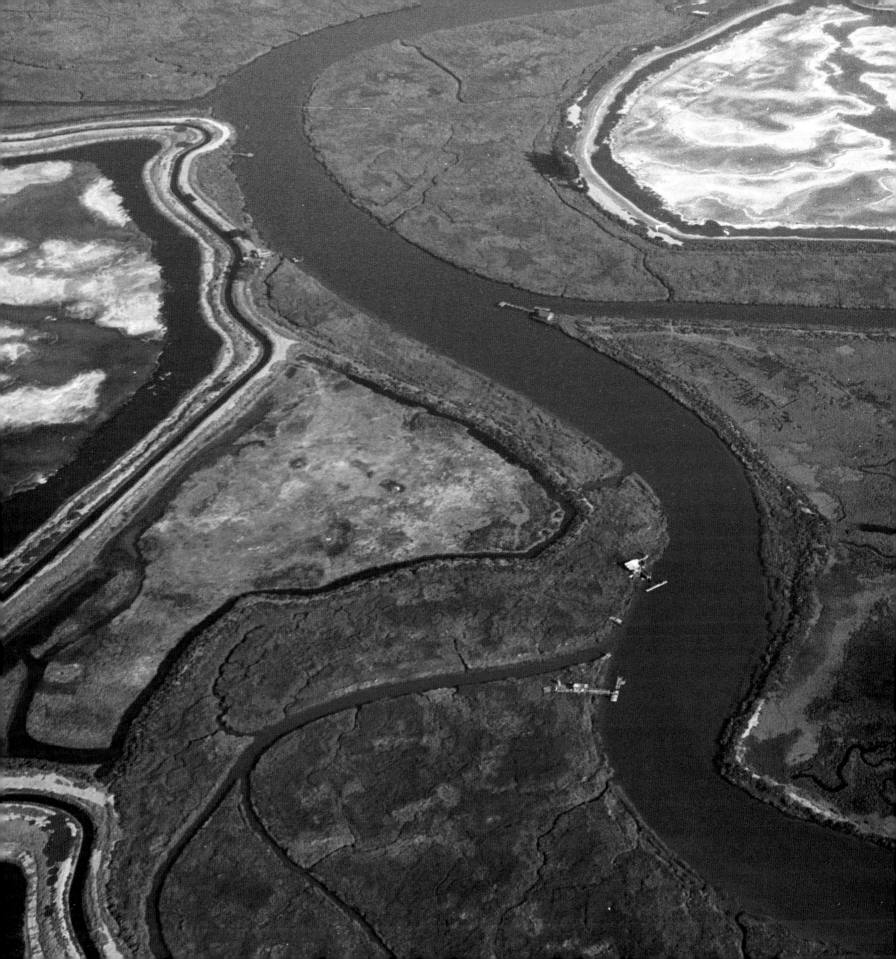

# SALT PONDS

Visitors landing in San Francisco International Airport have looked out the windows of their planes and wondered what horrible, dirty, red industrial pollutant had been dumped in ponds beside the Bay. Not to worry. It's just salt. Brine, to be perfectly correct, which is super-concentrated saltwater in the final stages of becoming table salt. The red color comes from tiny shrimp that thrive in brine. The salt ponds are actually far more bio-friendly than they appear, and some Bay life does quite well in these salt ponds. Black-necked stilts, avocets, and other shorebirds gorge themselves on the brine shrimp. Many other birds nest on the levies and marshy areas around the ponds.

The salt we use in our food comes from two places—underground mines and evaporation ponds. Ohlone Indians regularly collected salt from naturally occuring ponds in the South Bay. Since 1854, organized commercial salt evaporation has been a major use of shallow Bay lands. It's a simple business, especially in the Bay's southern arm, where the water is shallow and there is little freshwater stream runoff to

dilute Bay water. Shallow ponds are created with dikes; the ponds are flooded in the late summer when salt concentration is highest, then the water is slowly evaporated by sun and wind, leaving salt behind. The process takes five years and yields about 600 tons of salt each year.

The evaporation ponds have provided protected habitat for shorebirds like stilts, terns, and migratory waterfowl. The private, quiet channels between the ponds have been maternity wards for harbor seals. Even so, the commercial salt ponds have remained disconnected from the Bay's ecological ebb and flow. No more. Recently, Cargill Salt, the Bay's only remaining salt evaporator, sold 19,000 acres, over half of its ponds, to a coalition of federal and state agencies to be restored as native habitat.

The old salt ponds are perfect living laboratories for the new science of habitat restoration. But the job is daunting. There is far more to restoring salt marshes than breaching levies and letting the tide flow in and out. There is less silt in Bay waters than in times past. Without silt there can be no mud and without mud there can be no marsh. If the salt ponds are to be reincarnated as marshland

in a reasonable time, mud will have to be imported and sculpted to maximize sedimentation from tidal flows. Like seed trees after a forest fire, seed grasses will have to be planted in the new mud to slow tidal currents and keep the mud in place.

Mud, marvelous mud, is the habitat for the critters on which shorebirds feed. Sand fleas, isopods, amphipods, and a myriad of other animals burrow about just beneath the mud's surface. Avocets, black-necked stilts, willits, and sandpipers work the splash zone just above the lapping Bay waters that rise and fall with the tide. Muddy marshes connected to the tidal Bay are also nursery grounds for crabs and bass and other creatures that live their adult lives in more open waters.

Huge as the task may be, restoring the Cargill salt ponds to marsh will be eloquent testimony to the power of cooperation between groups, both governmental (CALFED, a work group that combines all the state and federal agencies with oversight of San Francisco Bay) and private (including Cargill, which will continue to provide management support for the project, along with nonprofit groups like Save the Bay and hundreds of skilled volunteers).

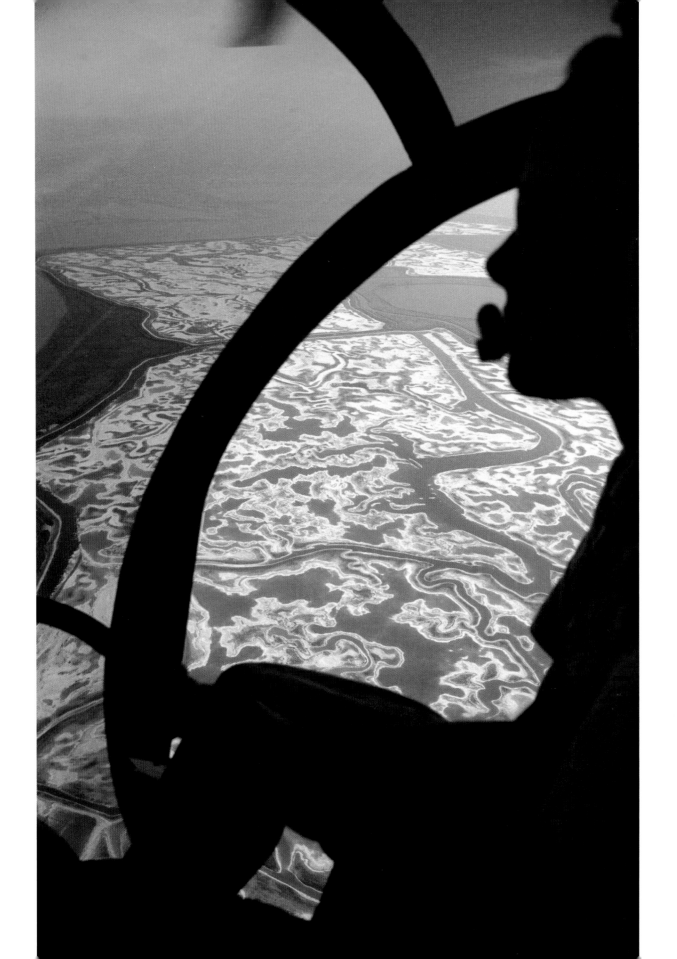

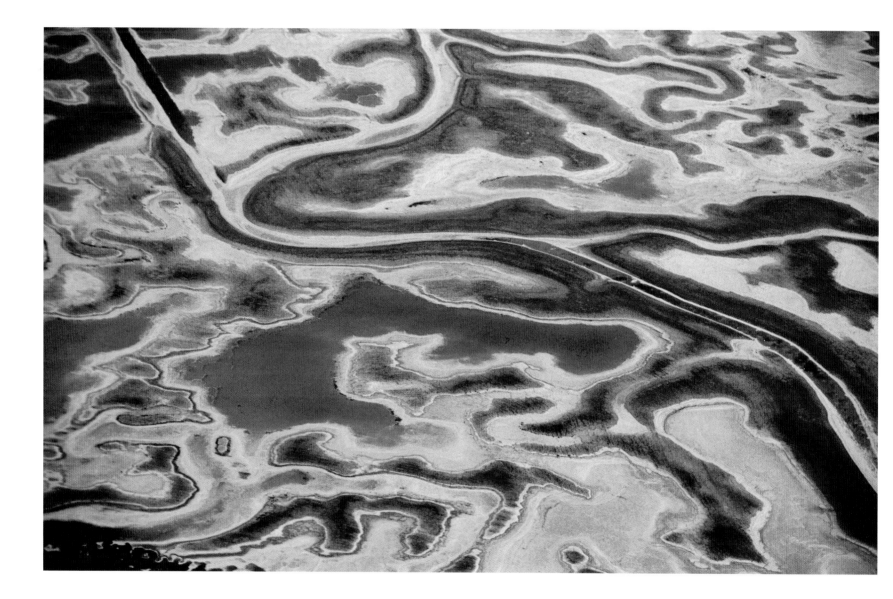

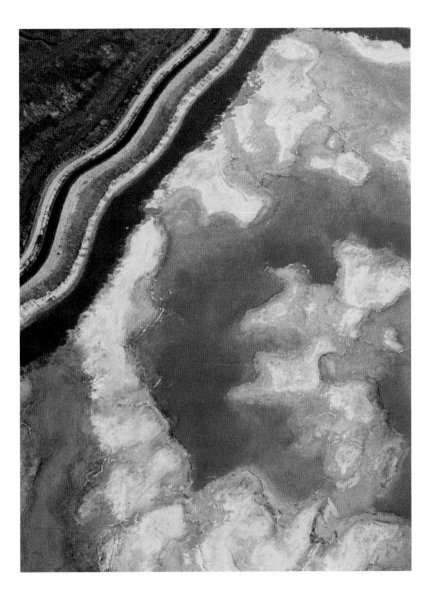

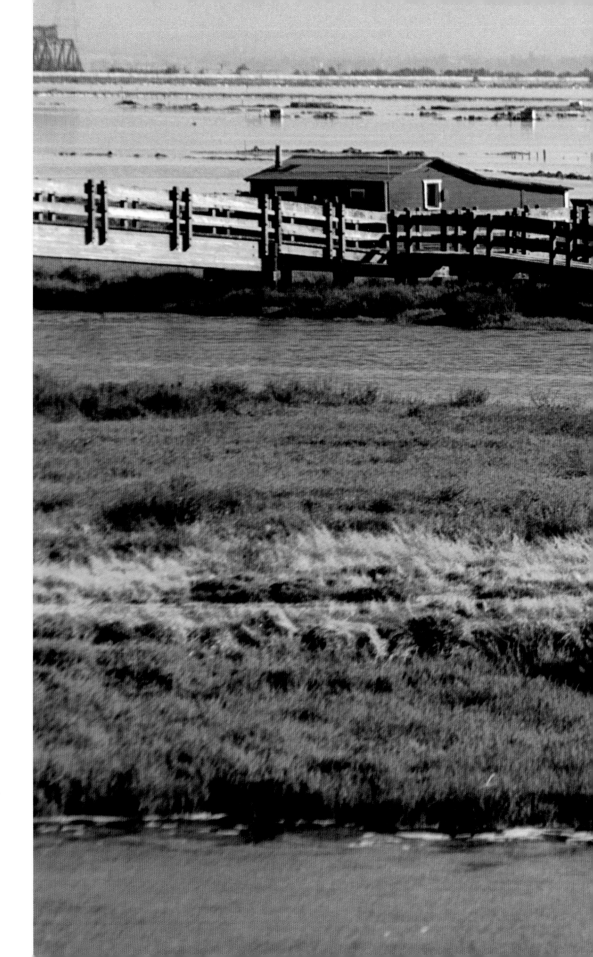

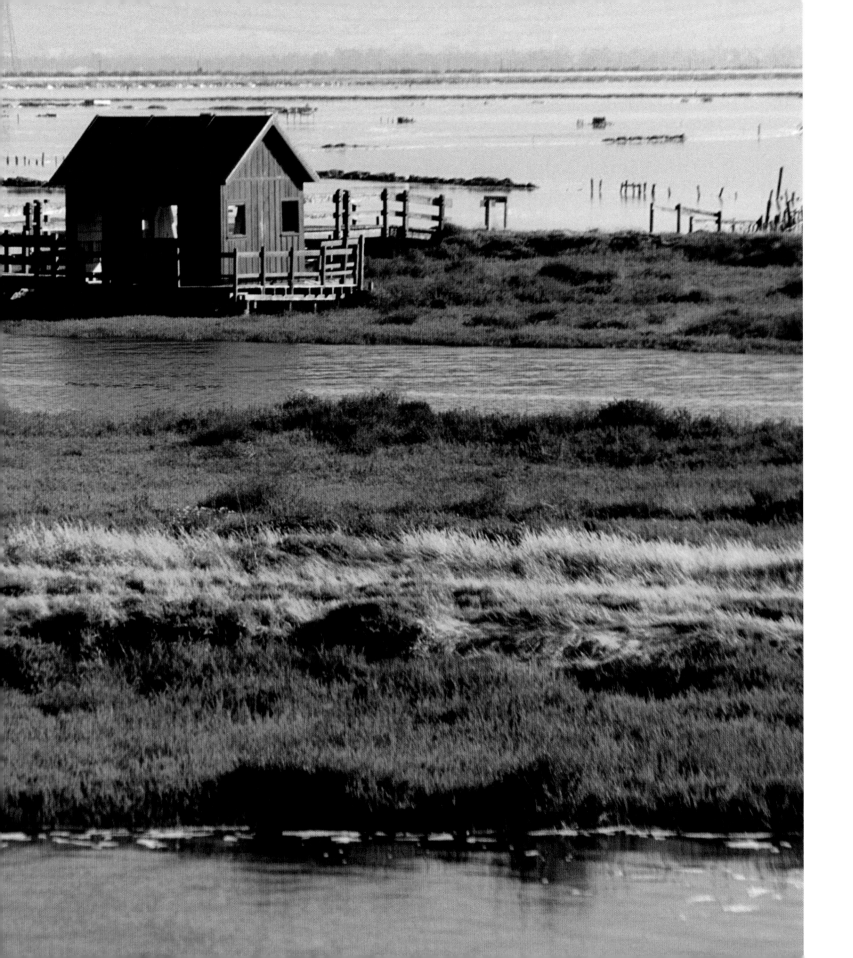

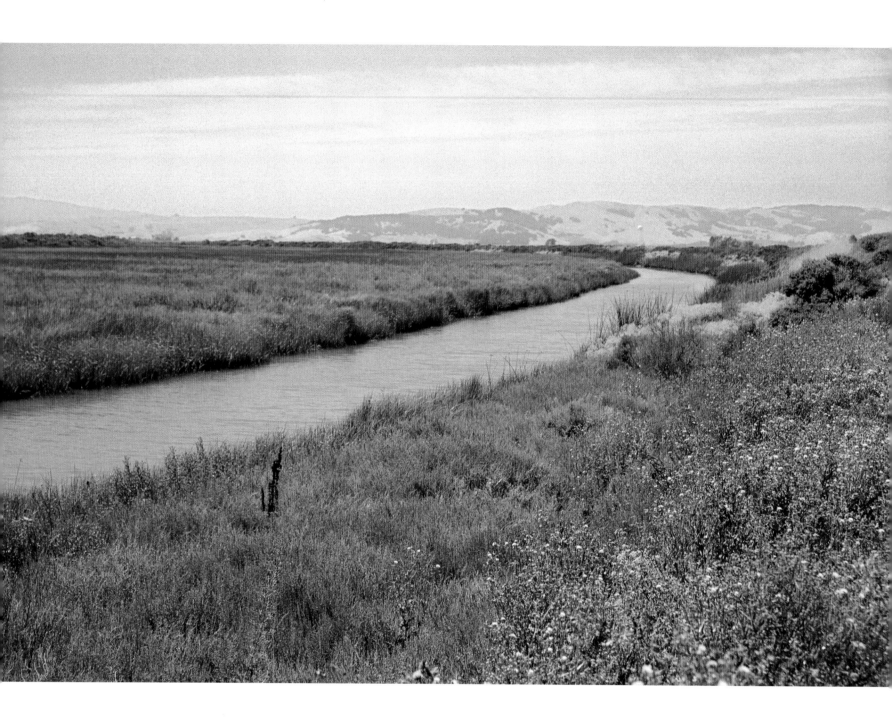

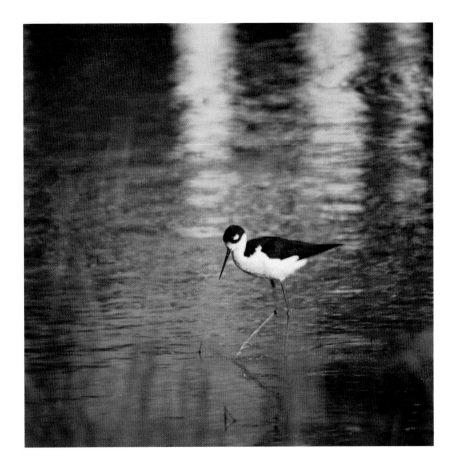

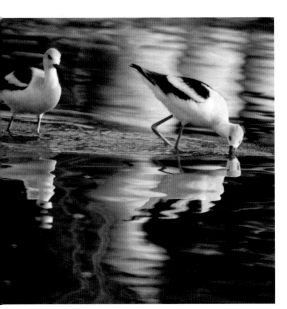
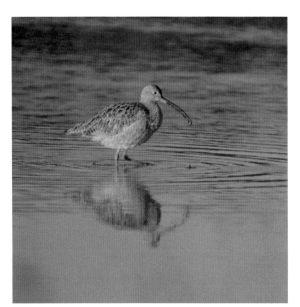
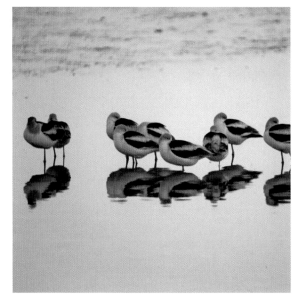

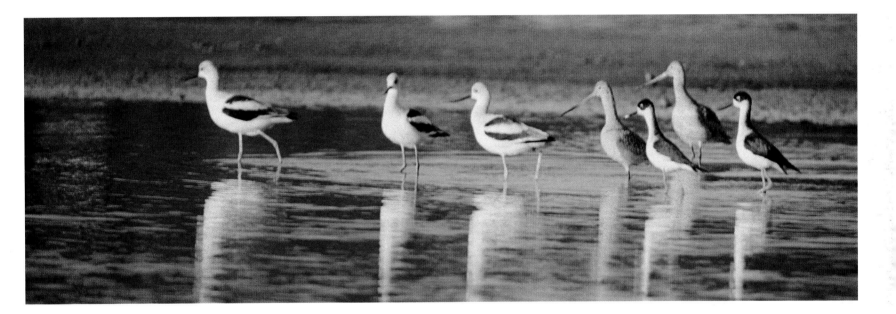

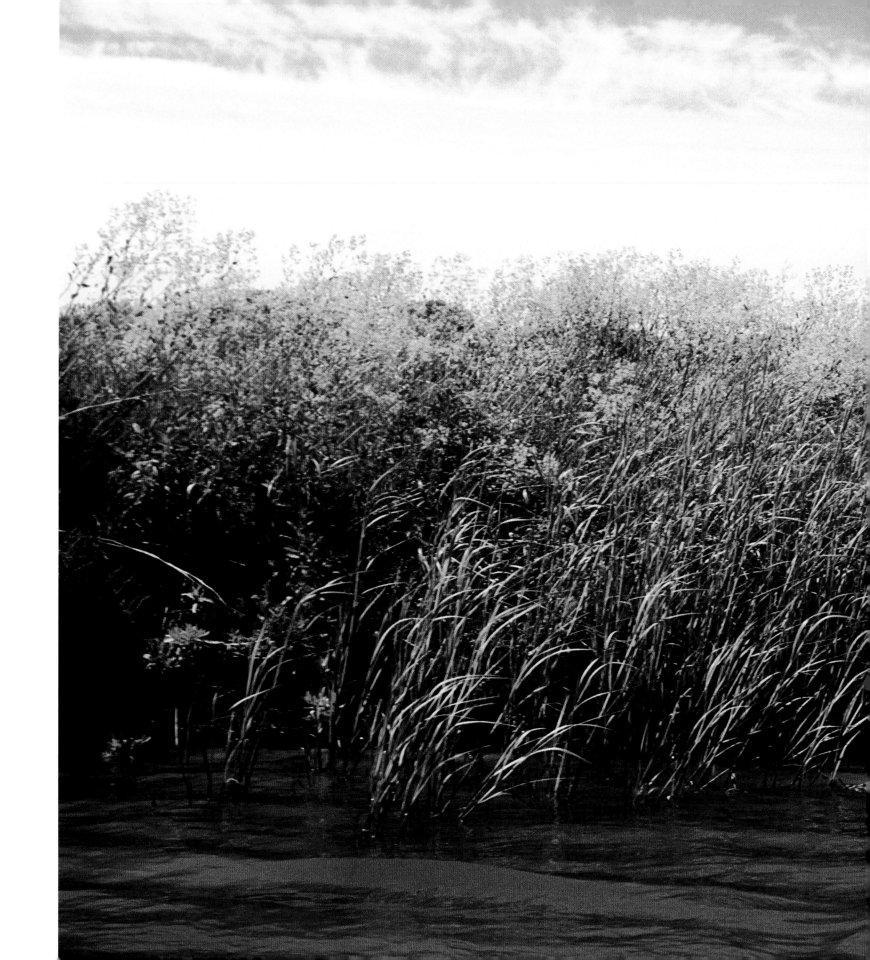

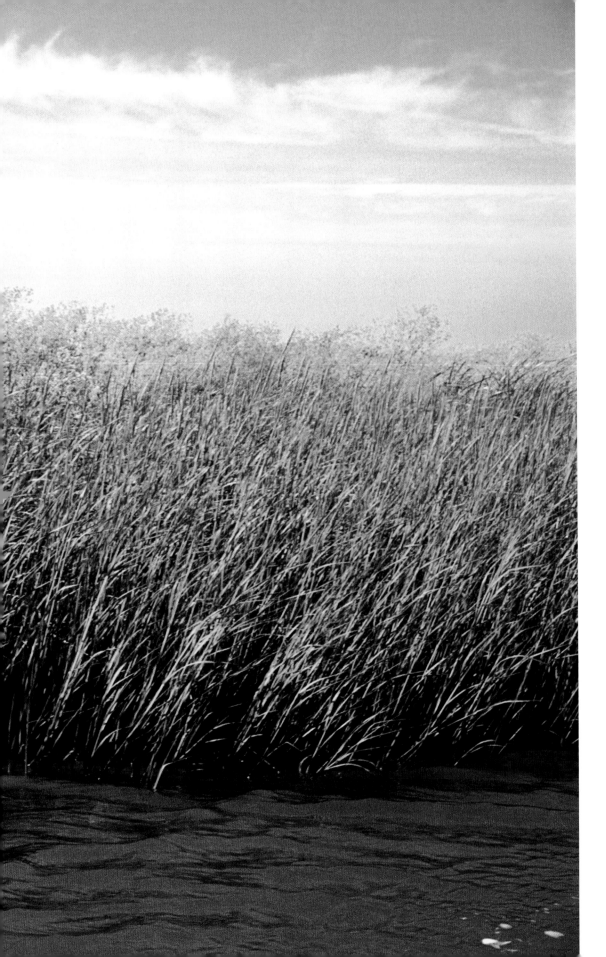

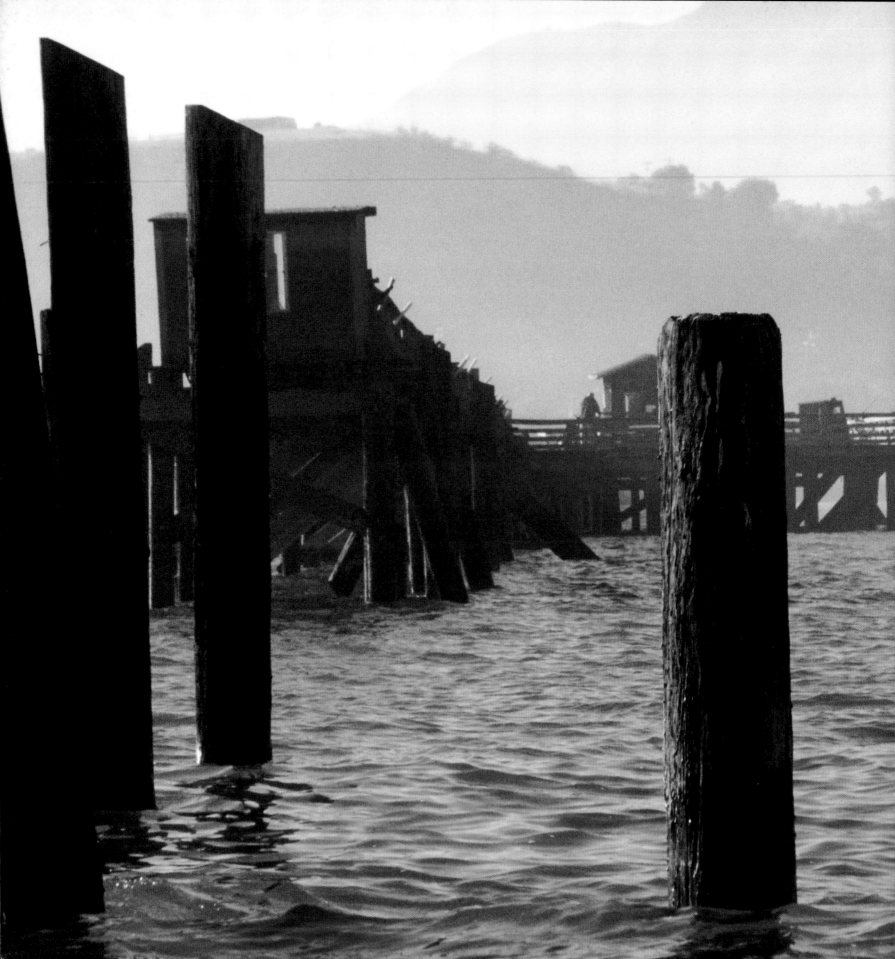

# LIVING ON THE WATER'S EDGE

E dge: for ecologists the word is magic. Edges are areas of great diversity and energy, places of constant change and challenge. We humans tend to revere great fields of single crops, whether they are fields of wheat, stands of timber, or pens full of salmon, yet inch for inch, acre for acre, edges are the most productive producers of life. Biologically, culturally, and even spiritually, there is no more dramatic edge than where land meets sea.

The first humans to settle the edge of San Francisco Bay, to make their livings both on land and sheltered sea, were Natives we now call the Ohlone. Their world was bountiful. There were oil-rich salmon in the spring, ducks in the winter, and elk year-round. New, pithy reeds grew in the Bay's marshes each year from which they could fashion very serviceable boats.

Chinese immigrants who came to Gold Mountain to find their fortunes saw that same abundance and established the first commercial fishing on the Bay. The Chinese understood there was more gold in feeding people than in prospecting. Food was scarce

in 1849 as the flood of gold-seekers swelled the population beyond the available food supply. But there were plenty of fish in the Bay. Young Jack London told of Chinese shrimp fishing in his *Tales of the Fish Patrol,* a tradition continued to this day by Frank Quan at China Camp State Park on the Bay's northwestern shore. Italians from Genoa pioneered the Bay's offshore salmon and rock fish fisheries and are still prominent.

But the oldest commercial use of the Bay is shipping. Since the first Spanish barks and Boston-based ships arrived 200 years ago, San Francisco Bay has been considered one of the world's greatest and safest harbors. Ten thousand ships visit San Francisco Bay ports each year, bringing goods from all over the world. With the oceangoing ships come tugs, barges, water taxis, drydocks, chandleries, longshoremen, teamsters….Economists say the shipping industry contributes over $2 billion to the Bay Area economy each year.

Edges can also be contentious. In the seventies, a Sausalito houseboat builder found himself captivated by building a Jules Verne-like island complete with a pipe organ. Some said Forbes Kiddoo was

posessed or at least eccentric. His "island" sprouted palm trees, a lighthouse, and a sand beach. Bay conservation managers spent the next twenty years saying his "monstrosity" was floating fill and had no right to exist on or in Bay waters. But times change. Today Mr. Kiddoo's 50 x 100–foot self-propelled island is considered part of the cityscape, a unique new restaurant floating off Pier 39.

Forbes Kiddoo is not even the latest in a long line of Bay artists/creators. For decades, the salt marsh beside the Bay Bridge seemed to sprout the most outlandish art after a high tide. Elaborate model airplanes inspired by the Peanuts cartoon strip mysteriously appeared on Bay pilings just beyond the reach of the curious and the acquisitive. And at this very moment someone is gathering found materials into an artistic statement he or she will leave for the world to enjoy, free.

San Francisco Bay's edge may be one of the most environmentally and culturally diverse places on our planet. No matter how often or long you wander its shores, there is always something new to be discovered.

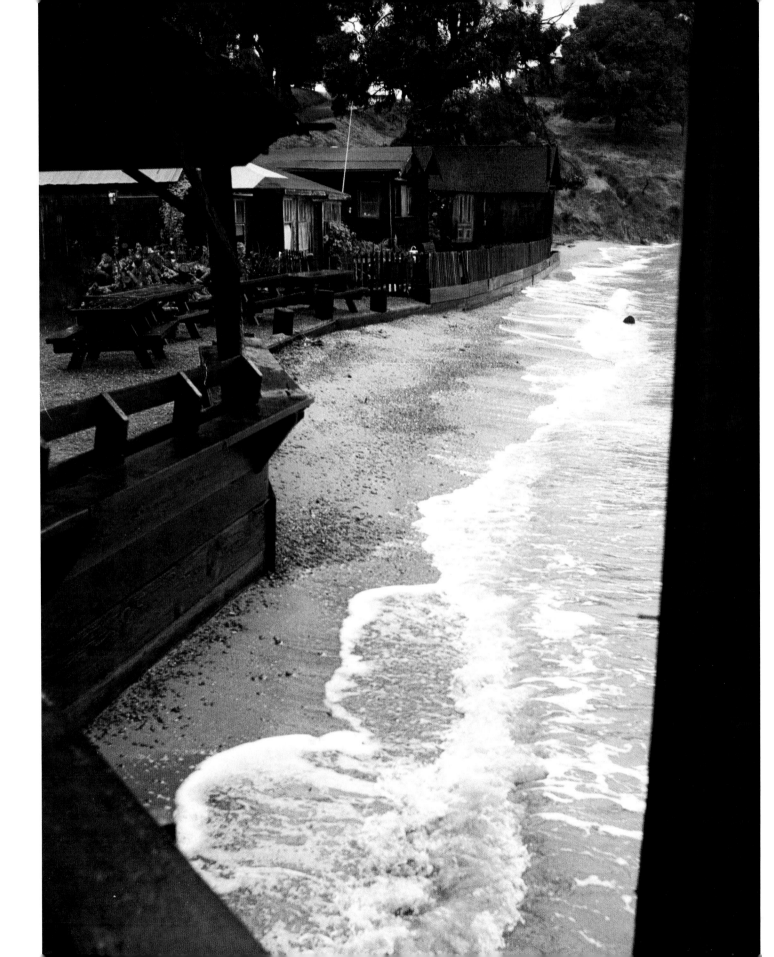

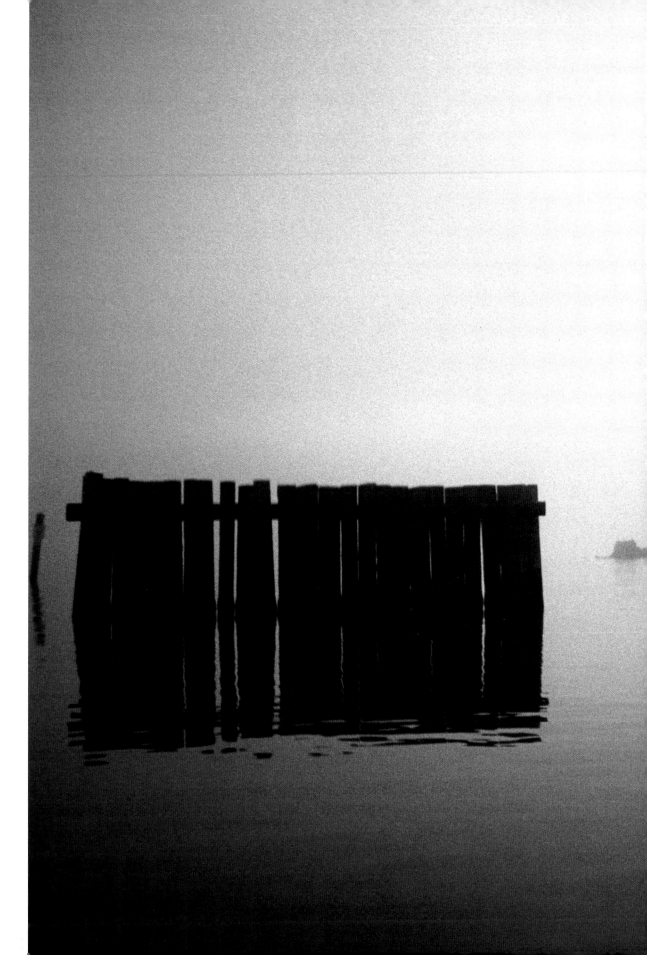

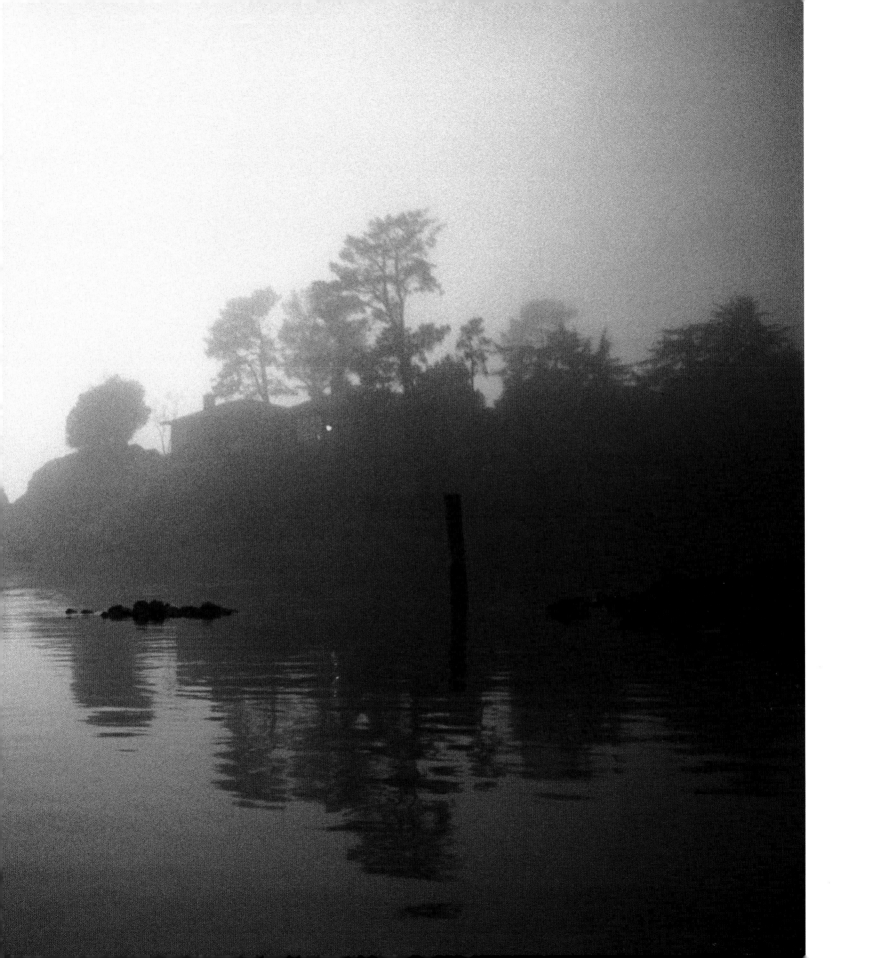

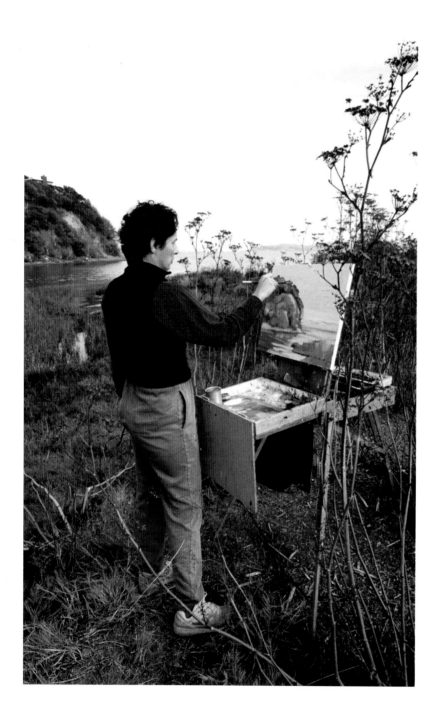

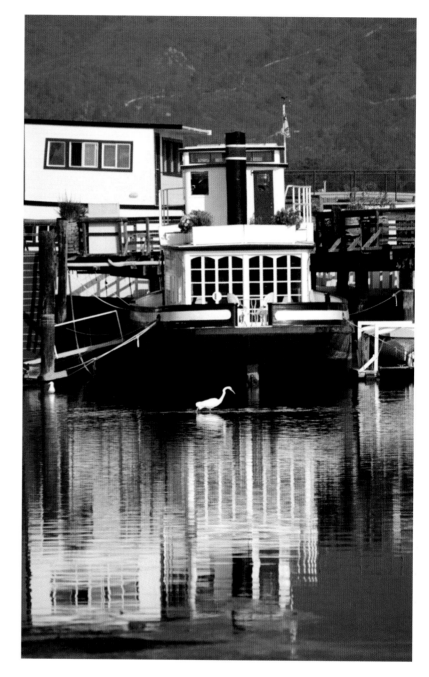

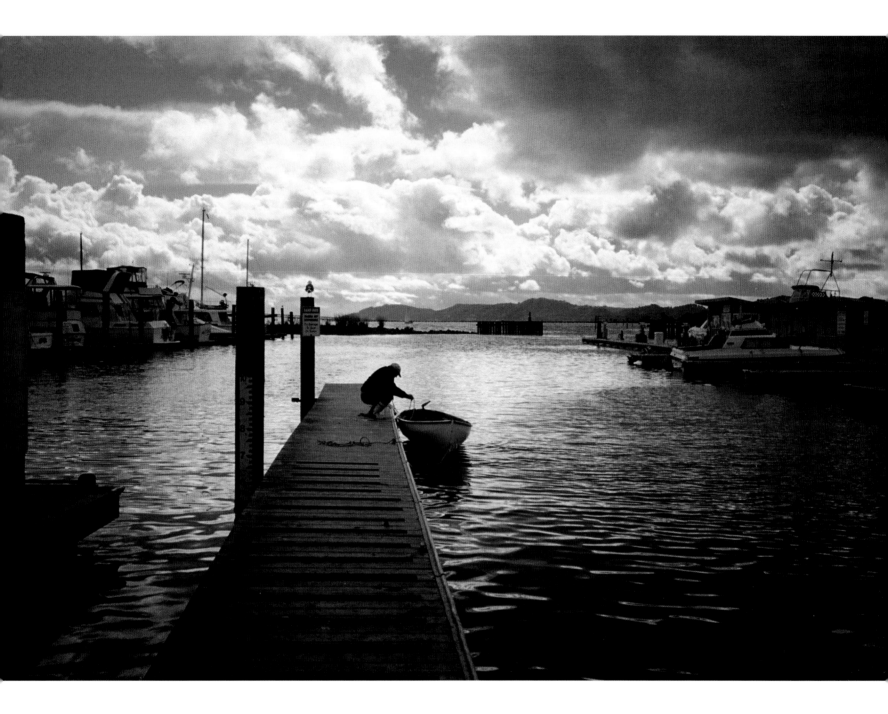

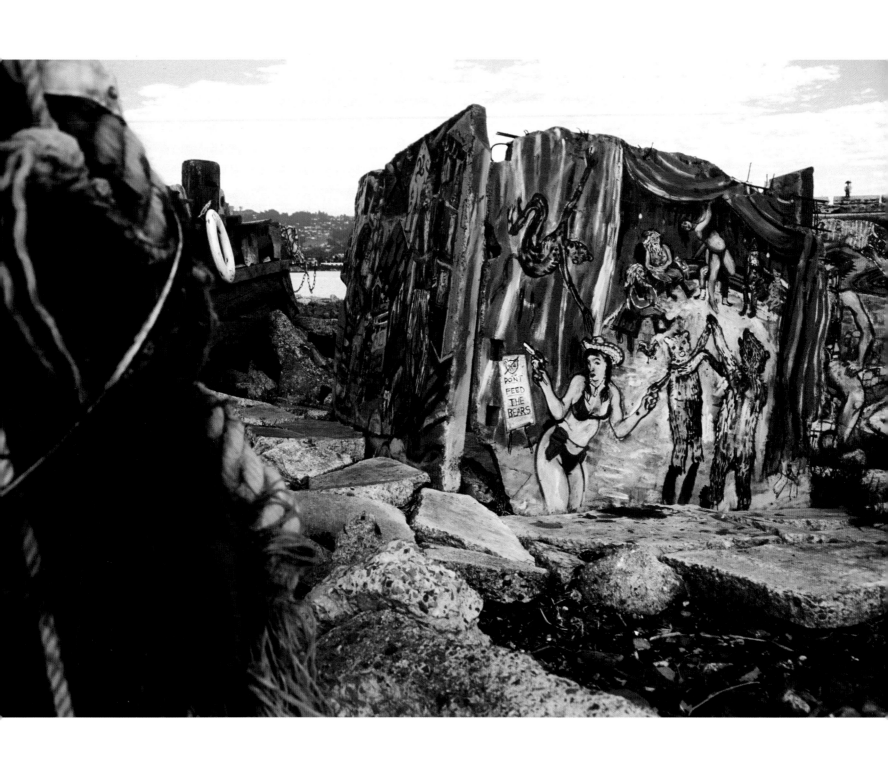

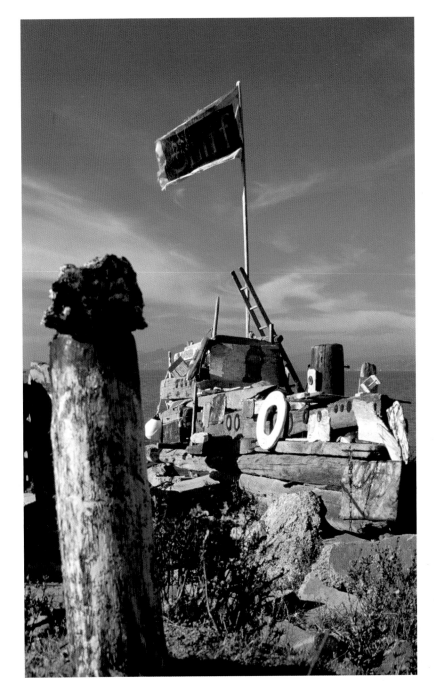

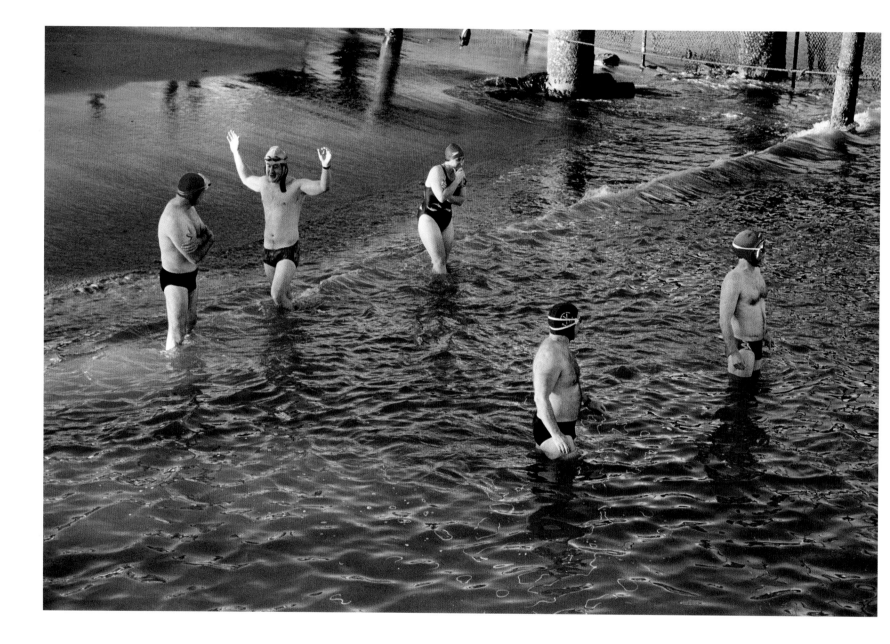

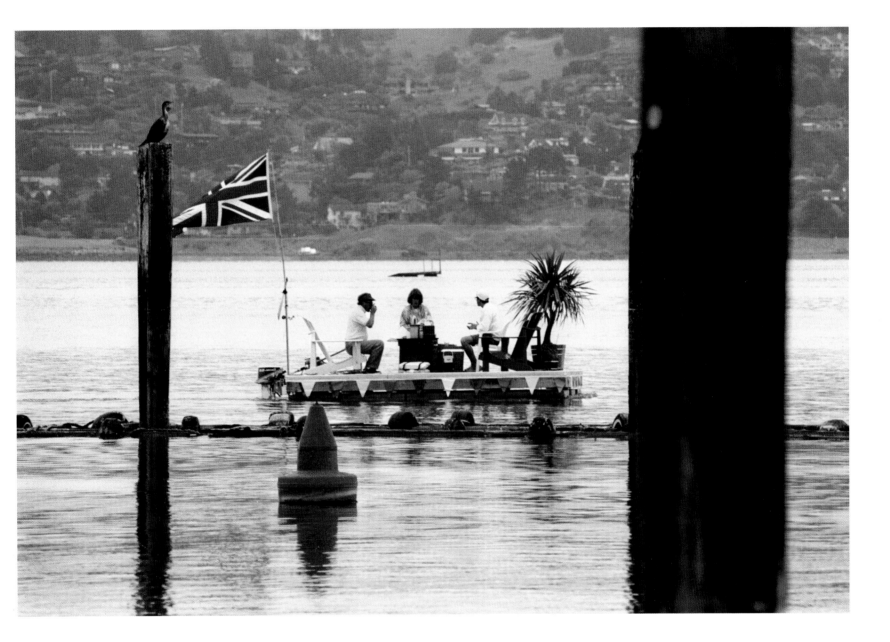

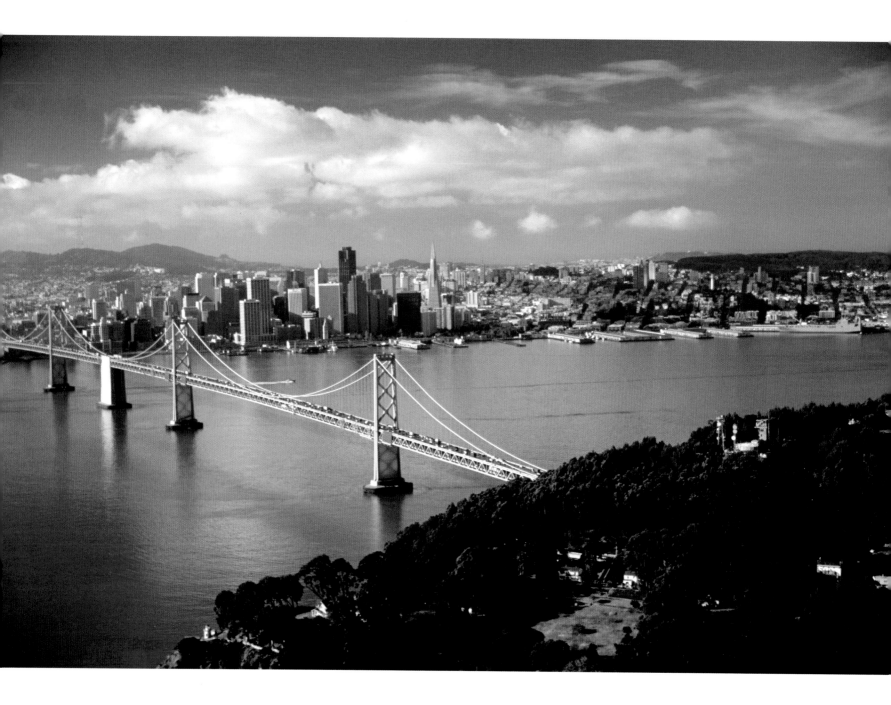

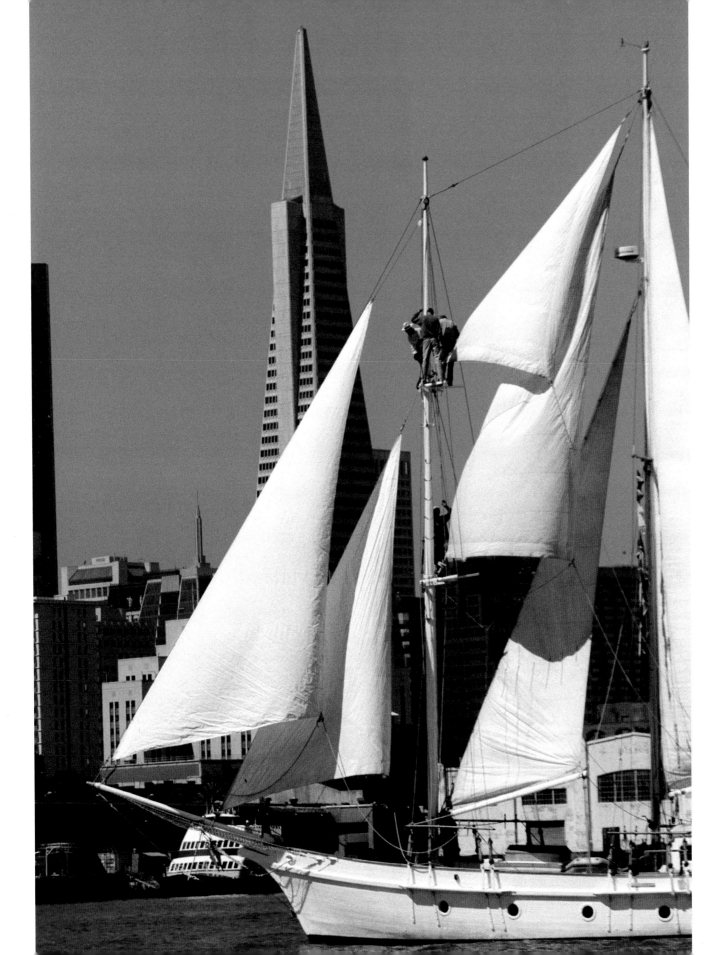

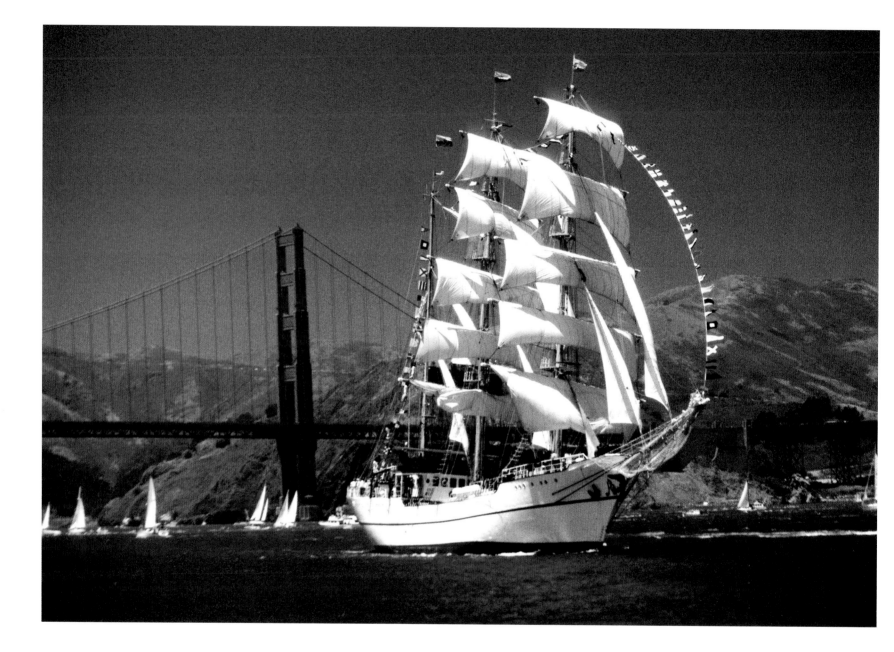

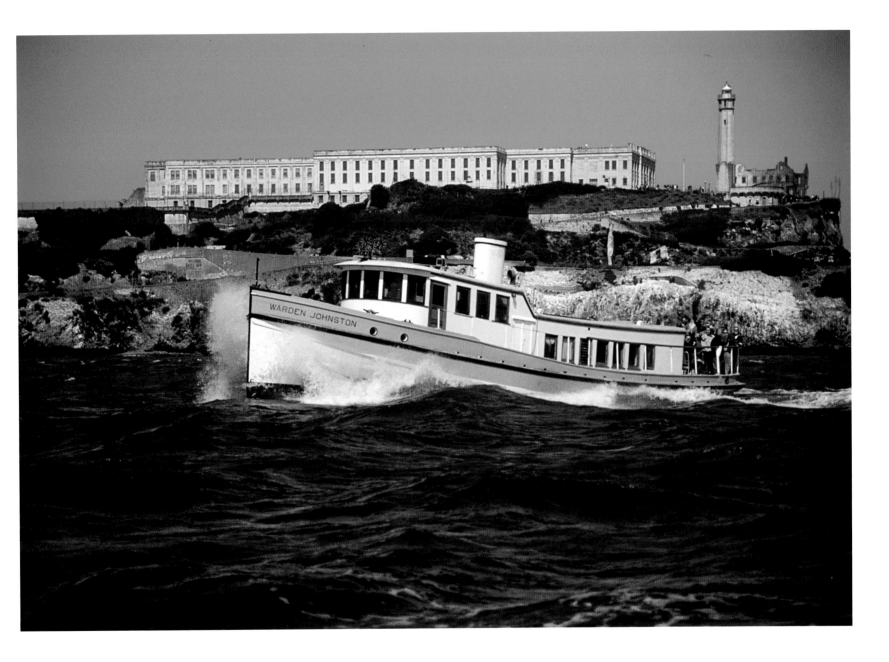

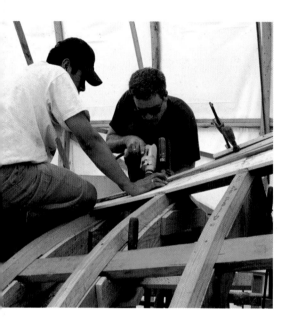
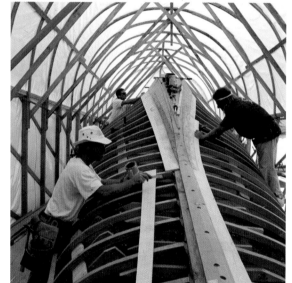
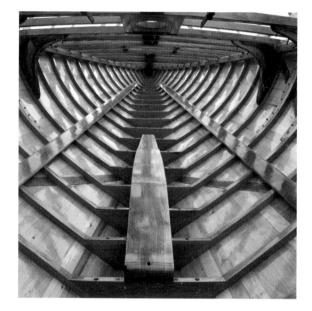

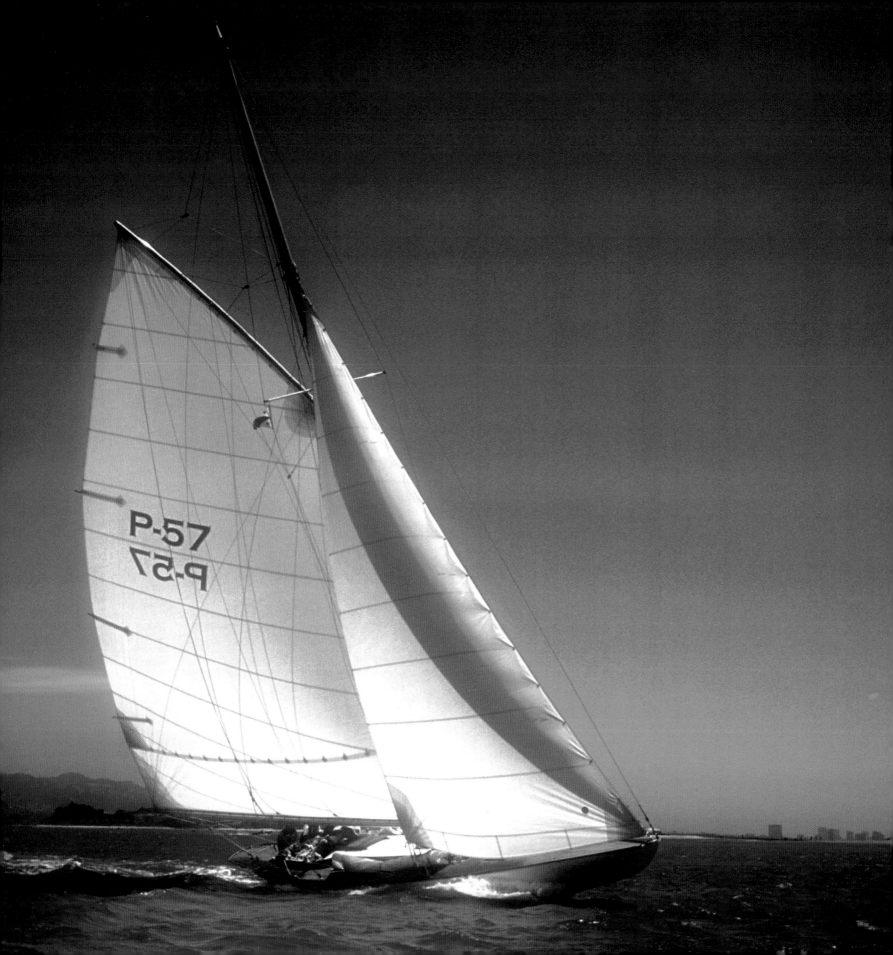

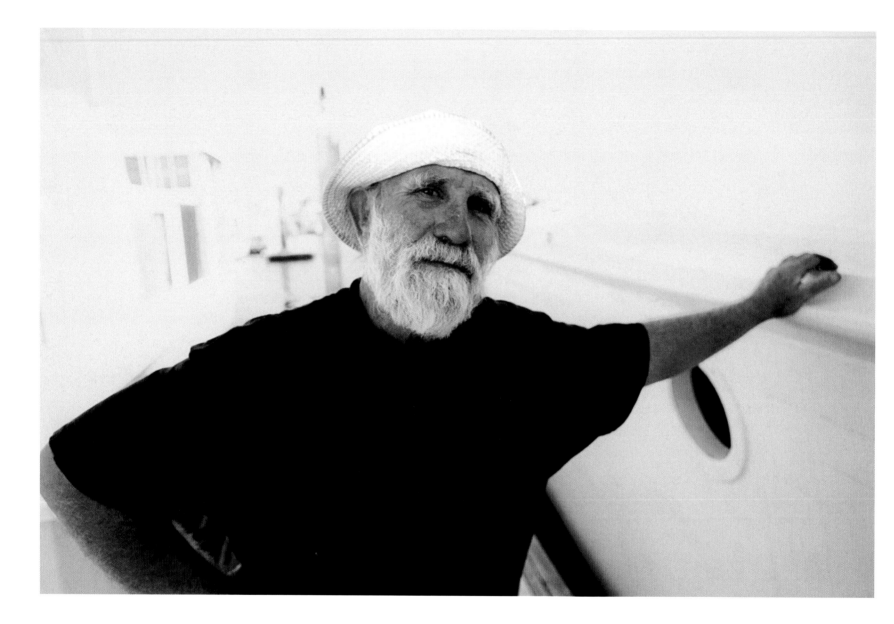

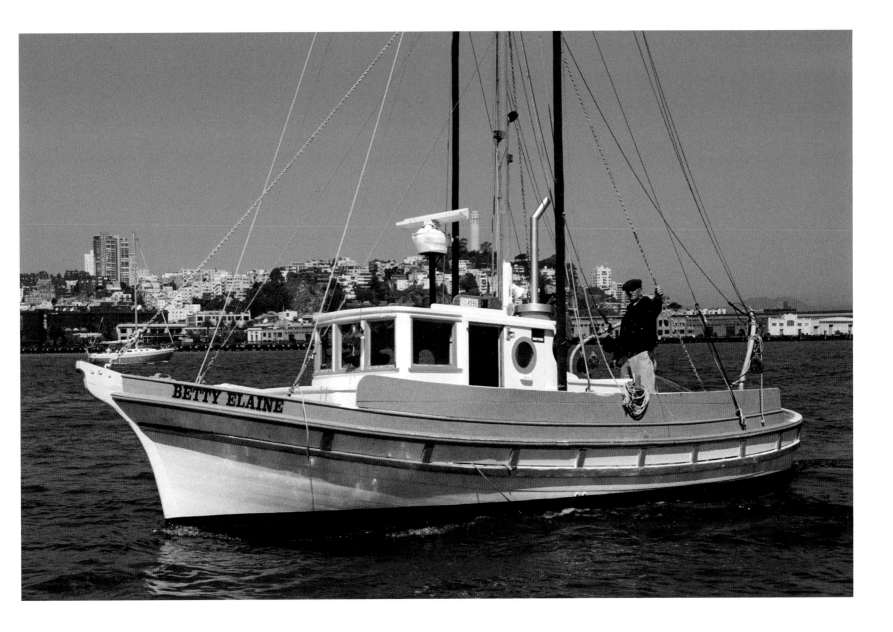

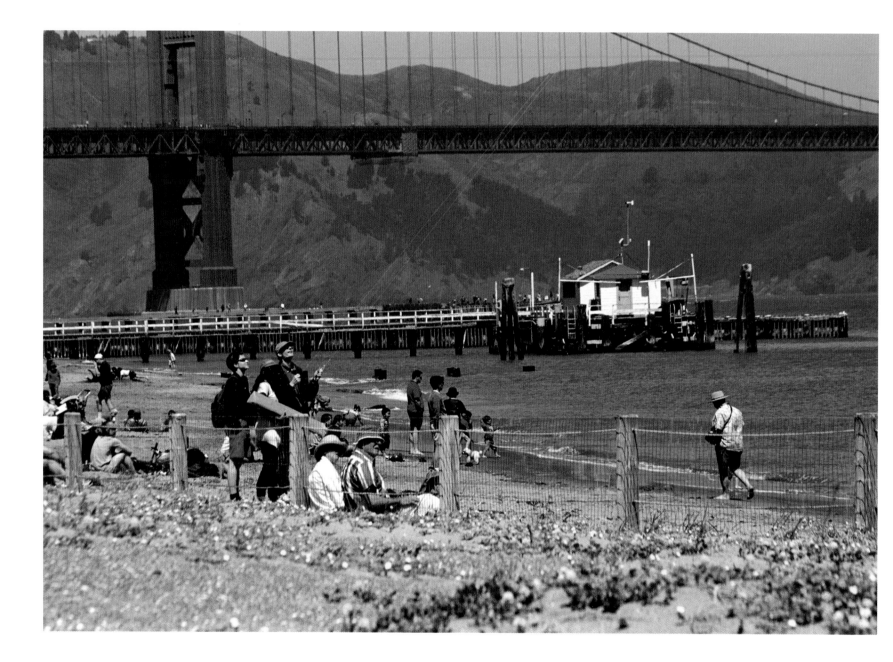

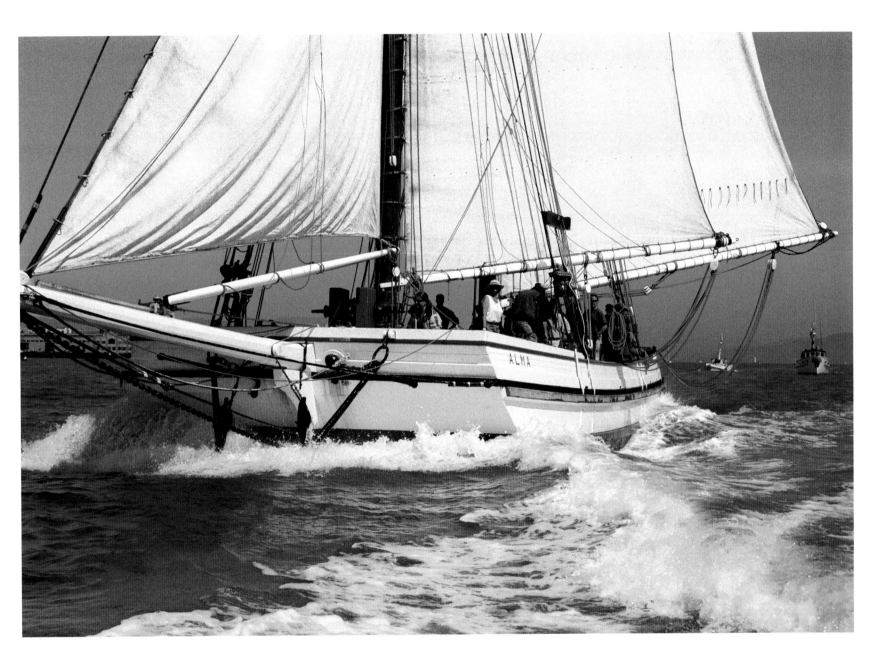

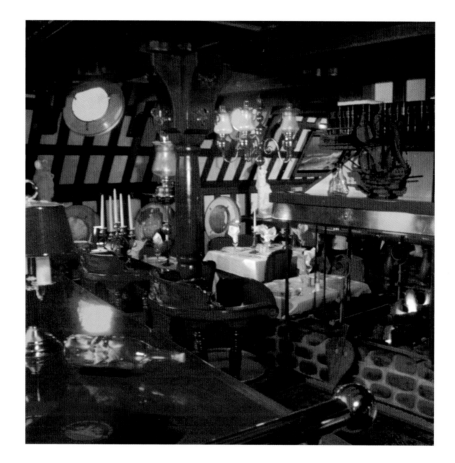

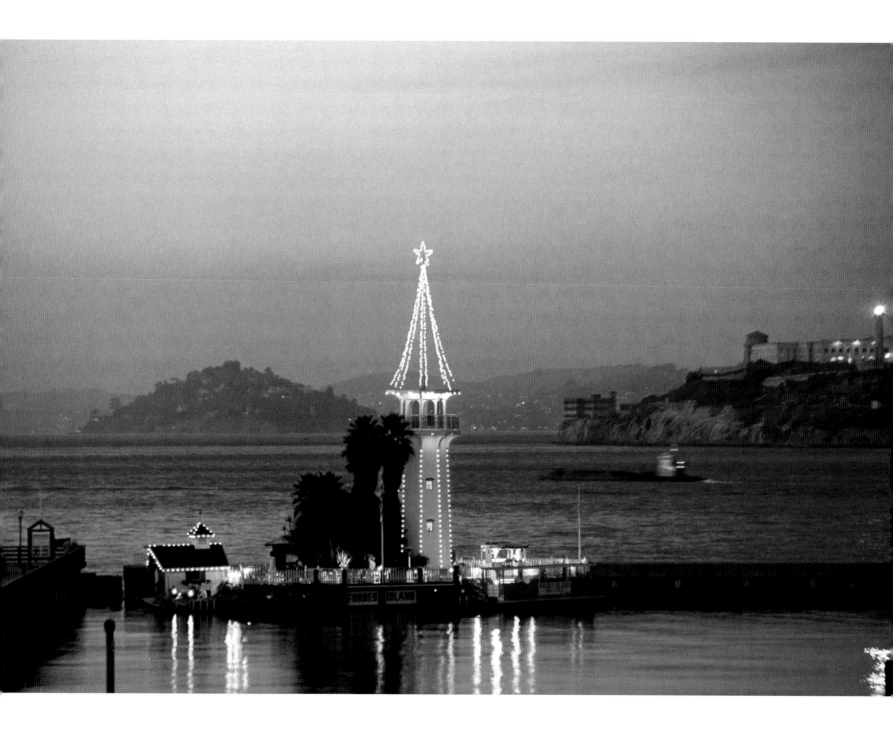

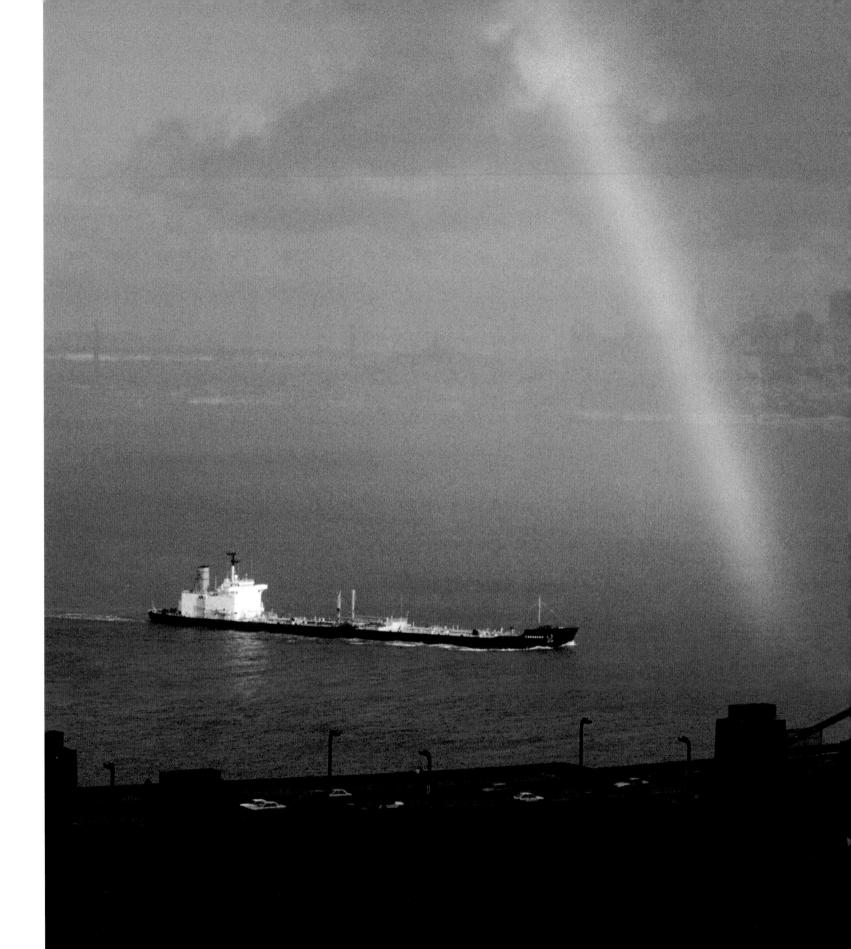

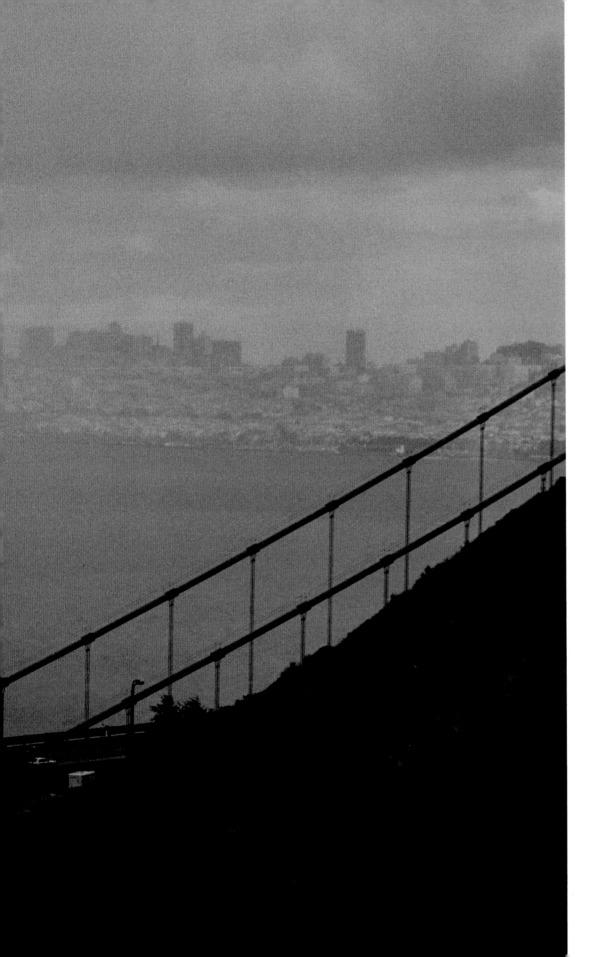

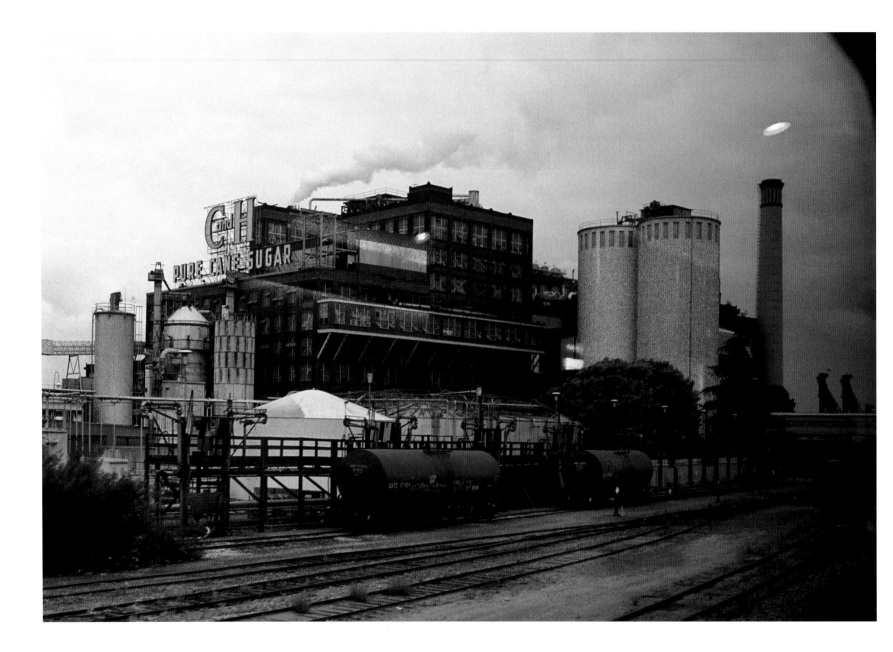

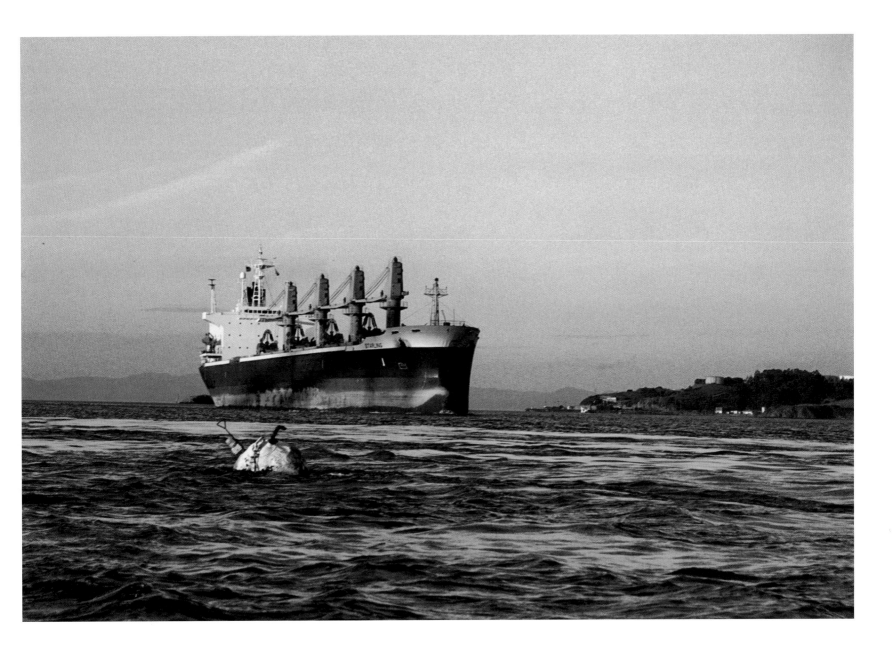

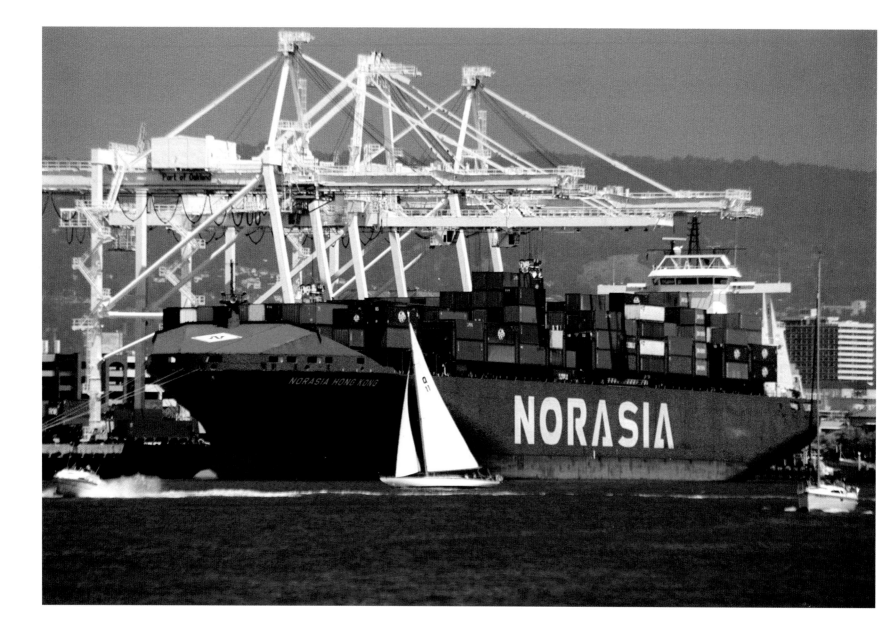

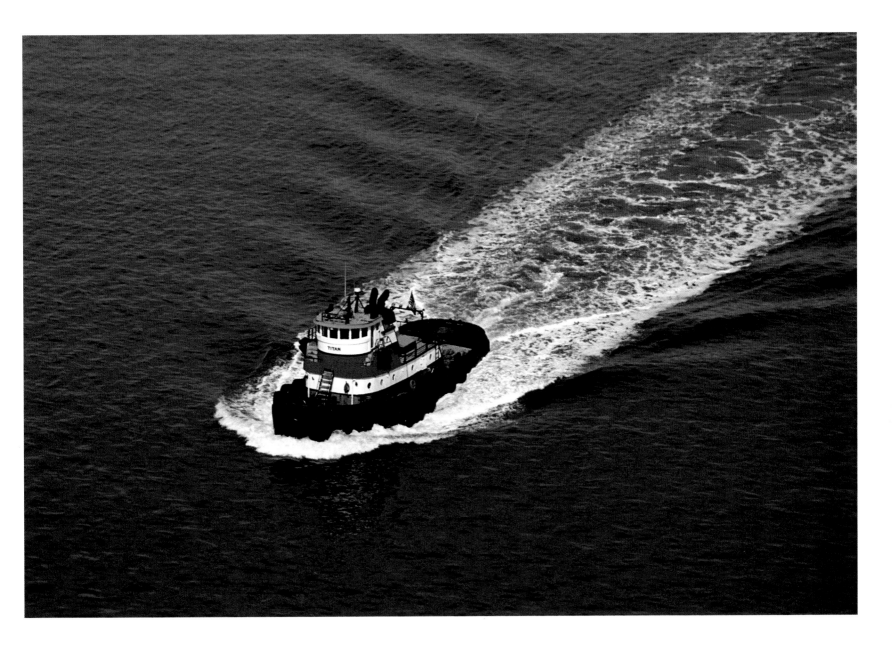

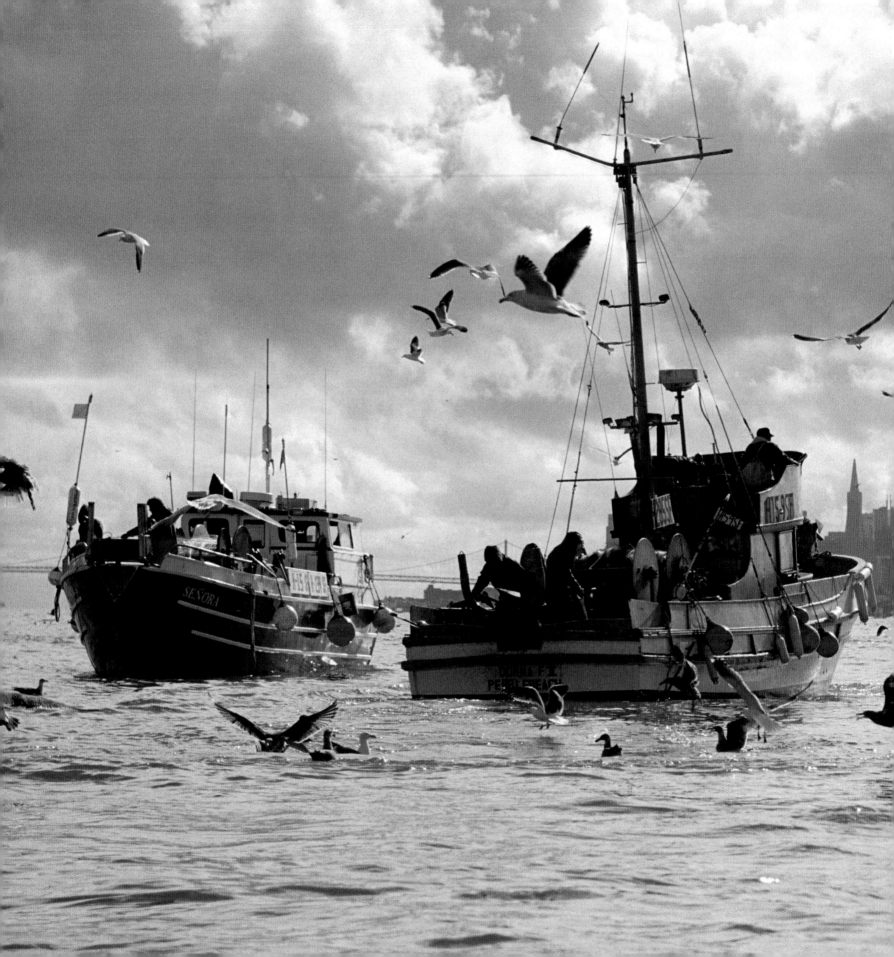

# HERRING

Herring come into the Bay from the ocean in November. With them come sea lions, harbor seals, and raucous gulls by the thousands. Even the bottom-dwelling sturgeons seem to come alive. It's as if the arrival of herring signals that it is time for all the other Bay critters to fatten up for winter. Dinner is served and everyone comes to gorge on the fatty herring.

Spawning takes place mostly at night. When winter rains lower the salinity of Bay waters, the herring lay their eggs. The females squirt streams of sticky eggs as they swim along shore, sometimes traveling several miles in a single pass. Each fish lays between 15,000 and 22,000 eggs. The eggs settle and stick on whatever is nearby. Rocks, pilings, seaweed, almost anything in the shallow upper layers of the Bay gets slathered with herring eggs. When the sun comes up and the tide goes out, the near deafening screams of feeding gulls and a telltale stale-fish aroma in the air leave little doubt of a herring spawn the night before.

At its peak, when the Japanese economy was at its strongest, San Francisco Bay herring fetched more than $3,500 per metric ton. The fishery was

so popular with commercial fishermen and women that permits had to be issued by lottery.

Catching herring is pretty simple. Small boats that look a bit like amphibious landing craft string fine-meshed nets out from shore. The herring can't see the nets. Most of the fish will swim safely through, but a percentage get tangled in the mesh. As the net is hauled aboard, the fish are shaken from the net and fall into the boat's hold.

The California Department of Fish and Game closely monitors herring populations and sets each year's quota to maintain herring numbers. In recent years the harvest has been around 3,000 tons. It is lower in El Niño years, when warmer currents move north in the winter and the herring's food source suffers. But there seems to be plenty for everyone. Harbor seal and sea lion populations in and around the Bay continue to climb. Fishermen talk of seeing legend-sized sturgeons snatching herring in the Raccoon Straits. And still the herring numbers remain stable. The California Department of Fish and Game's management of the San Francisco Bay herring harvest has received international recognition as a model for active fishery management.

Most of the harvest is shipped to Japan, where the roe is extracted and the fish are made into pet food. The Japanese market developed in the late sixties when Japanese herring populations declined. Herring roe is used in sushi, and a salted form of the roe is highly prized as part of the Japanese New Year celebration.

Herring roe on kelp *(kazunoko kombu)* is also a valued delicacy. To meet demand for herring eggs in this form, a new fishery has developed. Bull kelp, with leaves a foot long and five or six inches wide, is harvested off Southern California's Channel Islands, then rushed to the Bay, where it is hung from frames in the path of the spawning herring. The laid eggs are swished back and forth in the tide and currents. Several layers of eggs, enough to satisfy the demanding consumers, stick to the hanging kelp. The frames are then hauled up and the individual leaves harvested, then laid delicately into layers in boxes for immediate air shipment to Japan.

In a good year $9 million changes hands at Bay herring buyers, yet there is little fuss at the fisheries themselves. Most of the action takes place away from public view. The herring and the fishermen and women, understandably, arrive at the same time each year, do their business, then go back to wherever they came from and get ready for next year. And no one else seems to notice.

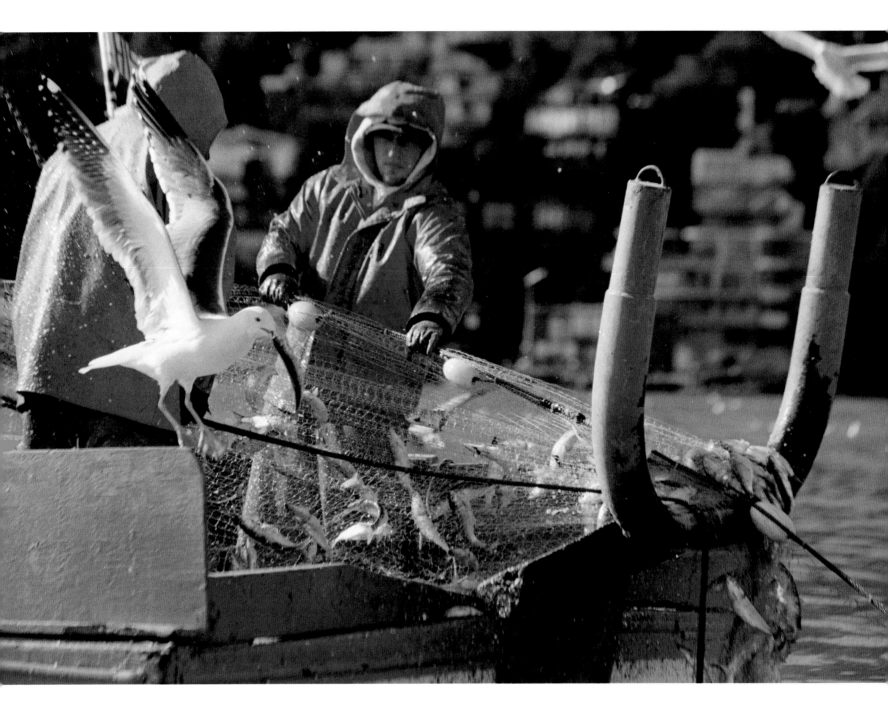

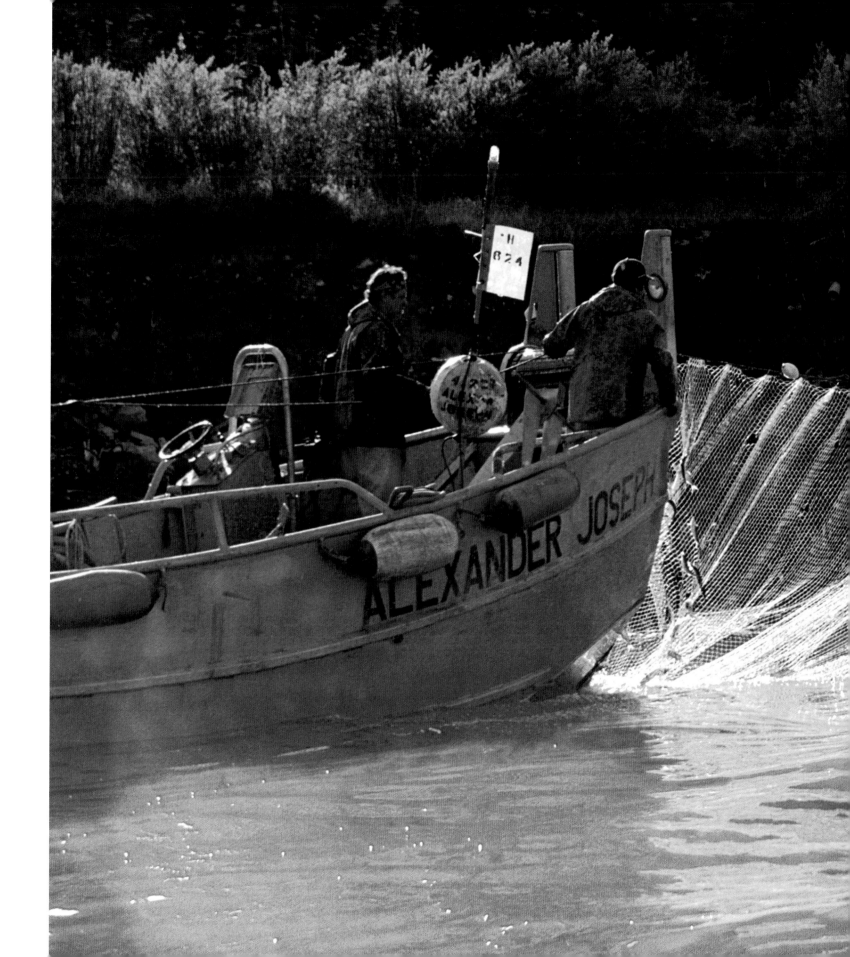

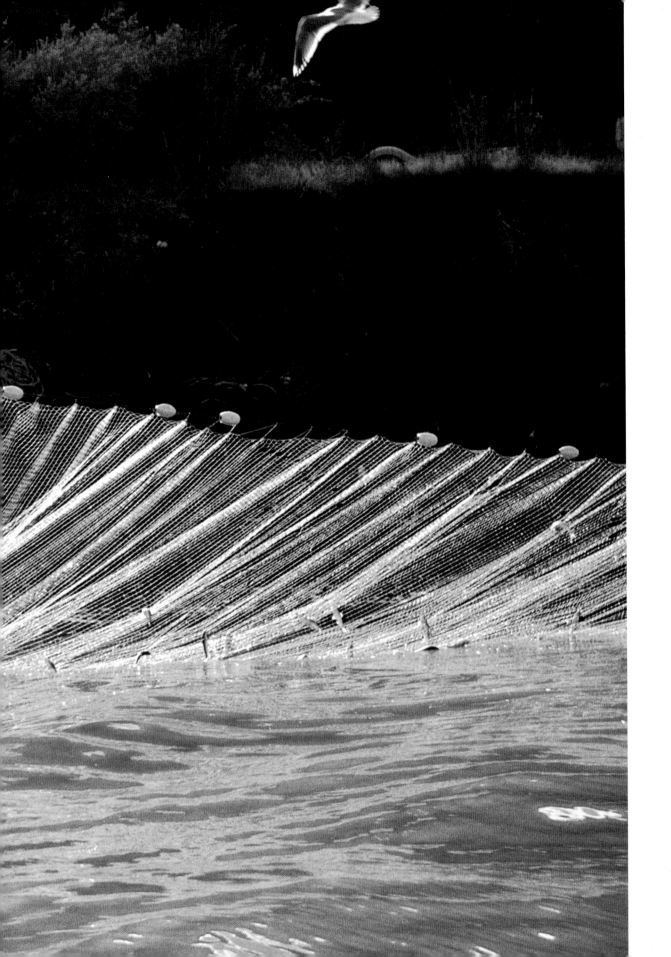

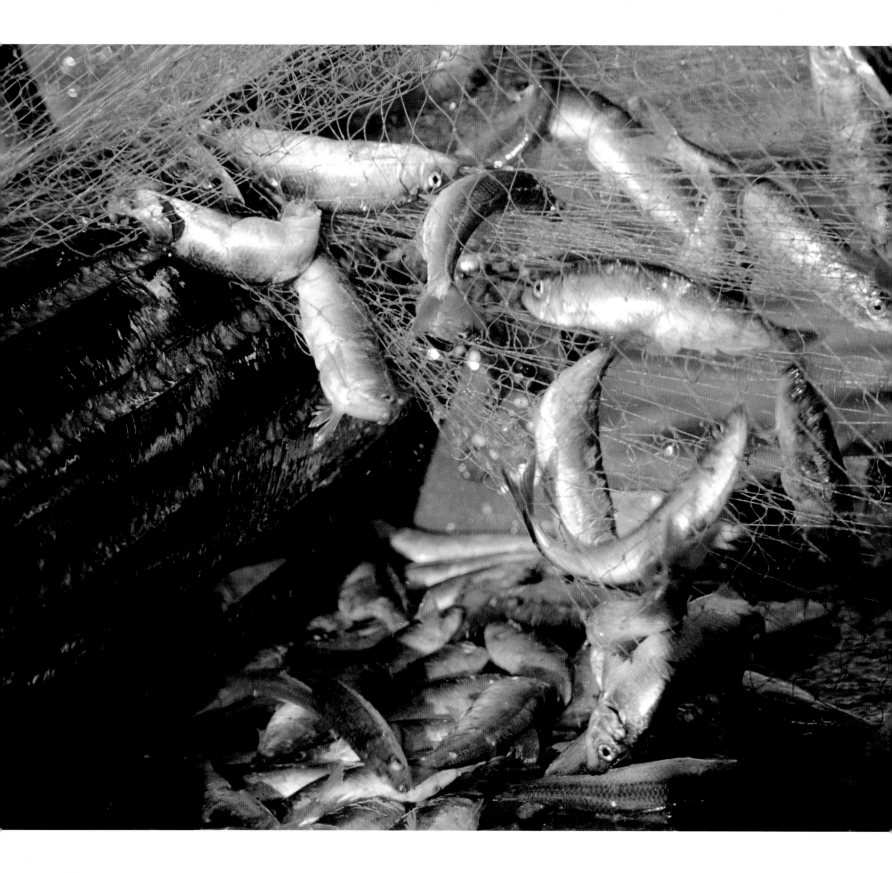

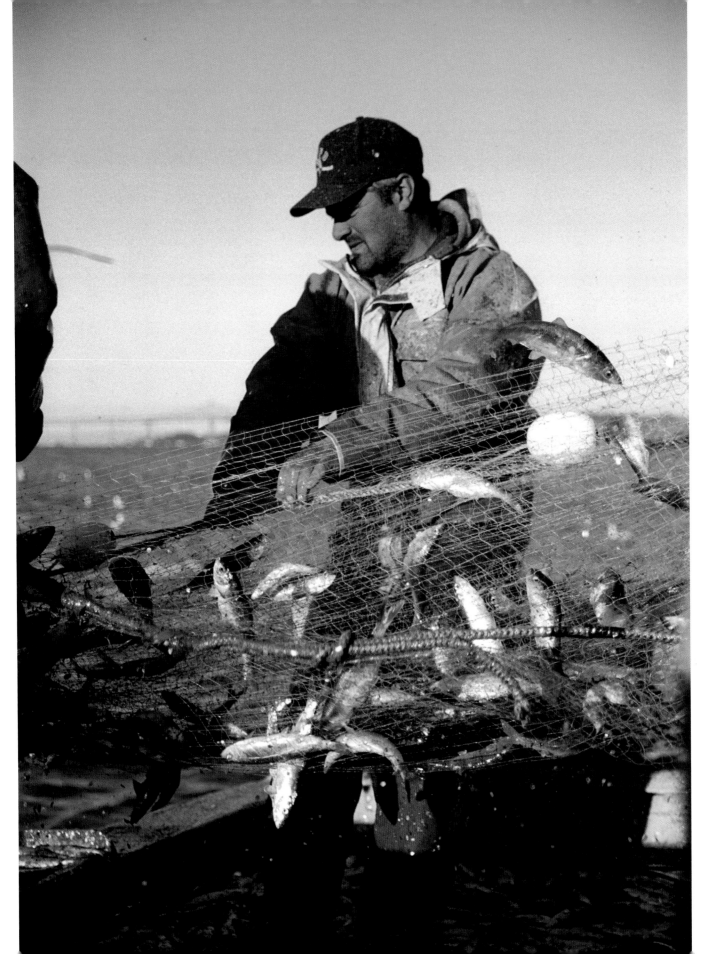

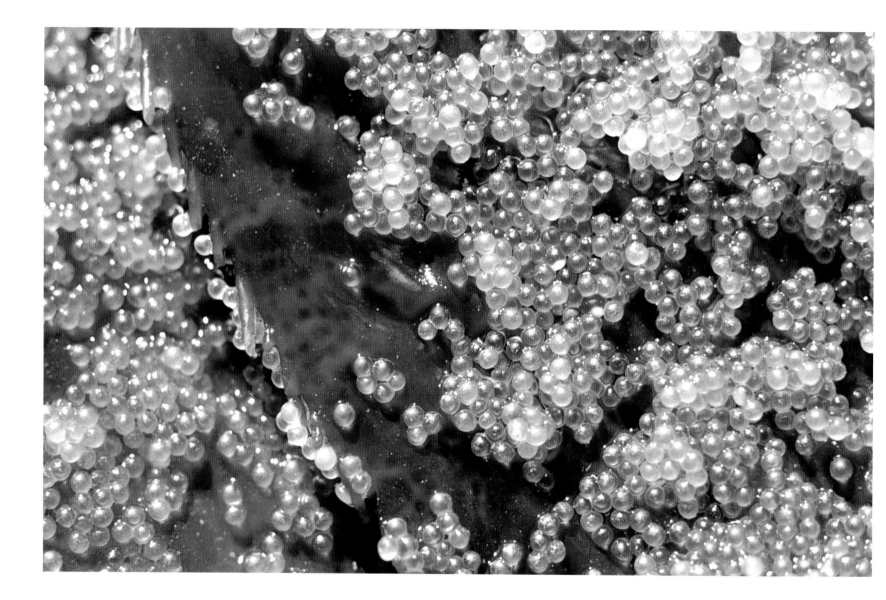

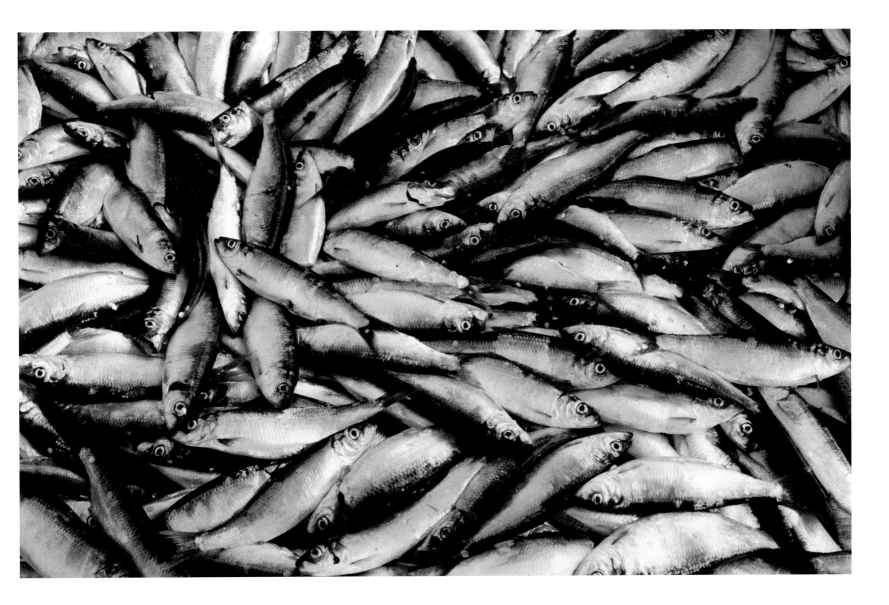

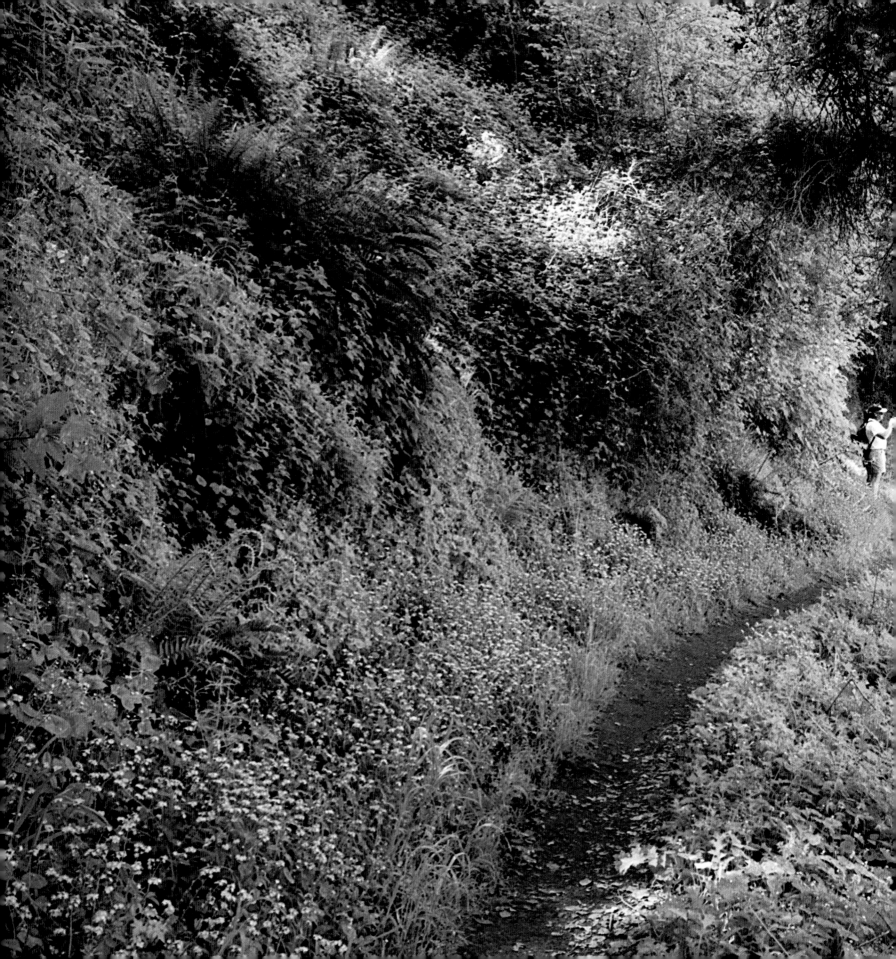

# A VIEW TOWARD THE FUTURE

Efforts to save San Francisco Bay were part of the growth of environmental values that flowered in the Bay Area in the sixties and seventies. San Francisco Bay today is cleaner, healthier, and freer-flowing that it has been in a century thanks to the dedicated persistence of countless volunteers picking up trash, studying the Bay, and pressuring city, state, and federal governments to create regulations to protect the gem that gives the Bay Area far more than its name. Now a new generation of Bay savers is stepping off from those successes with a plan to acquire bay lands and restore them to their native state.

Not long ago a tidal lagoon was sculpted from beach sand at what had been a small airfield in the Presidio. The project was a repatriation of sorts; Washerwoman's Lagoon, a freshwater marsh that once filled the area between Fort Mason and the Presidio, had been filled with the debris of the 1906 earthquake and fire. Under the direction of the Golden Gate National Recreation Area staff and a comprehensive master plan, volunteers planted over 100,000 native beach plants to stabilize the sand against the blustering westerlies. Isopods, amphipods,

147

and other invertebrates quickly colonized the shallow lagoon and right behind came shorebirds to feed on them. In the grassy uplands of this urban park, people picnic and fly kites in the shadow of the Golden Gate Bridge. The lagoon looks like it has always been there.

The California Academy of Sciences is sending teams of scientists and teachers to Bay Area piers and marinas to collect specimens from the Bay. The purpose is to create a baseline of what lives where as a way to measure any future changes in the Bay. The work they do will endure and so will their interest in the Bay's environmental health.

One of the biggest changes in Bay use since World War II is recreational: sailing, sport fishing, shoreline hiking, bicycling, and now wind surfing. Having a boat is no longer the exclusive privilege of the rich. Wind surfers zip across the Golden Gate on all but the calmest days. Sport fishers seem to ply every cove with dreams of Pacific halibut, salmon, and striped bass.

On any summer weekend there are more sails on the Bay than whitecaps. The Bay's ever changing wind and currents make sailing here a sailor's testing ground. They say if you can sail on San Francisco Bay in all seasons, you can sail anywhere.

Youngsters get the chance to test themselves against the Bay's elements in yacht club and park-sponsored junior sailing programs. The kind of boat varies but they all teach the same lesson—self-reliance. Alone on the water, it is the sailors and their boats. They learn by doing: by getting wet, righting the boat, and sailing on. Instructors and parents remain on shore. The experience is addictive. Many who feel their first puff of wind on sail in a junior program never get over the experience.

Some young sailors go on to racing big boats, one of the Bay's most active recreational uses. Some sail all their lives as an escape from the stresses of their careers. Others learn to build boats as shipwrights have for centuries. And there are always a few who discover the horizon and sail off forever.

The populations of recreators, professional and volunteer Bay savers, and the thousands who walk, ride, or skate along bayside paths and trails add up to a huge constituency that cares about and watches the Bay's health. Their numbers continue to grow. They vote and they write letters. Some even publish books or take photographs. With all these defenders, there is little doubt that San Francisco Bay will be here to nurture wildlife and inspire its human residents long after this new century's end.

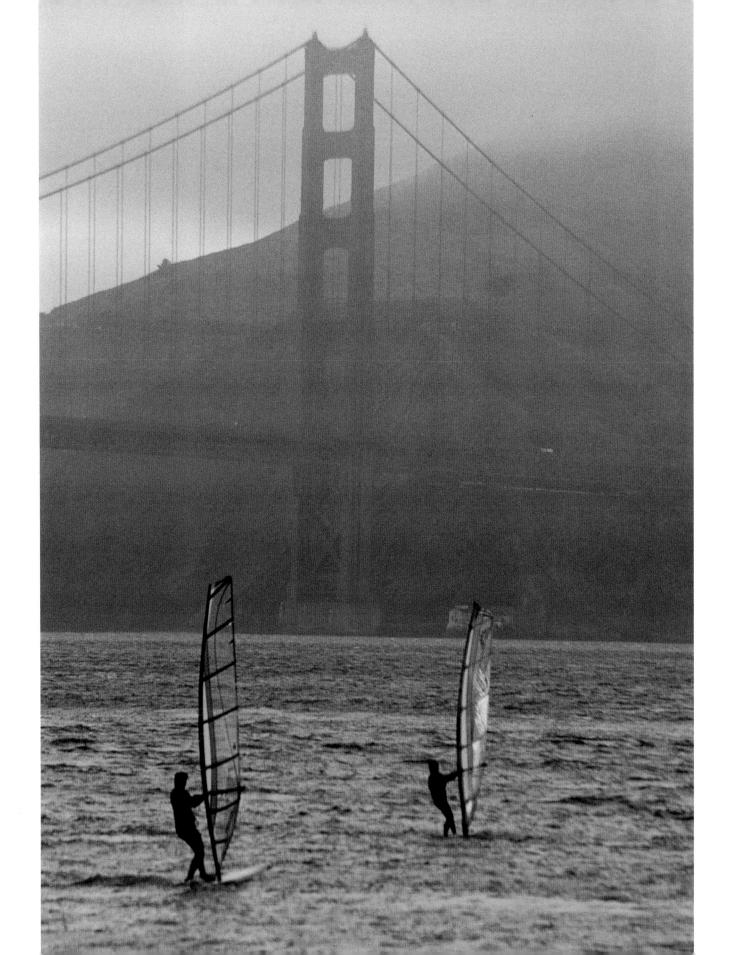

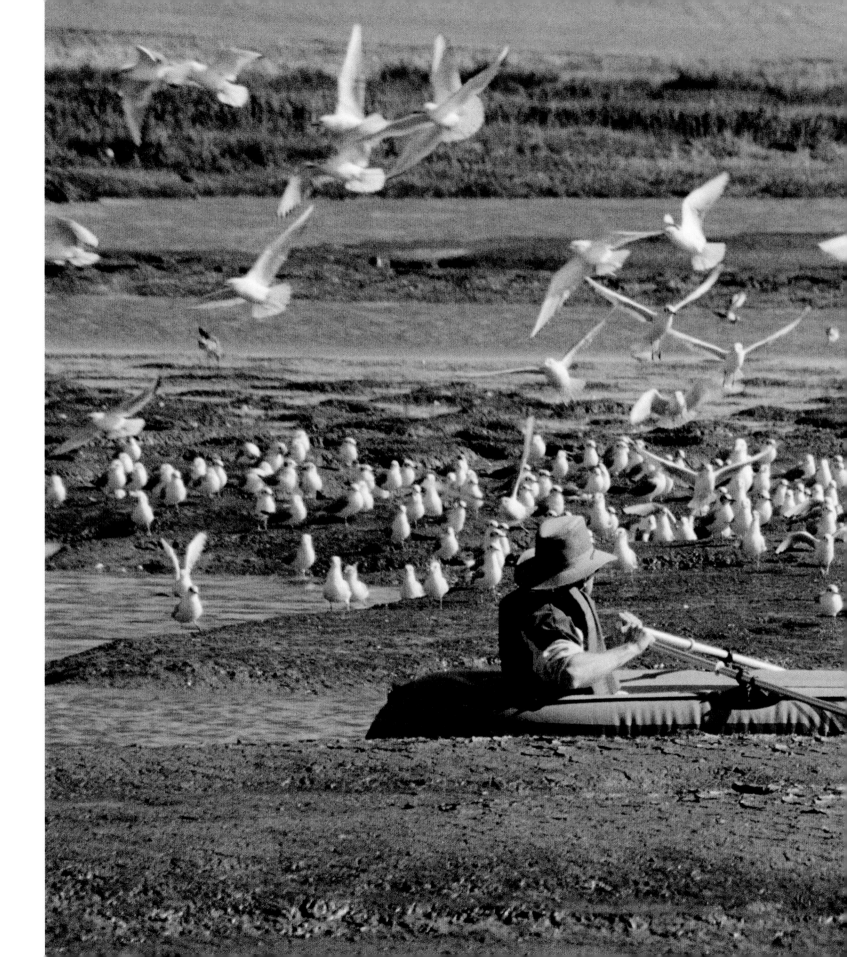

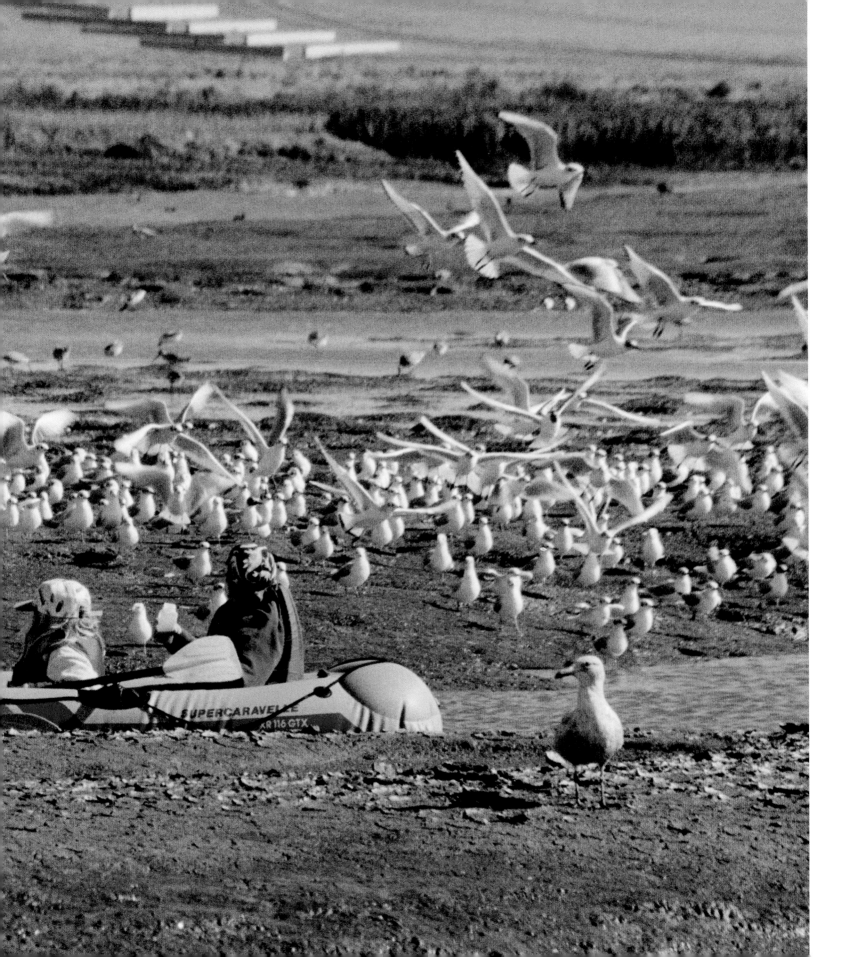

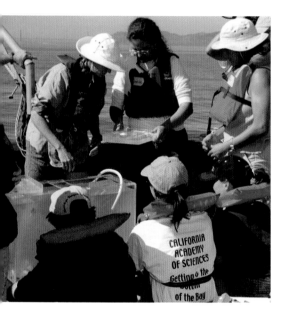

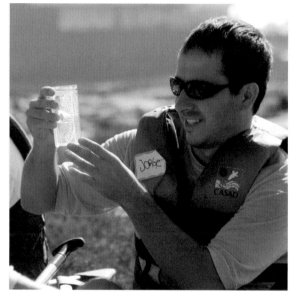

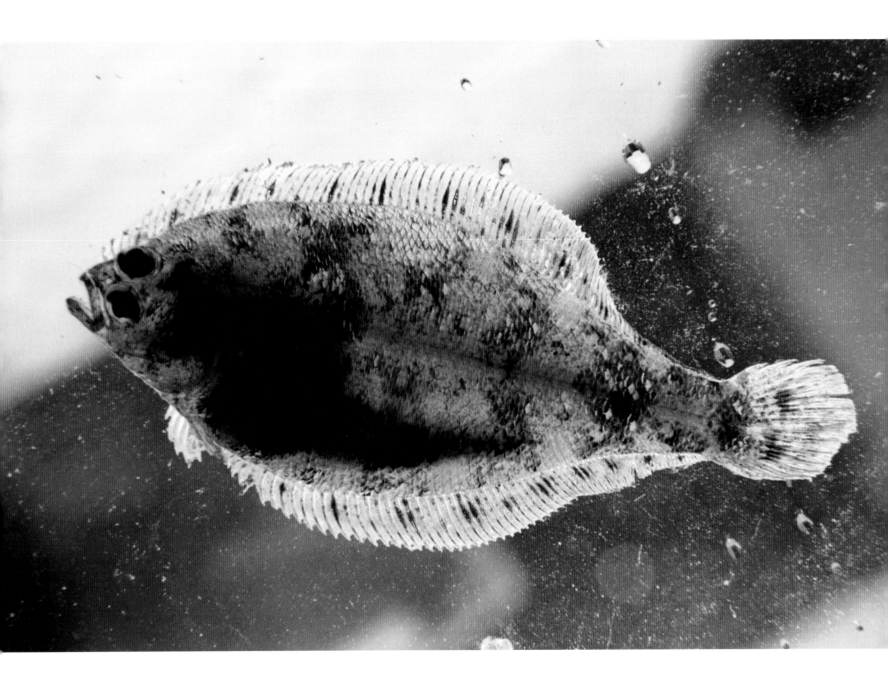

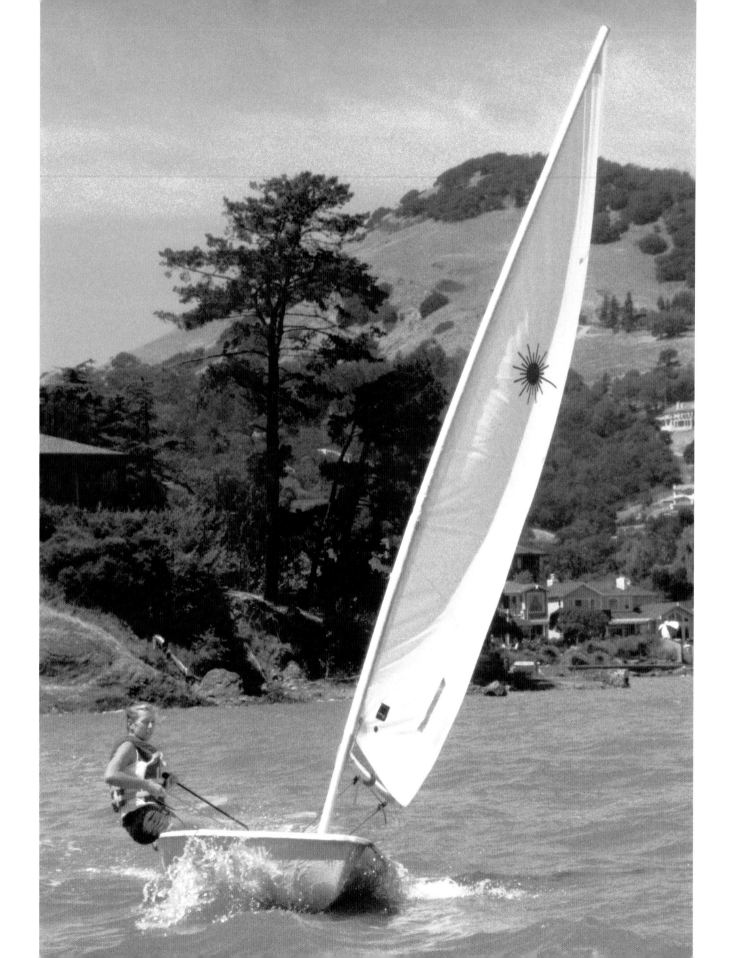

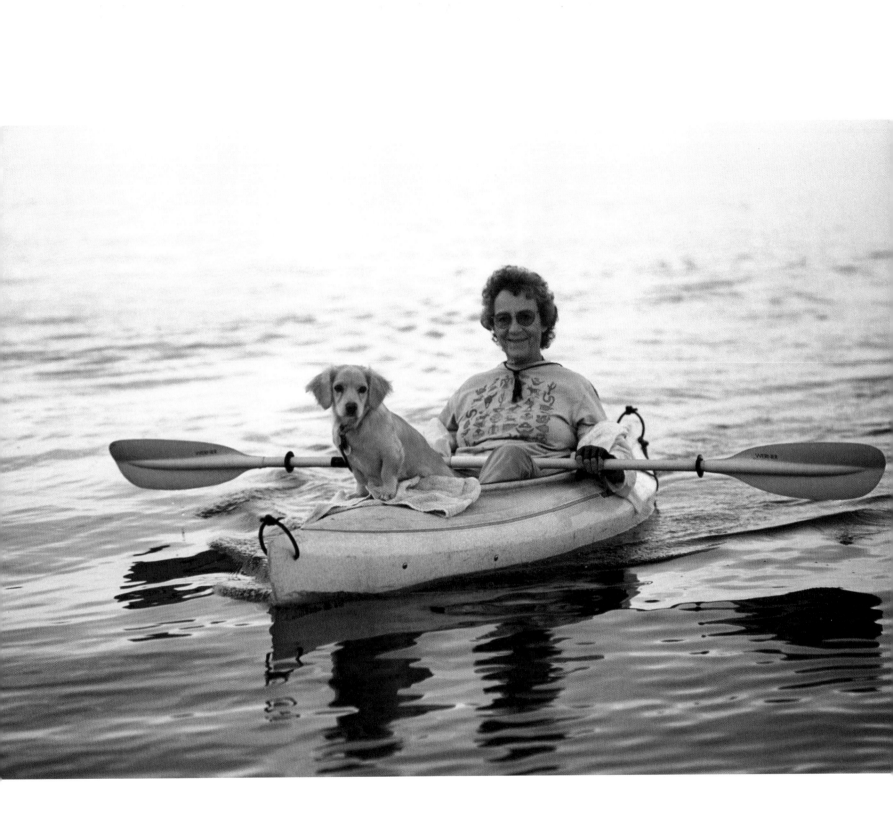

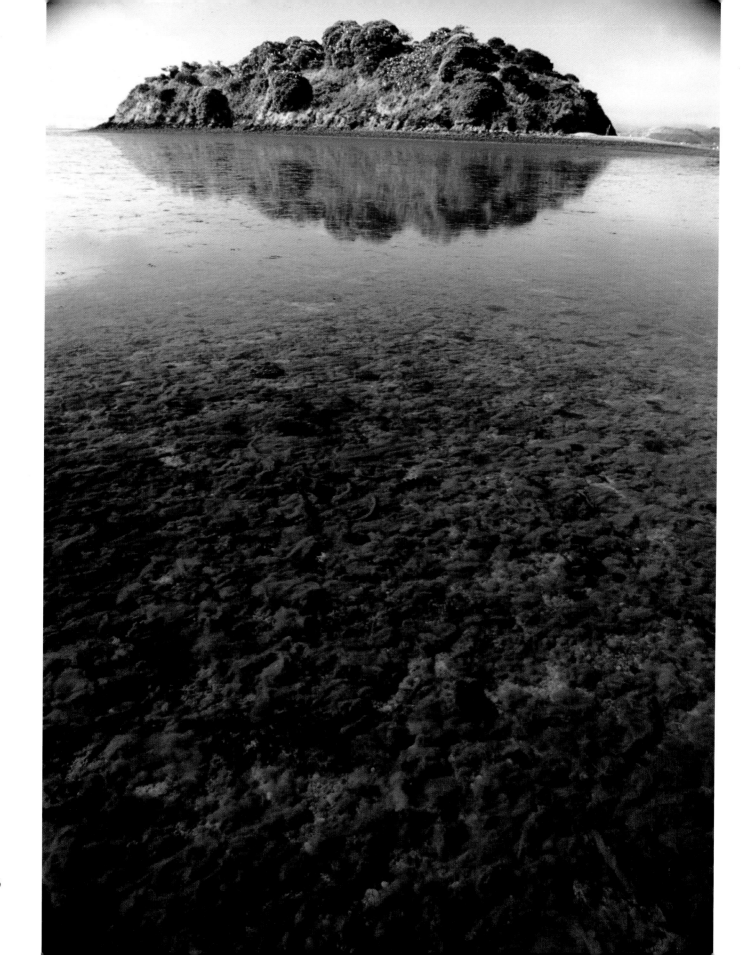

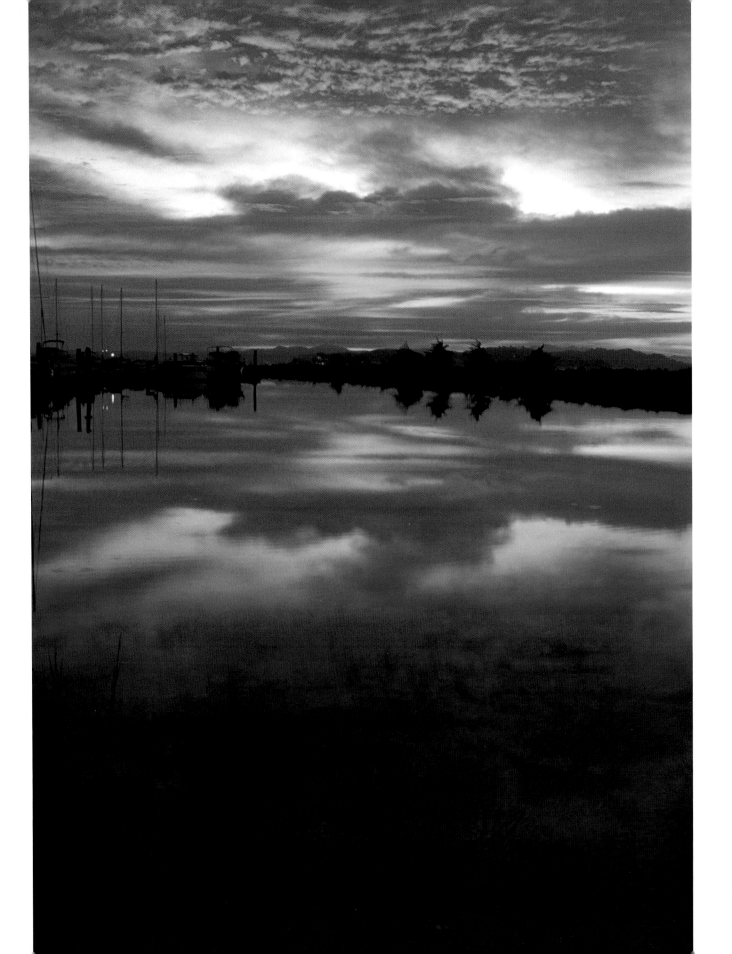

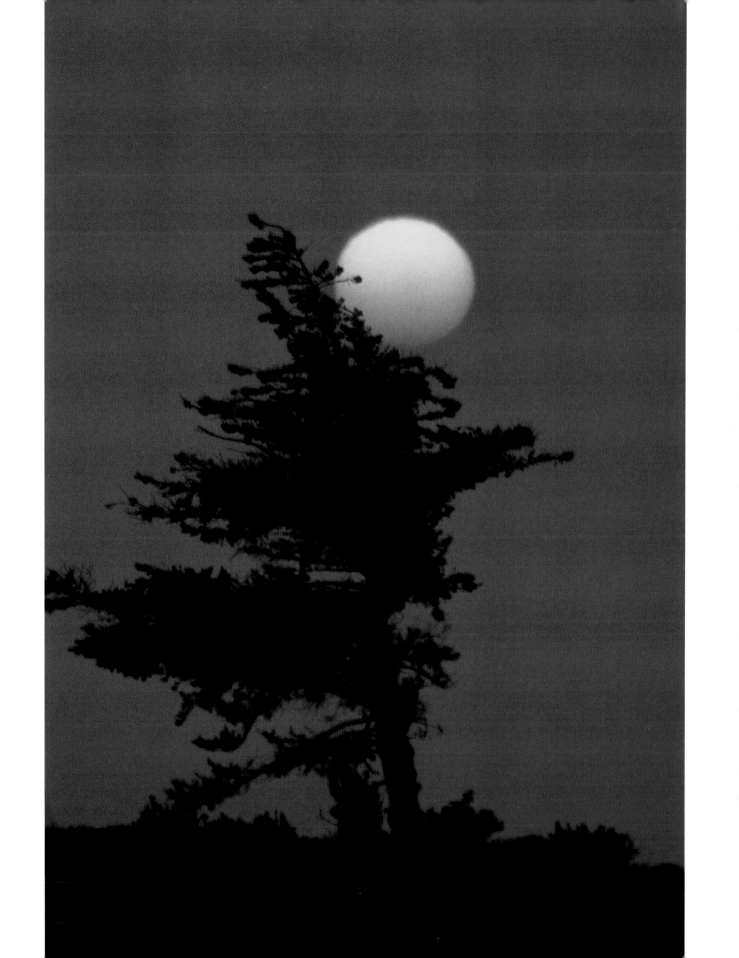

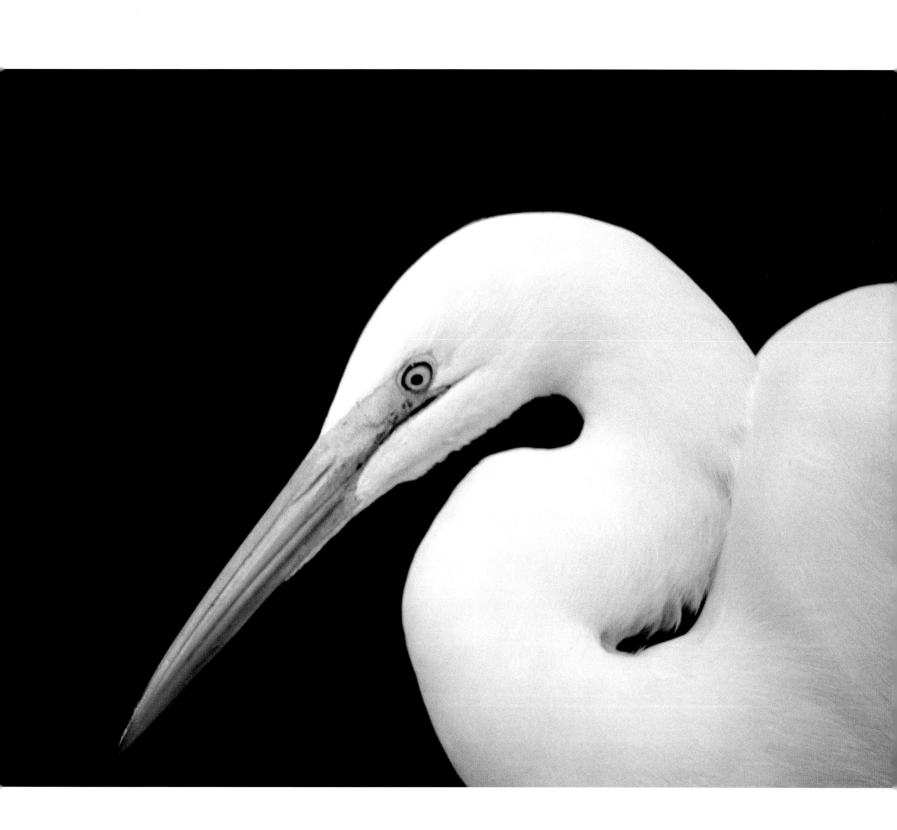

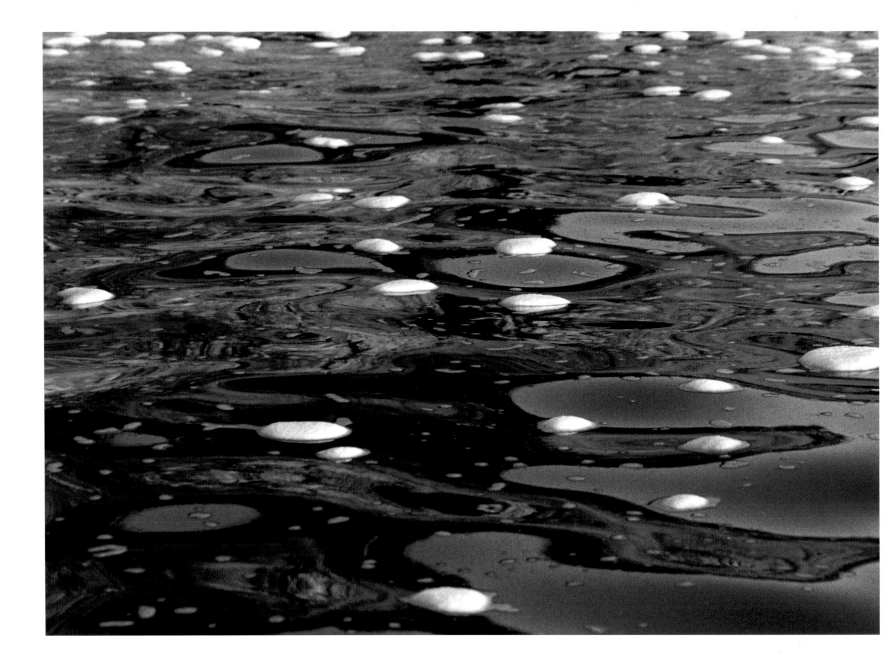

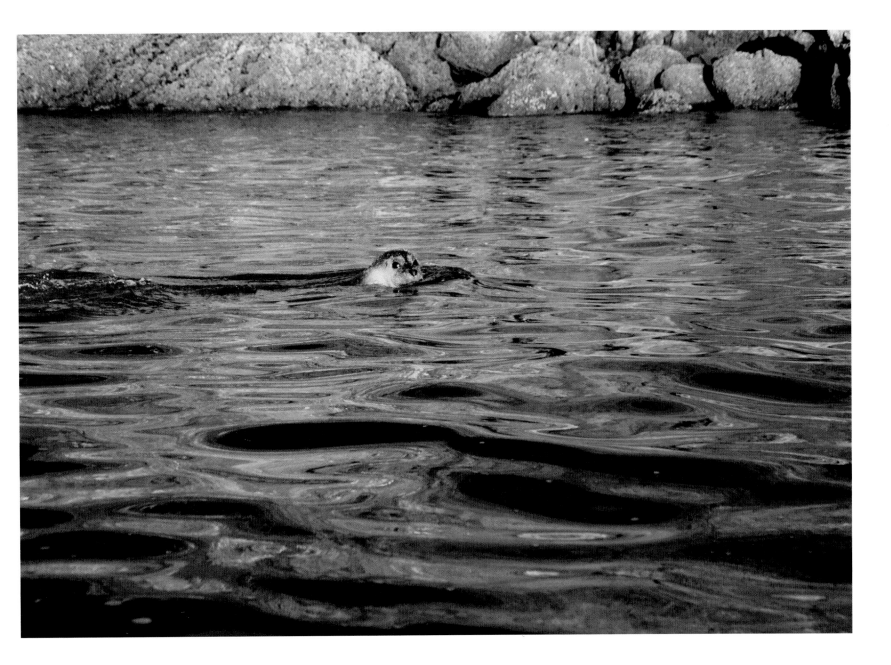

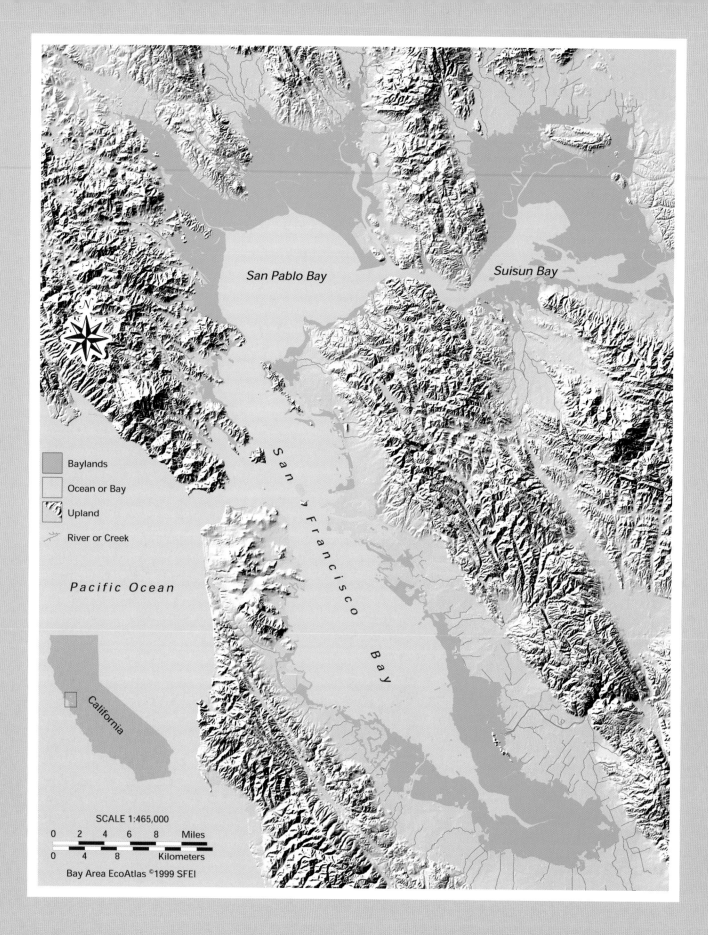

San Pablo Bay

Suisun Bay

San Francisco Bay

Pacific Ocean

Baylands

Ocean or Bay

Upland

River or Creek

California

SCALE 1:465,000

0  2  4  6  8  Miles

0  4  8  Kilometers

Bay Area EcoAtlas ©1999 SFEI

Raccoon Straits. Angel Island to right. From Golden Gate Bridge's north tower.

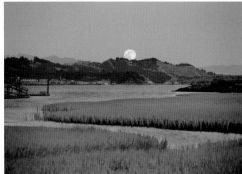

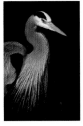

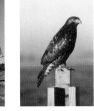

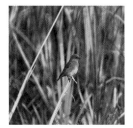

Moonrise over San Pablo Bay. Twice each year sunset and moonrise occur together, leaving enough light at dusk to create truly magical moments. Fortunately weather and planning worked together to let me record this one.

Great blue heron.

Rip tide near Marin Islands.

*Aldebran* in stiff breeze.

Rough-legged hawk.

North tower of Golden Gate Bridge and San Francisco.

Frank Quan's rowboat off China Camp State Park. Frank is the last of the China Camp shrimpers.

Reflections of sunset-lit cliffs on Angel Island.

Western bluebird at Galinas Pond.

CYCLES OF
WIND AND
WATER

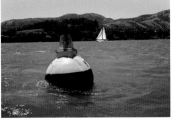

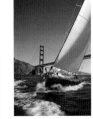

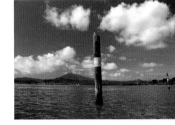

Outgoing tide at Yellow Bluff buoy.

*Alden* sloop heads out the Golden Gate.

Clouds show us that the movement of air is as complex as that of water.

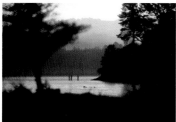
Crystal dawn.

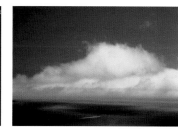
Fog covers Angel Island.

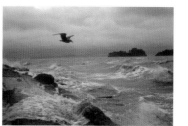
Seagull surveys storm-tossed debris.

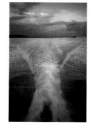
Twin-engine boat wake.

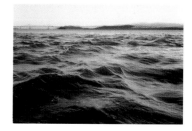
Choppy water of San Pablo Bay.

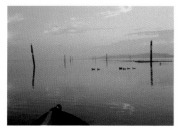
Ducks cross harbor entrance.

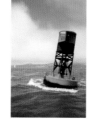
Reflections of *Roxanne.*

Alcatraz buoy.

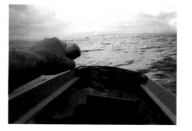
Having broken ties with land, the skipper of a small boat is interested in wind and current.

Porthole view of Mount Tamalpais.

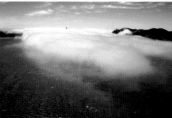
Fog streams in through the Golden Gate.

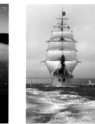
*Europa.*

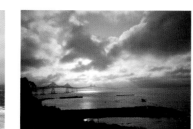
Twice each day, mudflats are bathed, then exposed by changing tides.

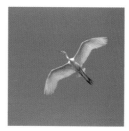
Great egret.

WETLANDS

North Bay marsh. Salt marshes have unique drainage channels that resemble the branching of human arteries. Twice each day the tide advances up these channels, carrying a rich soup of plankton and other marine life. The soup feeds young Dungeness crab, striped bass, and other Bay animals that use the marsh as a nursery ground.

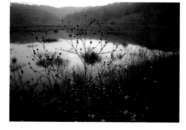
Bahia winter ponds.

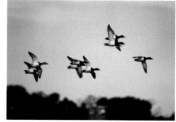
Winter migrant canvasback ducks.

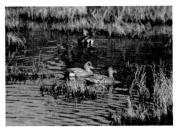
American widgeons.

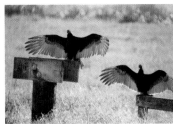
Turkey vultures use wings as solar collectors.

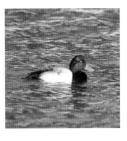
Greater scaup.

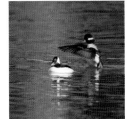
Bufflehead.

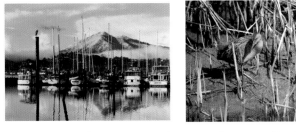
Northern shoveler.

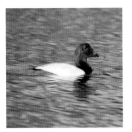
Canvasback.

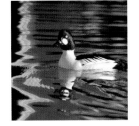
Pintail.

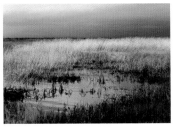
Common goldeneye.

Loch Lomond Marina, with a rare dusting of winter snow on Mount Tamalpais in background. The snow disappeared with the first rays of sunlight. The marina gives easy access to the Bay for both boaters and birders. Ninety-five species of birds are seen there regularly, including the endangered California clapper rail. Usually only heard elsewhere on the Bay, the secretive rails can often be seen at sunrise sauntering through the watery edges of the marshes that line the marina.

GRIZZLY ISLAND

Grizzly Island marsh.

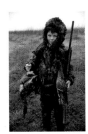
Danny Kizirian returns from predawn Youth Hunt.

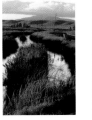
Magic hour on Grizzly Island.

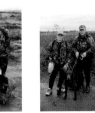
The Youth Hunt is a family event.

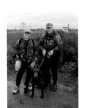
Well-trained dogs fetch shot ducks.

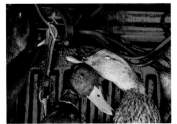
"There is a living and a dying during a day in the field." Conrad Jones, Department of Fish and Game, 2001.

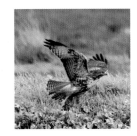
Rough-legged hawk, a Grizzly Island predator.

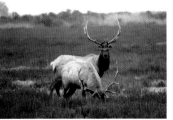

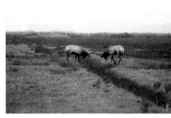

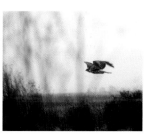

Repatriated tule elk on Grizzly Island. California Department of Fish and Game has raised endangered elk herds and reintroduced them to "safe" habitat that was formerly part of their range. The elk are still rare.

Winter Games, elk style.

River otters, unaware of their endangered status, congregate in a Grizzly Island slough.

Grizzly Island's cattails and winter grain. Duck food.

Hawk ghosting Grizzly Island.

UNDERWATER WORLD

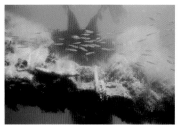

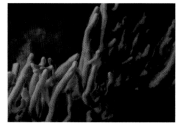

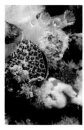

Juvenile smelt.

Red-beard sponge.

A barnacle-covered mussel.

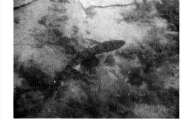

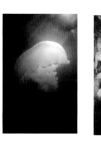

Mussel covered with orange colonial tunicate.

Bat ray "flies" through Richmond inner harbor.

Tiny, iridescent smelt, as if from a Japanese garden.

Leopard shark, common in the Bay.

Jellyfish near commercial fish dock in Sausalito.

Translucent sea squirt and band of colonial tunicates.

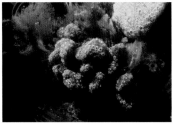

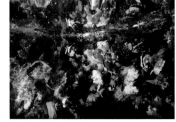

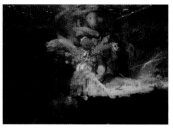

Colonial tunicate.

From below, the water's surface can become a mirror.

Keel of a long-dormant boat. Submerged objects quickly become favored habitat for marine life. Barnacles begin growing on whales within days of a baby whale's birth. Unless it is toxic to marine life, anything left under Bay waters sprouts algae, sponges, sea squirts, and all manner of other marine plants and animals.

Bryozoa and sea squirt.

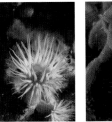

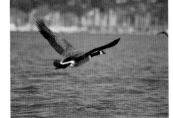

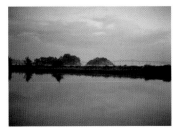

Sea anemone.   Feather duster worm.

Mule deer.

Mountain lion. Abandoned kitten raised at Marine World.

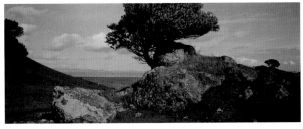

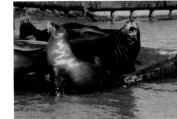

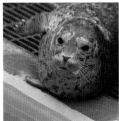

Bay tree overlooking San Pablo Bay.

Canada goose.

Late spring wildflowers on a coastal ridge. Bay is behind us. Fog-shrouded Bolinas Lagoon.

Marin Islands with Richmond–San Rafael Bridge in background.

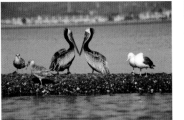

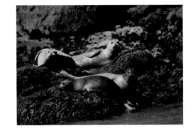

Western gulls and brown pelicans.

Sea lions on mid-channel buoy with full moon rising.

Sea lions at Pier 39. Male roaring.

Shy harbor seals on rocks by East Brother lighthouse.

Harbor seal pup recuperating at Marine Mammal Center.

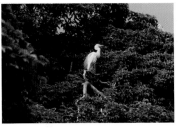

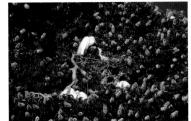

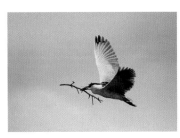

These two images were taken one month apart. Until the young hatch and begin feeding, the snowy egret nests are not obvious. For thousands of years the westernmost of the Marin Islands has supported breeding colonies of great blue herons, great egrets, black-crowned night herons, and snowy egrets. Long privately held, the Marin Islands and the breeding colonies are now managed by the U.S. Fish and Wildlife Service.

Seawall on eastern Marin Island. Breeding colony in background.

Black-crowned night heron.

167

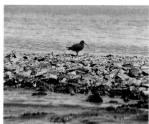

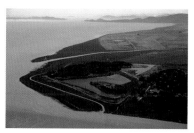

California buckeye growing on edge of Marin Island overhangs Bay.

Spring cloud.

Black oyster catcher.

Killdeer nest at Day Island.

Day Island.

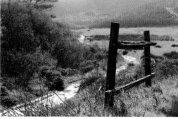

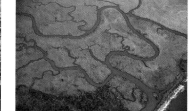

Tennessee Valley trail connects Bay with coast.

Seed heads on late spring grasses.

North Bay marsh in spring.

California poppy.

Rock rose.

Forget-me-not.

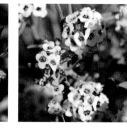

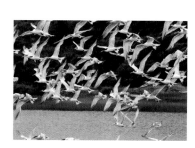

Morning glory and rattlesnake grass.

Douglas' iris.

Sweet elysium.

Goldfields.

Forster's terns.

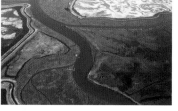

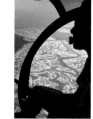

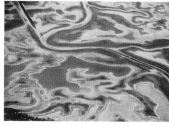

Salt ponds in North Bay.

White salt, red brine shrimp.

Nature paints with microbes and brine shrimp.

Brine ponds and feeder channels.

Salt crystals on mud.

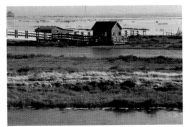
Don Edwards National Wildlife Refuge beside Cargill company salt ponds.

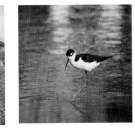
Rainbow Slough.

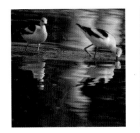
Black-necked stilt.

Avocet feeding.

Sandpiper.

Avocets sleeping.

Marbled godwits with avocets and black-necked stilts.

Healthy cord grass grows along bank of slough.

Old San Rafael/Richmond ferry pier (now San Rafael Rod and Gun Club).

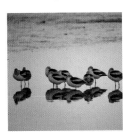
China Camp State Park. This old shrimp-fishing camp hosts picnickers, distance swimmers, and the remnant of a once thriving fishery operated for nearly a century and a half by Chinese. The shrimp netted in the shallow waters off the camp are grass shrimp used primarily for bait. The edible Bay shrimp sold in the park's tiny café now come from Monterey.

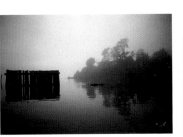
A light glows through the fog.

Artist Julie Nunes.

Sausalito houseboats in 1972. Few Bay issues have been more controversial than controlling "live-aboards." Today's live-aboard population, though larger than most realize, is much smaller than it was pre-World War II, when many of the Bay's deeper sloughs and channels supported ark cononies.

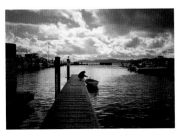
Some reflections are internal. Boat-builder Jack Dunbar contemplates his work. We had just launched his fourteen-foot *No Finer* dory. Nothing turns heads in a marina more than a well-found boat.

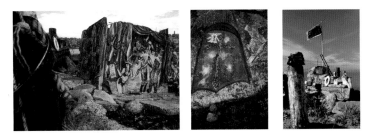
Albany Dump. The unsupressable artist gives us all hope and courage as well as a good laugh.

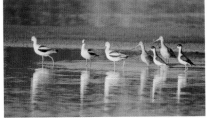

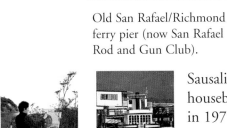

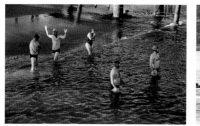

Brave swimmers at Aquatic Park.

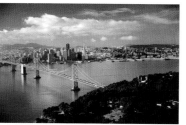

Teatime on the British Isles.

San Francisco and Bay Bridge beyond Yerba Buena Island.

Triangles.

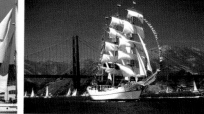

Equador's maritime training ship *Guayos* in the 1999 Tall Ships Festival.

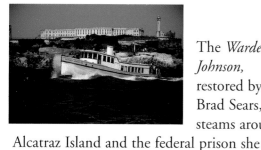

The *Warden Johnson,* restored by Brad Sears, steams around Alcatraz Island and the federal prison she once served.

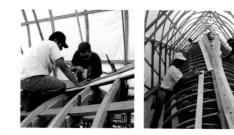

An international crew of shipwrights under Jeff Rutherford rebuild the 1911 classic racing sailboat *Joyant* in Richmond.

*Joyant's* second sail after her rebirth.

Wayne Gross, everyone's notion of an "old salt."

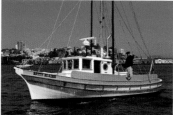

A classic Monterey fishing boat off North Beach.

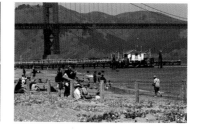

Crissy Field, Golden Gate National Recreation Area, on opening day.

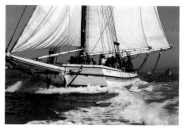

Hay barge *Alma* with volunteers from National Maritime Historical Park.

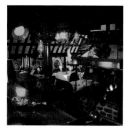

Forbes Island interior.

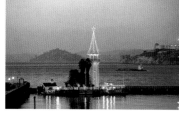

Forbes Island, San Francisco's most unique waterfront restaurant.

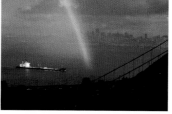

Tanker stands out to sea. From north tower of Golden Gate Bridge.

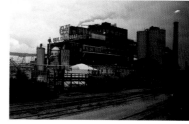

C&H Sugar plant was built at the mouth of the Carquinez Straits on the Sacramento River because of abundant freshwater needed to process sugar. Subsequent diversion of water to southern California allowed saltwater to fill the river channel past Antioch. The plant is now supplied with freshwater via a huge pipe from the delta.

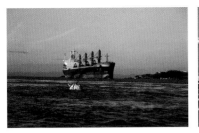

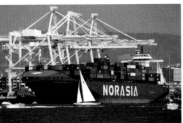

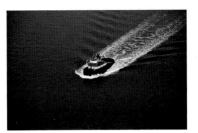

Multi-cargo ship steams down Richmond's inner channel.

Oakland's Seventh Street Terminal.

*Titan,* modern harbor tug.

HERRING

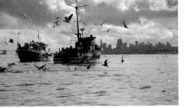

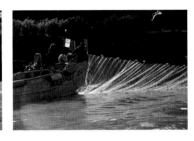

Herring gill netters.

Western gull shares in herring harvest.

Gill net at low tide.

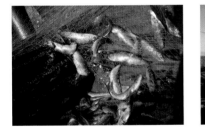

Fisherman John Tarantino shakes herring from a net as it rolls onto a drum.

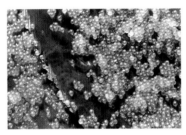

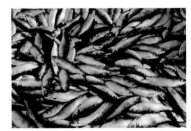

Net comes aboard.

Herring roe harvested on bull kelp.

Herring await icing.

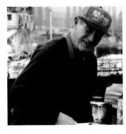

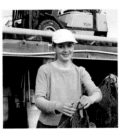

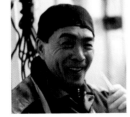

Fishermen and fisherwomen from the Sausalito dock, 2001–2002 season.

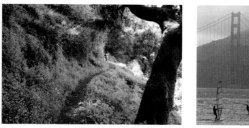

Angel Island spring
wildflower walk.

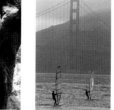

Windsurfers.

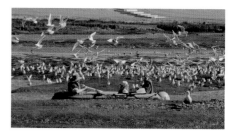

Family explores mudflats near
Palo Alto at low tide.

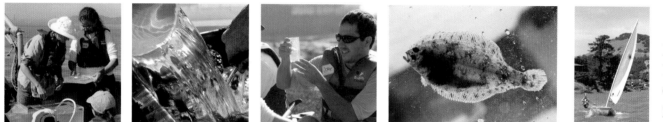

California Academy of Sciences personnel, together with Bay Area teachers, gather
specimens to establish a baseline of what exists in the Bay at this moment.

Meghan
Hartnett, sail
camp partici-
pant, now
majoring in
environmental studies.

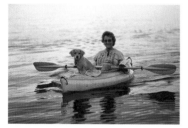

Inexpensive,
light kyaks
have given
many people
access to the
Bay. These old friends explored near China
Camp.

Shallow waters
at low tide
show the Bay's
bottom.

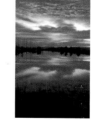

Sunrise over
Loch Lomond
Marina. Being
present for a
special sunrise
lights a flame that connects us
to the universe.

Sunset over
lone juniper
on seawall.

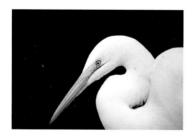

Great egret.

Sea foam and reflections at
sunset.

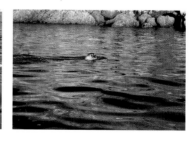

A young harbor seal and
the photographer swim in
a sea of gold. For both, San
Francisco Bay is a treasure.
Man, who has been the
Bay's most active despoiler, must now awaken and work
on restoration. We must change from takers to caretakers.
That assures us a place in the future.

Cameras: Nikons F and FE2; Canon EOS 1; Nikonos III and IV; Olympus XA; and plastic disposable cameras.

Films: 35mm color negative, Fuji Reala, Superia X-TRA, and a few miscellaneous slide films.

After processing the negative film, I had prints made, either 4x6 machine prints or, when there was burning or dodging to be done, 8x10 custom type "C"s. These prints became the raw material for making Canon laser prints, my final result. I used the Canon 800 and 1000 series of color copiers and fell in love with the way they could saturate the colors and with the way they "saw" blues. The machines have a wide range of controls that are not often used in fast commercial output, but are ideal for making art prints. The machines are sensitive and need constant maintenance, but when working as they are designed to, they are capable of making beautiful, rich, and stable prints. To get the desired "saturated-colors look" into the book, we made high-res, 35–50 MB scans of over three hundred final negatives and adjusted the files in Adobe Photoshop until the picture took shape to my liking. The scans then went to Hong Kong, where further pre-press work assured an ink-on-paper output that matched the color palette and saturation of the Canon prints.

# RESOURCE GUIDE

During the last four years of exploring the Bay, I've run into a number of organizations that I think are pretty cool. If you want to find out how to get on a boat and get out on the water, or if you want more scientific detail about something that's caught your imagination, you might find it by contacting one of these groups. This is a personal resource guide; it's not trying to be comprehensive or complete, it's just a bunch of good folks that I learned from, who can teach you more about the Bay.

**Angel Island Association** (415) 435-3522, www.angelisland.org. Find out about doecent-led tours and Sylvia's wildflower walks in spring.

**Angel Island–Tiburon Ferry** (415) 435-2131, www.angelislandferry.com. Independently owned ferry worth driving to Tiburon just to catch a ride.

**Aquarium of the Bay** 1-888-SEA-DIVE, www.aquariumofthebay.com. Local and exotic underwater life up close. Located at Pier 39.

**Audubon Society–SF Bay Restoration Program** (415) 947-0331, www.audubon-ca.org. Audubon's special Bay program of science, public policy, and conservaton education. Audubon has eight area chapters as well.

**Bay Area Open Space Council** (510) 654-6591, www.openspacecouncil.org.

**Bay Area Discovery Museum** (415) 487-4398, www.baykidsmuseum.org. Hands on for kids of all ages. It's at Fort Baker, right by the north tower of the Golden Gate Bridge.

**Bay Crossings Magazine** (510) 351-3113, www.baycrossings.com. A newspaper-format magazine of Bay living, free at ferry terminals.

**Bay Model Visitor Center** (415) 332-3871, www.baymodel.org, www.spn.usace.army.mil/bmvc/. Fabulous working model of the Bay covers two acres. Exhibit space, Bay history, school tours, and self-guided tours in several languages. I found a really good, regularly updated bulletin board of Bay news clippings.

**The Bay Institute of San Francisco** (415) 506-0150, www.bay.org. Great group of people in Hamilton Fields, Novato.

**Bay Nature Magazine** (510) 528-8550, www.baynature.com. They have their own people finding hidden treasures and printing results in their quarterly magazine. This is how I found the elk.

**The Blue and Gold Fleet** (415) 705-5555, www.blueandgoldfleet.com. The easiest way to get access to the bay is to either walk down to the water's edge, or jump on a ferry boat. You can get some wind or some salt spray either way.

**California Academy of Sciences** (415) 750-7449, www.calacademy.org. The academy recently launched the Bay: 2K project to study Bay invertebrates. Call Roberta Ayres at (415) 750-7449 for more information. Visiting the natural history museum is a must. I love the academy's mission statement: "To explore and explain the natural world."

**Cal Adventures** (510) 642-4000, www.oski.org. Berkeley Marina, sailing, windsurfing, sea kayaking.

**California Canoe and Kayak** (510) 893-7833, www.calkayak.com. In Oakland by Jack London Square.

**California Wild Magazine** (415) 750-7117, www.calacademy.org. The excitement of the natural world and man's place in it. Quarterly publication of the California Academy of Science.

**Crissy Field, Presidio of SF Visitor Center** (415) 561-4323, Education Center (415) 561-7753, www.crissyfield.org, (415) 427-4779. Golden Gate National Parks Conservancy (415) 561-3000, www.nps.gov/prsf.

**Department of Fish and Game, "Herring"** (650) 631-2530, www.dfg.ca.gov.

**Don Edwards National Wildlife Refuge** (510) 792-0222, http://desfbay.fws.gov. At the east end of the San Mateo Bridge, right next to Cargill's salt ponds.

**Ducks Unlimited** 1-800-45DUCKS, www.ducks.org. Oldest nationwide organization that buys and preserves habitat.

**East Bay Regional Parks** (510) 562-PARK, www.ebparks.org. Your group can get a permit to visit little-known Brooks Island in Richmond, a breeding area for terns and gulls.

**EPA Environmental Protection Agency** (415) 947-8000, www.epa.gov/region9/lib-hot.html. At work studying and monitoring the health of the Bay.

**Estuary Magazine** (510) 622-2412, subscriptions: (510) 622-2321, www.estuarynewsletter.com. Great bi-monthly newsletter/magazine with environmental news about the Bay. They publish more than one point of view on a subject, backed up by phone numbers, and they're not afraid of controversial subjects.

**Fishing in the City** (415) 892-0460 for Ethan Rotman, the SF Bay Area co-ordinator, (707 944-5500 for Department of Fish and Game Regional Office, www.dfg.ca.gov/coned/fishcity.html. Great

programs for city kids all over the Bay Area. They also have a mobile aquarium, which can go to schools with a ranger named Robin.

**Grizzly Island Wildlife Area** (707) 425-3828.

**Golden Gate National Recreation Area** (415) 561-4700, www.nps.gov/goga/.

**Latitude 38 Magazine** (415) 383-8200, www.latitude38.com. The definitive magazine on sailing. "We go where the wind blows." Covers local sailing, races, and around-the-world cruising. 45,000 subscriptions all over the U.S. and forwards to an eager international audience. Free each month at West marine stores and marinas. It's a treasure.

**The Marine Mammal Center** (415) 289-8620, www.marinemammalcenter.org. Animal rescue, rehabilition, and education center in the Marin Headlands. Store at Pier 39.

**Marine World** (707) 643-6722, www.sixflags.com. Wildlife park, oceanarium, and theme park in Vallejo. Naturalists have been showing audiences native wildlife for thirty-five years. Also see the mountain lions.

**www.anaturalmatch.com** (707) 874-1667. Resource guide for free-lance educators who specialize in the Bay.

**The Nature Conservancy** (415) 777-0487, www.nature.org.

**Environmental Volunteers, Palo Alto Interpretive Center** (650) 961-0545, www.evols.org. Environmental educational programs.

**Port of Oakland** (510) 627-1100, www.portofoakland.com.

**Port of San Francisco** (415) 274-0400, www.sfport.com.

**San Francisco Estuary Institute** (510) 746-7334, www.sfei.org. A private nonprofit organization working to improve the Bay.

**San Francisco Estuary Project** (510) 622-2465, www.abag.ca.gov/bayarea/sfep/sfep.html. These people, in cooperation with the EPA and CALFED, have published two huge, highly detailed books on San Francisco Bay, its flora and fauna, the distribution of wetlands, and specific recommendations for enhancing habitat.

**San Francisco Maritime National Park Association** (415) 561-6662, www.maritime.org. On the water at the foot of Hyde Street. They have a collection of old ships, events, wooden boat building, and a museum. Volunteer for the day and get to sail on the historic *Alma.*

**San Pablo Bay National Wildlife Refuge** (707) 562-3000, http://pacific.fws.gov. They cover all the islands in the Bay. Good info.

**Sausalito Bay Adventures** (415) 331-0444, www.sausbay.com. Rents whalers, RIBS, and trawlers, with or without a captain.

**Save the Bay** (510) 452-9261, www.savesfbay.org. The oldest water protection group on the Bay. Organized to "celebrate, protect, and restore the San Fracisco Bay and Delta." Great guided canoe and kayak trips, adventures, and projects.

**Sea Trek Ocean Kayaking Center** (415) 332-8494, www.seatrekkayak.com. Great place to learn how to kayak in Sausalito. They even have their own sand beach. Trips, classes, and rentals. (There is supposed to be a guide to kayak launch sites or maybe to launch ramps around the Bay as well).

**Shorebird Nature Center** (510) 644-8623, www.cityofberkley.info/marina. A Berkeley Marina experience program and adventure playground for kids.

**Sierra Club** (415) 977-5500, www.sierraclub.org. *Sierra* magazine, *Yodler* newspaper. The original voice of the wilderness.

**SNIFF** A loosly knit group of artists who paint and sculpt on old debris at the Albany industrial dump. Art for art's sake on display and open to the elements on the shoreline just north of Golden Gate Fields Racetrack. Regular patrons visit weekly to see what's new in this wonderful unregulated, unorganized environment. No leash laws yet. Sniff's e-mail is elsob@earthlink.net.

**Stormwater Management** (415) 499-6528, www.mcstoppp.org. You know those little fish painted on the street by the storm drains? Well, that's them and more. They monitor water that runs into the Bay and try to minimize pollutants carried along with it.

**Thurseve Paddle Report** Great write-ups with photos of weekly adventures on the Bay by a group of die-hard kayakers. Ask John Boeschen to put you on his list at boeschen@pacbell.net.

**U.S. Department of Fish and Wildlife** (800) 872-6277, (510) 792-0222. They manage five wildlife refuges in the San Francisco Bay area.

**Waterkeepers** (415) 561-2299, www.waterkeepers.org. Private watchdog organization with an impressive list of accomplishments.

*An Introduction to the San Francisco Estuary* by Andrew Cohen with drawings by Jack Laws. Readable and informative, it's available from Save the Bay for free. It's forty pages long and they'll only want two bucks for postage.

*San Francisco Shoreline Guide.* Another great publication by UC Press. It's a product of the California State Coastal Conservancy and it's available at bookstores.

*Birding at the Bottom of the Bay.* Available from the Santa Clara Valley Audubon Society. Extensive guide and trail maps on where to view birds in the South Bay.

*Easy Waters of California* by Ann Dwyer. Lists locations of boat launch ramps.

I want to thank all the friends and project supporters who have helped make this book possible. Thanks to Dr. William Ehrenfeld for the purchase of a large number of my pieces for the Ehrenfeld collections, and to Maureen Tishma for collecting my work, and to Heidi and Scott Sharfman as well. To the California Academy of Sciences for the exhibition and generous rental fee, especially Terrance Gosliner, Keith Howell, Linda Kulik, Marco Centina, Lyla El-shamy Roberta Ayres, and Crissy Black. To the San Francisco Airport Museums, Blake Summers, and Tim Taylor. Thanks to the Army Corps of Engineers Bay Model Visitors Center, especially Liz Robinson and Christanne Gallagher. To David Loeb and Carolyn Brown at *Bay Nature* magazine for the article and great referrals. At the Port of San Francisco, I want thank Renee Dunn for the purchases, assignments, and for believing in the project. Thank you to Ethan Rotman from Fish and Game, who graciously invited me to his house and gave me a who's who of agencies and people around the Bay. To Paul Jones from the EPA, who told me about duck hunters having their finger in the dike of habitat destruction, and to Conrad Jones of the DFG, who introduced me to both the hunters and the wonderful natural world of Grizzly Island. Thank you to Paul Revier of Save the Bay for his enthusiastic support and encouragement throughout. And thanks to Bob Pritikin for sharing his early environmental writings on the Bay, commissioned by The Sierra Club.

I would further like to thank "herring people" Frank Annicelli, owner of the commercial fishing dock in Sausalito, and Joe Garafallo of C&K, and thanks to all the fishermen and women I've met over the last few years who were interested in my book and who let me take their pictures. Thanks to Bobby and Helen of Bobby's Focsle Cafe, and to Pat Lopez of the Loch Lomond Marina for inviting me to show my work.

Special thanks are due to Alex Syed of San Rafael's Copy Central, for taking the time to teach me how to use the Canon printers; I love the colors. To Phil at Ram Insta Press for patiently working with me. Thanks to you, Photoshop expert Josh Morgan, who made most of the scans in this book and began the color system we are using. To Michele Kakovic, who continued the work, and to Kevin, Susanne, and Ed of Iris Photo-digital for the big scans. Many thanks to everyone at Marin Filmworks, who processed hundreds of rolls of film and made most of the original work prints. Special thanks to Nathan in their digital department for organizing, correcting, and burning the final disks.

I want also to thank author and Bay historian Nancy Olmstead, with whom I became friends after fighting over the color copy machine. Thanks to Mubin Sweeney for being my dive buddy. Thanks to Ron and Gil for keeping the old Evenrude outboard running as long as possible, and to Ken Kaplan for selling and setting up the new Yamaha. Regards to everyone at Sal's Inflatables for the repair work and for convincing me I had a good boat in the Avon R.I.B. Thanks to Dave Leach for selling it to me in the first place.

I would like to thank close friends who kept me going. Jack Dunbar for teaching me about boats, and for putting a sail rig on the dory. Thanks to fellow artist Mary Flemming for her encouragement and for finding some of the images with me. To Joni Blancan, my adventurous boating buddy, to Henry Wolf for making the idea sound real and for playing the piano, and to Brian Austin, who kept the jobs rolling in. Thanks to old friends, divers and artists John and Patti Rothrock, for making me realize I had a "significant body of work."

The final thanks go to New York photo editor Lois Brown, who made sense of it all, and to Rebecca LeGates, Heyday's art director, who did such a beautiful job designing the book. Lastly, thank you Malcolm Margolin for realizing that I really wouldn't go away.